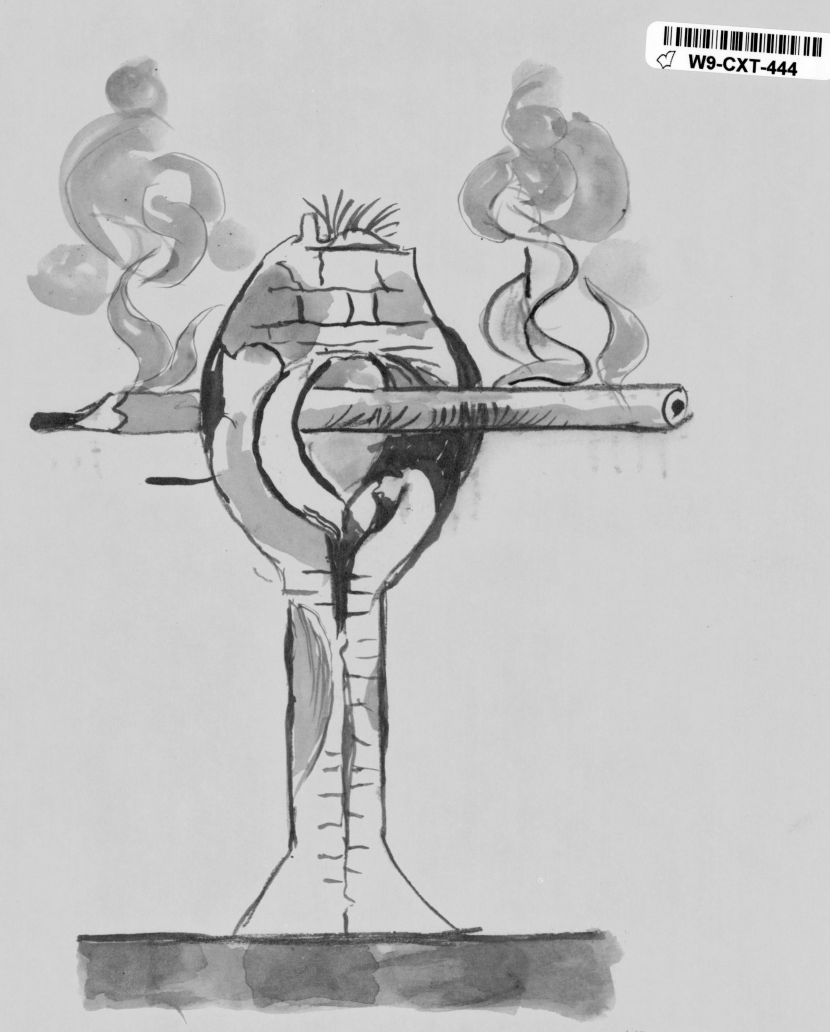

GRAHAM SUTHERLAND

COMPLETE GRAPHIC WORK

ROBERTO TASSI

GRAHAM SUTHERLAND

COMPLETE GRAPHIC WORK

INTRODUCTION *Roberto Tassi*
EDITOR *Edward Quinn*

NEW YORK

Graham Sutherland's most recent aquatint series, the Bees *(Plates 179–92), is preceded by a technical note and short discussion on the artist's approach to the medium, together with documentary photographs of him at work on this series.*

First published in Great Britain in 1978 by Thames and Hudson, London

© 1978 Ediciones Poligrafa, S.A., Barcelona

Published in the United States of America
in 1978 by:

RIZZOLI INTERNATIONAL PUBLICATIONS, INC.
712 Fifth Avenue/New York 10019

Library of Congress Catalog Card Number: 77–77662
ISBN: 0–8478–0116–0

Printed in Spain

Contents

Editor's acknowledgments

I would like to thank Graham and Kathleen Sutherland for their very helpful collaboration and especially the artist who put his personal collection of originals at our disposal to enable us to obtain the best possible reproduction quality.
I would also like to thank the British Museum, the Tate Gallery and the Menton Biennale for their help and all the private collectors and art galleries who gave their assistance.
My thanks are due to the author Felix H. Man and the publisher Galerie Wolfgang Ketterer, Munich, whose book on Graham Sutherland, Das Graphische Werk 1922–1970, is an invaluable work of reference.

Edward Quinn

Introduction

Graham Sutherland first turned to graphic art in 1922, and ever since print-making has been among his constant concerns. In this he is unusual among twentieth-century artists, and indeed among English artists in general. His preoccupation with the graphic media is seen in the fundamental importance of line in all his images. It is line that presides over the birth of his forms, delimits them, allows them to bloom, shatters them, traces their inner structure, the strata, the fragments of which they are composed, and the appendages, antennae or spikes that sprout from them. Line, in short, creates the complex organic structure that delineates the growth and the destiny of forms; and it is line that serves to establish the relationship between one form and another.

Roger Fry has said that the art of the English painters of the last two centuries is 'primarily linear – and non-plastic'. But even earlier we find the great art of the illuminated manuscripts of the Irish monks based on an arid, spare, almost abstract linearism. And William Blake, in the late eighteenth and early nineteenth centuries, drew the extraordinary illustrations for his great poems with a hesitant, wavy line that breaks, stretches, becomes sharp and piercing, wrapping every figure and every plane in a kind of cocoon. Nor are these two examples taken at random, for with both, especially with the second, the art of Sutherland has a direct or indirect connection arising out of the fundamental values of line.

Sutherland's exploration of reality is analytical. He observes keenly the great variety of forms that impinge upon his notice at every step; he then isolates some, subjecting them to a profound analysis – determining their structure, breaking them down into elements and interpreting their functions so thoroughly that, be it a rock, a leaf, an animal or a human face, it is investigated in every particle of its 'being'. With a painter's eye, he penetrates to the most obscure corner, even following the course of the vein beneath the surface. And when a form that is totally familiar is ready to be reborn as a pictorial image, it is above all line, with its extreme ductility and mobility, that can render an account of the analysis. This is why Sutherland's graphic work, essentially based on line, is so important for his study of expression.

The significance of another basic element in his language should not be overlooked and that is colour, for Sutherland is a great colourist, and therein lies no contradiction. The concept of a contrast between drawing and the use of colour, which has so often conditioned both classical and modern writing on art, is misleading and wrongly seen as a problem. More often than is usually admitted, both elements exist in the work of one artist. With Sutherland the effect of this co-existence is exceptional and it explains, moreover, why his graphic work is largely made up of lithographs, for the lithographic technique is one in which the use of colour may predominate.

There is also another factor, inherent in Sutherland's working methods, that helps to explain the graphic development of his work. While he responds to external emotional stimuli, he does not assimilate them for immediate use but stores them in some remote corner of his mind, allowing them to burgeon, thus beginning a close study of the forms that have attracted him. Sutherland is not impulsive, rather poetically contemplative and deep-thinking. Never was a man so mistakenly labelled an expressionist, though he is quite frequently so described. In fact, the basis of his way of working is precision, which he takes to such lengths that it becomes a moral precept. We should not forget that he once studied engineering (1919–20), and that he has always been fascinated by machines – instruments based on precision.

When Sutherland confronts the form of an object that he intends to use for the elements of a picture or an engraving, he studies its every particular, each fibre, every outline, the proportions and relationships between its several parts, the internal and external lines that determine its structure – and also, if it is an animal, its movements and bearing. He endeavours to capture all the infinite particularities that nature has invented and then brought together to form an insect, a stone or a tree. He observes, investigates and understands. Thus the slow pace required by the creation of a graphic work is in proportion to the slowness of his appropriation of the image. Precision is an engraver's most precious gift, the nicety and sureness of his line are the very tools of his trade, and his consciousness of the necessity of every line, of its absolute, definitive function, is something that must never fail him. Sutherland's precision, his obstinate insistence on ensuring the expressive functionality of every detail, make him an artist well equipped for the language of graphic work. Profundity of vision is combined with the rigour of line.

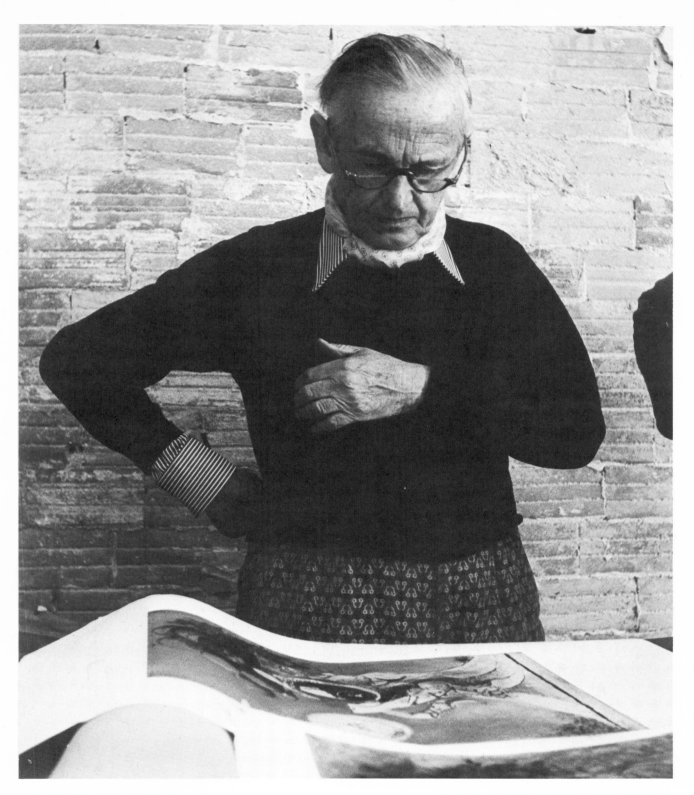

Graham Sutherland in his *atelier* at Menton

Sutherland, then, is aware of the significance of technique; he appreciates its inherent value, which concerns every artist. On the one hand, the work of the artist is linked by technique with every other kind of human activity, while on the other hand, through technique, the artist is enabled to cross that line beyond which the mysteries of expression take shape, a realm in which he can attain the essence of poetry. Since the success of graphic work depends so heavily on technique, we can understand the importance Sutherland gives it, for he knows and practises the technique of etching and lithography with a skill that is perhaps unique today.

It is evident that a general knowledge of Sutherland's world, of his poetic creation, is necessary as an introduction to his graphic work, to the same extent and in the same terms as it is to his painting. In our own time Sutherland has created a great poetry of form. Life that surrounds him is an immense storehouse of forms, some of them clearly visible, others still concealed and waiting to be discovered. Thus everything has its form, by which is not meant simply the evolution of a surface, the external aspect, but also the archetypal character or, as Sutherland himself says, the ancestral mould. Hence by knowing the nature of forms seen, total knowledge – external and internal – is acquired.

For all great artists there are two ways of confronting reality: some make an assault, and engage in a kind of hand-to-hand struggle to seek out and grasp the inner essence; others prefer to stand by, silent and motionless, with an increasingly penetrating gaze, waiting with infinite patience for the reality to be revealed. This is the attitude we find illustrated in the well-known anecdote related by Reynaldo Hahn who, walking with Proust in a garden one day, observed the writer stop in front of a rose, motioning to his companion to go on alone so that he might remain for a while in contemplation, waiting for the secret essence of the flower to reveal itself to him. Waiting, in fact, for something like one of Joyce's 'epiphanies' to take place.

Sutherland belongs to this second group of artists; forms present themselves to him also as 'epiphanies', as essences of objects that 'explode towards' him; and when he speaks of 'the mould of their ancestry', he reveals profound understanding of the psychological meaning of phenomena. The interpretation of those moulds is the result of long contemplation, of the artist's patient watchfulness as he waited for a sign. Sutherland made this even clearer in a recent interview, when he said, 'there is a thread of family likeness in the images which I find, which speak to my own

particular nervous system. That is to say, there are certain conjunctions of form which touch each person's inborn predilection.'

At the beginning of the nineteenth century, Constable remarked, 'A man sees nothing in nature but what he knows.' The essence of forms that the artist has extracted from reality is in truth the projection on to them of his own inner life; the ancestry of the artist reveals itself through the ancestry of forms.

When Sutherland speaks of 'a thread of family likeness', he means something very similar; if certain forms – that are the result of the conjunction of objects, elements of nature, of the way in which they arrange themselves at a given moment and of the particular life or image that light gives them – touch an 'inborn predilection', it means that the artist already holds within him, genetically, the imprint or tracing of those forms, which he endows with a personal significance; this is why he feels so excited when he recognizes them in nature and why he immediately appropriates them, considering that they are already his.

The process may be a little complex, but it explains how these forms that come to life on Sutherland's sheets of paper or canvases, maintain their normal structure; they are recognizable as natural objects, but at the same time have taken on another image and a significance that are unusual, unexpected and new; they have become uniquely and specifically his. They are recognized and unrecognizable at the same time; at once themselves and something else. 'All my paintings', says Sutherland, 'are based on a sudden and personal encounter with some part of nature.'

His world is not governed by the passing of time; there is no place in it for change, for a sense of corruption and gradual progress towards death, the melancholy and anguish of what is fleeting; it is a very different world from that of the Impressionists, of Proust or of Bonnard. Instead we find a fixing of forms, an immobility and also metamorphosis; not conforming with the external rules of time, but rather according to the internal laws of meaning. Though movement and transition are contained in it, they do not lead to any final way out, proceeding rather from one meaning to another, taking a circuitous route instead of following a straight line. The sense of time in this artist's work is contained, as it were, within his forms; having been present at their birth in nature, and then at their extraction from nature by the artist, time has remained inside them. That is why we cannot make the acquaintance of Sutherland's images in any immediate, violent, traumatic

way, but only by prolonged and painstaking study; they have been slow in formation, their growth measured, progressive and layered, and they are equally slow to reveal their meaning, slow to become clarified. Time, in fact, together with light, the painter's subconscious and his feeling, is one of the forces that govern and direct these forms.

Sutherland's works have something immutable that relegates them at once to the present and to the distant past. Occasionally it seems that the objects that appear in them are from time immemorial, and that over them the seasons have passed without a trace, giving them a feeling of eternity.

Indeed, the similarities to be found in different forms beyond the several realms to which they belong, are based upon this very atavism. But here we must be careful, for the dense network of analogies that links the various spheres relating to nature – whether human, animal, vegetable or inorganic – is, if we go by its more superficial meaning, a sign of pantheism. Yet Sutherland is certainly not a pantheist, nor is he, in this aspect either, a romantic; he merely endeavours to capture the essence of things by arduous in-depth investigation, and the greater the difficulties the higher his chances of success; he reaches the meaning that lies 'behind', succeeds in finding the truth behind truth. The visual analogies are not there to indicate the quality and the interchangeability of the whole, but they help us to arrive at their true meaning. Sutherland himself has explained this very well: 'It is not so much a question of a "tree like a figure" or a "root like a figure", but of bringing out the anonymous personality of these things; at the same time they must bear the mould of their ancestry. There is a duality; they must be themselves and also something else. They are formal metaphors.'

Sutherland's style, in fact, is wholly based on metaphor; in his images we find a surface reading of their direct relationship with natural forms, but also the deeper meaning that leads us to another subject. Their ambiguity lies in the fact that they contain these different meanings. The more immediate, more directly visual level on which an image by Sutherland presents itself is that of the manifestation of forms; the forms are presented as what they are, as definitive metamorphoses, and in this guise they have no need to be explained. On this level, the metaphor, as Mallarmé wrote in his *Divagations* on the nature of poetry, corresponds to an absolute power; it has its own function and its own meaning. Sutherland's image, like that of Mallarmé, neither requires nor accepts any commentary; all it propounds is the mystery of its existence, and from this mystery the poetry blossoms forth.

12

It is at this point that we come to the most fundamental characteristic of Sutherland's work, the one that makes it unique and places him among the greatest artists of our time. It is based, as we have seen, on the poetry of forms, which is something very close to the intangible essence of poetry, but, at the same time, it can be seen to be very rich in content. Though it goes beyond the particular, beyond any direct relationship with history, it becomes a testimony of its age, within which is reflected, perhaps in greater depth than in any other work, the probable aspect of modern man.

For something quite miraculous happens with Sutherland. He goes on his exploring walks through the woods, along the banks of estuaries, across quiet dusty roads, through gardens and up hills; meditating, observing, all his faculties concentrated in his eyes, he registers an object, an animal, a form. These he isolates, studies, measures and then transforms, broken down and regenerated, into the complex poetic imagery of his painting. This amounts to an act of transfer from the natural to the pictorial context, but in that transition the form has been enriched by expression, it has become a mark of human life, of the passage of time. Apparently without realizing it, just by working on the forms, Sutherland has recorded the history of our existence. He himself once said (in 1951) that 'a painter is rather like a piece of blotting-paper'; with fine sensitivity, rapidly and almost involuntarily, he absorbs. What? Not only the innumerable signs that nature offers him, the countless forms she strews along his path, if it is illuminated and not a blind alley, but also aspects of the human drama man now experiences, the atmosphere and the meaning of the age. If an artist is really a piece of blotting-paper, then, like Sutherland, he creates poetry and also bears witness.

The forms we see in Sutherland's pictures and lithographs are complete, definitive images, but beside them is a shadow, like the invisible projection of an ambiguous essence. His works are haunted by an unknown presence, undefined and immaterial, but stemming from the relationships that govern the essence of the forms and their conflicts. Few artists of this century give as clearly as he does a sense of the tragic disquiet and anxiety-ridden malaise that are the substance of contemporary life, and convey this not with the superficial violence of desecration, of the will to deform, but with the serenity and aloofness of poetry.

In Sutherland's work there is a sense of waiting; a kind of suspense weighs on the image, as though some unknown event were about to take

13

place: it is the feeling, at times, of being on the edge of a precipice, at the frontier of some unexplored country. In his first encounter with Wales in 1934, which left a definitive mark on his way of seeing things and his feeling for poetry, Sutherland had that impression as he contemplated the landscape. Recalling this in 1942, he wrote, 'The clear, yet intricate construction of the landscape of the earlier experience, coupled with an emotional feeling of being on the brink of some drama, taught me a lesson and had an unmistakable message that has influenced me profoundly.' But this sense of waiting is present throughout his work, not only in his Welsh landscapes; his ability to discover it in nature, and to extract it from the scenery of Wales, evidently derives from some inner power that is a constituent element of his subconscious.

The life of man has always been something that is balanced between obscure forces; it has never been other than the consummation of a waiting period, but the life of contemporary man multiplies the obscurity, the waiting and the consummation. Sutherland has more than once represented the image of a dark looking-glass, with a figure just appearing on its surface, and he has also said that things make their own way from the depths to emerge in the looking-glass. In this way he has expressed a metaphor of his art; for this art is a mirror of the contemporary world, and on its surface appear, in the supreme beauty of poetry, the images of our life.

Graham Sutherland commenced his artistic career, when he was about nineteen or twenty, as an engraver. This activity, however, was not just a tentative initiation, an experimental preparation for a career as a painter, but a true practice of the art of engraving that, in its duration and quality of result, evinces a completeness in itself and also expresses a role in his work as a whole. Here the artist reveals his personality, finds his own themes and lays the foundations of his characteristic language. In ten years, Sutherland engraved rather more than thirty plates, which, except for a few that were dry-points, were all etchings.

It seemed that engraving was to be the whole world of art for him: he made a very close study of all its techniques, engraved his various plates, was elected an Associate of the Royal Society of Painter–Etchers and Engravers in 1925, and eventually became a teacher of the subject at the Chelsea School of Art. Graphic line exerted its unique fascination on the sensitive, intelligent and rational young artist that Sutherland then was; the

facile enthusiasms and languors of youth were enclosed and confined within the severity of graphic linear structures and the purity of black and white.

Throughout his career one of Sutherland's main characteristics has been a certain separation or distance between the emotion he feels in the face of reality and the actual birth of his images; at an early stage he felt the need for a slow process, a prolonged meditation; he learned how to make the lines he traced definitive and perfect. Those ten years of practice have had a great influence on all his subsequent work, and even when he discovered colour, fell in love with it and realized that it was to be a fundamental element in his world, he continued to pay attention to precision, sureness and the need for structure in his chromatic fantasies. This initial choice was certainly influenced by a consciousness of his destiny; and perhaps also by his interest in such artists as Samuel Palmer, who had been an engraver as well, and William Blake, whose work in engraving, painting and poetry has always had a latent effect in Sutherland's career.

The influence of Palmer, which is the most generally recognized and almost always supposed, wrongly, to have been an active element during Sutherland's first decade as an engraver, did not really come till about 1925. In the three preceding years there were other influences, like that of the great masters of engraving, Rembrandt and Méryon, and the subtle, delicate work of Whistler, full of poetical light and shade, indicating Sutherland's interests as a student.

The first engravings by Sutherland that we know were dry-points: *Sylphide* (plate 1a), followed by *Arundel* (1b) and *Coursing* (Greyhounds) (2), done in 1922; they seem to be no more than a couple of studies, yet in them, especially in the second, we find an elegance of form, a tautness of line and a sharpness of structure that are uncommon in the work of young men of nineteen and point to a great vocation.

In the following year, 1923, Sutherland, surprisingly advanced in his command of technical language, executed a series of engravings of very complex construction; in one of these, *Barn Interior II* (4), can be seen, still in a rather inchoate state, the first signs of that attention to objects and forms that was to become so keen. In these plates, almost all of which except *Barn Interior* are views of London such as the Thames and its bridges or groups of old houses in the poorer districts, Sutherland combines reminiscences of Méryon and Whistler. Not the 'fantastic' Méryon, on the brink of madness,

15

but the extraordinary recorder of a Paris in chiaroscuro, the artist Baudelaire loved so well, the Méryon who produced *Le Pont-neuf* and *La Morgue*. The Whistler influence in these engravings comes from the 1859 *Series of Sixteen Etchings of Scenes on the Thames and other Subjects*, that most fascinating, animated and sensitive work of the artist's youth; *Barn Interior* seems to derive directly from Whistler's *The Lime Burner*.

But in the same year (1923) we find the engraving entitled *The Black Rabbit* (8), which is surprisingly different, showing less of the influences just mentioned, and where the effect of Rembrandt first appears; here there is a very positive advance in the change from urban themes to a landscape of lofty trees, country cottages and a river meandering in deep curves over the distant plain. Here one begins to sense a new fantasy and vision, the first faint signs of that dark mysterious side that was to give a double sense to all Sutherland's work, and it was to become dominant in each of the nine etchings he did in 1924. It is not, however, too far-fetched to suggest that in *Warning Camp* (9) and *Number Forty-nine* (14), both of them representations of abandoned cottages, the shadow of Palmer can already be seen, particularly glimpses of that artist's engraving *The Skylark* or the water-colour entitled *A Barn with a Mossy Roof*, though for the moment it is only the superficial influence exerted by the charm of the subject. The Rembrandt influence, on the other hand, is at its height in *The Philosophers* (12), a work quite fit to be hung beside the two biblical scenes created by Sutherland (in accordance with the subject set) when he entered for the Prix de Rome in 1925 as an engraver and was one of the finalists. In these engravings, which are his only works to have an anecdotal subject, Sutherland also made excellent use of the knowledge gained from his impassioned study of the great sixteenth-century engravers of northern Europe, particularly Dürer, and in *Cain and Abel* (17) he reflects a certain taste for illustration characteristic of that period.

Number Forty-nine is a beautiful work; there is an extraordinary familiarity with the technical side of etching in the white trellis of the framework, all that remains of the roof, hanging over the black below, or in the thick blanket of moss and leaves that still covers part of it; here we already have the sense of the forces of destruction that was to be one of Sutherland's constant 'underground' themes. Until then only Van Gogh, in his Neunen period, had painted anything to approach it for verity, squalor and a fantastic feeling of truth – but Sutherland was as yet unfamiliar with Van

16

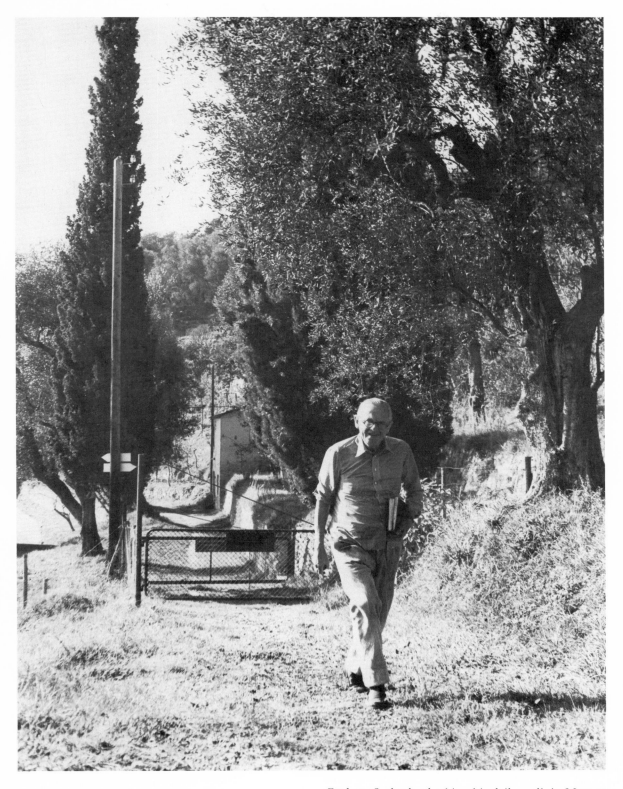

Graham Sutherland taking his daily walk in Menton

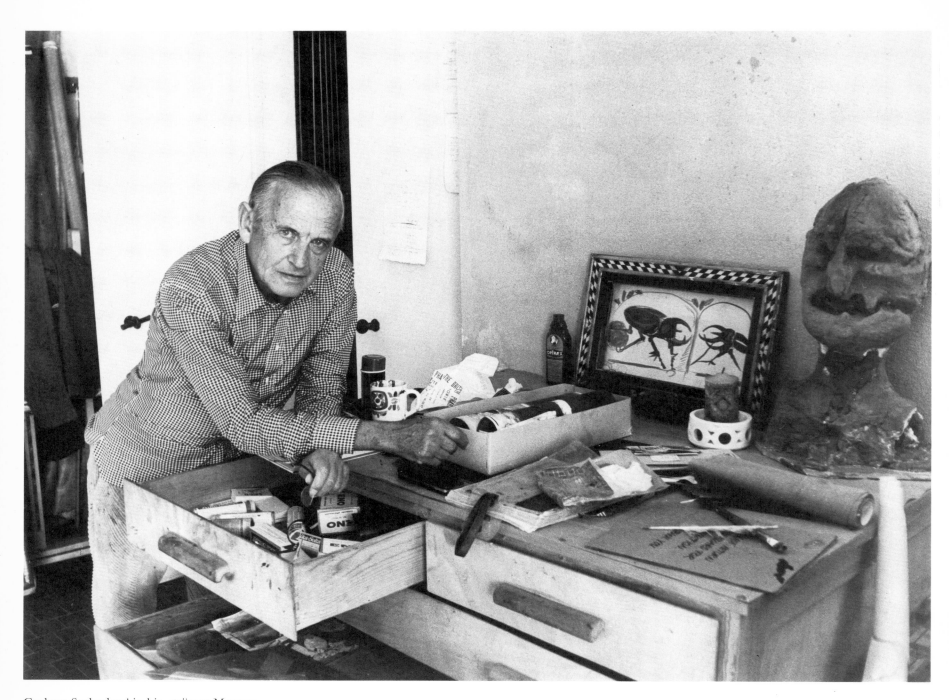

Graham Sutherland in his *atelier* at Menton

Gogh's work. In *Number Forty-nine* we are at the beginning of the splendidly creative period in which Sutherland was to reveal, presently in the field of etching, his complete personality as an artist.

This personality was fully exposed in the works done in 1925; in that year he produced only three etchings, but each is a masterpiece. It was now that the influence of the visionary Palmer of the Shoreham period began more fully to be shown. At first it was only in the engravings and drawings but later, apart from an occasional – and partial – indication of the subject, extending to Sutherland's technique and his treatment of chiaroscuro. It showed in the presence of the sun and its light shining through the trees, the starry sky streaked with horizontal clouds, the contrast between the evening dusk that is already creeping over the land in thickening shadows and the soaring beams of the setting sun. His way of treating the masses with a network of lines that create myriads of little points of light, like an immense gleaming palpitation, remind one of the phrase, referred to by Raymond Lister in one of his studies of Palmer, in a letter written by the artist in 1876 where he speaks of 'those thousand little luminous eyes which peer through finished linear etching'.

But in *The Village* (20) – probably the first of these three etchings – apart from these suggestions of Palmer's influence, which is barely noticeable here, we have the full revelation of a new and absolutely original vision that henceforth was to remain the basis for Sutherland's most characteristic language. For can we not see in these multiple intersections of different planes, like overlapping tongues or waves, in this vision of the profundity of space rising, the same structural traits, allowing for the difference of years, styles and experience, as in the Welsh landscapes that he did in 1934, 1944 and 1975? The richness of the variously illuminated areas of colour, the diversity of the web of lines that stretch across every little corner and then blend into the throbbing symphony of the whole, and the meticulous control and irregular progress of the graver, indicate the work of a master in this genre. In the all-embracing poetry of the image, with tilled fields, weary labourers, their wretched cottages and the evening stillness that weighs on everything, the atmosphere is that of Millet rather than of Palmer.

We find a similar atmosphere in *Pecken Wood* (21), a work that is still more intense, one might even say more dramatic, than *The Village*, with the labourer bent under the weight of his bundle, the scattered logs, the ruts

that the cart has sunk in the lane, the wood at nightfall – the first of Suther-land's woods – and, finally, emerging from it in the reflections of the sun's last rays, that gnarled holm-oak with ivy tendrils creeping up its trunk. This tree is the proud and beautiful ancestor of the 1953 'standing forms', and of all the other trees that proliferate in Sutherland's work. In *Cray Fields I* (18), also done in 1925, there is less drama but greater magic: the bewitching atmosphere of Palmer, now also to be found in the paintings and water-colours, is clearly in the ascendant here, as we can see from the stars, the tall spikes and the line of hop-poles. It is the same with the plates engraved over the next four years; Sutherland's work becomes somehow rare, as though distilled, and each plate engraved is the sum of a long labour of observation and meditation. Throughout this period the influence of Palmer continues, most noticeably in the atmosphere, which seems to be suspended, wrapped in mystery and a tinge of mysticism. The sun, the doves, the stars, the birds and the sheep all become religious symbols; the air is one of enchantment; the contrast between light and shade, though violent, is not disturbing, but seems rather to diffuse an air of quietude over the world. In general, however, the feeling is one of abstraction rather than life.

The definitive advance towards what was to be the true world of Suther-land came in 1929, when he seems to have shaken off the Palmer-inspired mysticism and to have achieved a more direct, dramatic relationship with nature: his surfaces were now almost completely occupied by trees, great woods and their shadows. Towards the end of this year – it is dated 1929/30 – Sutherland engraved *Wood Interior* (29), a very evocative work and one that is highly significant on account of its relationship to the artist's future product, for in it there are already certain surprising parallels, even across the gap of forty years, such as the one between the tree in the foreground, with its roots emerging from the earth, and the tree in the 1972 work, *The Forest* (121), which was also to be the subject of many water-colours and paintings. But the most interesting aspect is the way in which the idea is expounded. The 'interior of a wood' is one of the most characteristic themes in Sutherland's work and, as such, it is of great psychological and symbolic importance; it has been depicted very frequently and is the place where he has discovered the strangest, most fantastic forms and form-light relationships, the ones that best correspond to his 'inborn predilection'.

Sutherland's daily excursions and rambles in search of subjects, the 'ambush' he lays for forms, very frequently take place in the depths of a

wood; and Soavi's excellent book, *I luoghi di Graham Sutherland*, 1973, gives us realistic, poetic and transfigured evidence of these occasions. The painter sets out in the morning, his sketch-book under his arm, along one of the local lanes; quite soon he reaches a point at which, after a moment's hesitation, he plunges into the wood where every dimension changes, the shadows become fleeting, tremulous things, dense and fantastic, and the trees create a luminous tangle of protection, directing the whole of their ascending power towards an invincible sky, displaying their great monstrous, earth-bound roots, becoming creatures of both air and earth. If a ray of light makes its way through the leaves and branches, illuminating a patch of undergrowth, a nut, a clump of bushes, a strip of moss or a puddle, it creates the minor mystery of a form being born, taken out of the semidarkness and outlined according to the size and shape of the opening in the branches above that has allowed the ray to penetrate; the wood has a wealth of forms and shadows, murmurs and odours; it holds protection and fear, offers us a path strewn with adventures, discoveries and scares; it is the maternal womb, but it is also the place where the adolescent goes astray, loses his mother. In *Wood Interior*, done at the early age of twenty-six, Sutherland depicts for us the scene of his adventure and his poetry.

In an etching of the following year, the only one Sutherland did in 1930 and the culminating achievement of the years of engraving work, there is no interior of a wood, but the trees are still the protagonists. Here that hollow tree of Gainsborough, which roused Constable to such enthusiasm, has not lost its almost realistic configuration but has become a monstrous 'personage', inspiring and portending terror, while the shadows sprawl across the space with lowering intensity and the dazzling white trunks of two dead trees seem to writhe like imploring spectres. An air of death broods over this *Pastoral* (30). Here Sutherland has created, for the first time, the tragic landscape: a situation in which nature reveals her drama and her cruelty. During those years in which the Surrealists, their movement then at its height, were trying to obtain fantastic haunting images from a technique based on the liberation of the subconscious but with the assistance of the intellect, Sutherland, quite uninfluenced by either the movement or its methods, was already demonstrating his ability to create images of mystery and dramatic suspense, images that convey a hidden inner truth of their own, without ignoring visual reality or abandoning nature. This is one of the aspects on which his importance as an artist is based.

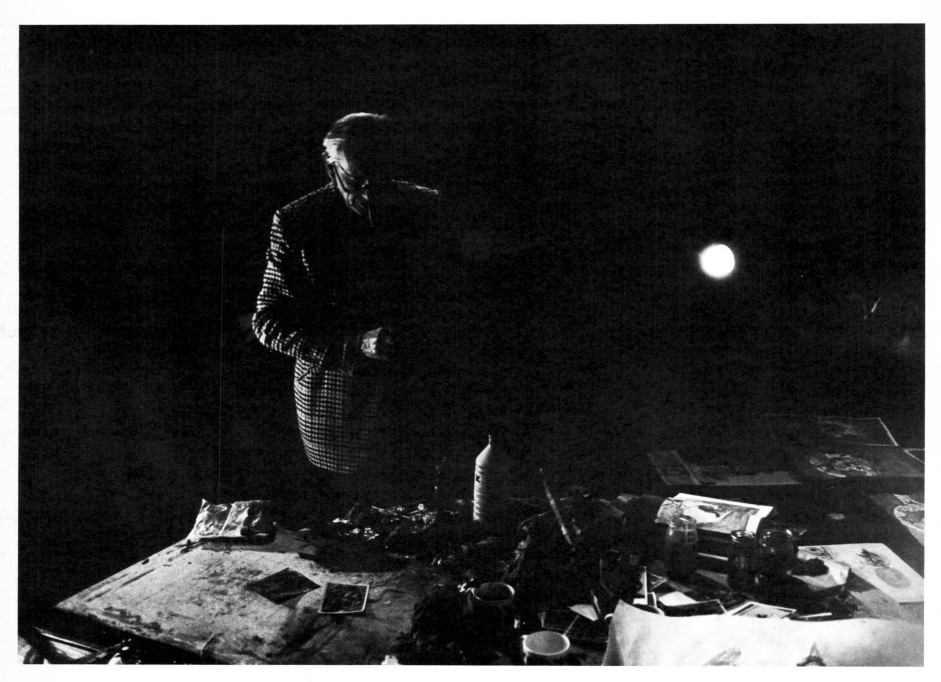

Graham Sutherland in his *atelier* at Menton

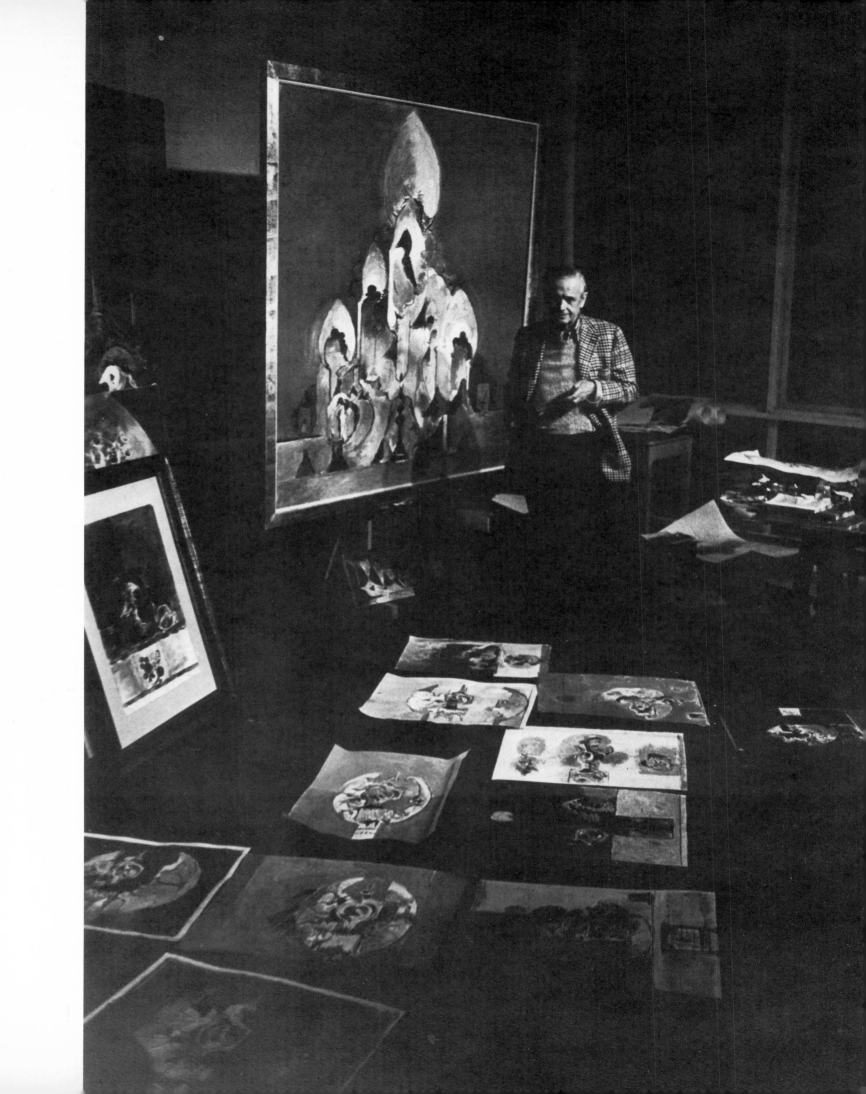

This point, however, marked the beginning of a long hiatus in Sutherland's production of graphic work, broken by only a few engravings at very irregular intervals. He had begun to paint; after nine years of black and white, even with all the subtle variations of tone permitted by his mastery of the technique, he had decided to tackle colour and was already on his way to becoming one of the greatest colourists in English art. Tentatively at first, between 1931 and 1934, with a series of landscapes done in Dorset most of which he destroyed, and of which all that remains is an occasional specimen of the corresponding water-colours; much more positively later on, after his visit to Wales in 1934.

This encounter with the Welsh countryside was decisive for Sutherland and for the foundations of his poetic art. He was to stay many more times in Wales between 1935 and 1945, and the whole of his work during those ten years is dominated by the absolute magnificence of the Welsh scene. Those hills were the source of his original vision, of his way of painting, of his magical mastery of colour. Some critics have voiced the opinion that Sutherland first discovered colour and light in the south of France in 1947 where he began staying for prolonged periods from 1948 onwards, but this is mistaken. It happened in fact much earlier in Wales and it was so definitive that nothing has occurred to modify it since. We can hardly fail to recognize in *Entrance to Lane, Gorse on Sea Wall, Green Tree Form: Interior of Woods* or *Mountain Road with Boulder*, those extraordinarily beautiful pictures done in 1939 or 1940, the particular intensity and refinement, the poetic quality of the colour and the diffuse charm of the light, at once subtle and violent, that were to be constants of all his later works.

This long and fundamentally important period is represented in the graphic work by an engraving, *Clegyr-Boia I* (Landscape in Wales) (33), one of two done in 1936, in which for the first time Sutherland combined etching with aquatint to improve the rendering of the tenuous quality of the shadows and the brightness of the light. It was, however, his last plate in black and white; his discovery of colour brought with it a significant change in his engraving technique, for he now turned to lithography, in which he could develop the interplay and arrangement of the different colours with their expressive contrasts. In this he was encouraged by Oliver Simon, master typographer and a director of the Curwen Press. His first lithograph was *The Sick Duck* (37), 1937, which was followed by some illustrations for Shakespeare's *Henry VI* (40–44) in 1939 and for Francis

Quarle's *Hyroglyphics* (46–48) in 1943, these latter being the only lithographs inspired by his visits to Wales and also the sole examples of graphic work done between 1940 and 1945, when Sutherland was an Official War Artist. Thus his real work in lithography began in 1948 and has continued, with very few interruptions, up to the present.

Lithography offers possibilities of language well suited to the demands of Sutherland's poetic inspiration; that is why he has devoted himself so completely to this technique, in which he has achieved a mastery and obtained such results that he has become one of the greatest lithographers of our time. There is probably no other artist who can create on a sheet of paper such a rich, profound and fascinating ensemble of graphic signs, planes of colour and tonal variations, creating an image just as complete as that of a painting – and even, since he exploits this technique to the limits of its expressive powers, with certain characteristics that painting does not possess. Lithography permits a union between line and colour in which the severity of the one restrains the emotive possibilities of the other, the graphic structure enclosing the luminous, variable universe of colour. In lithography, however, this structure does not possess the almost puritanically ascetic absoluteness of an etching, while on the other hand colour cannot live in it on light and passion alone, as in painting. A softer line and more opaque colour give lithography a quality of intimacy and inner serenity, so that works in this technique seem almost always to be covered by a veil of melancholy. The fact that in lithography the dramatic quality must become inner rather than outer; the analytical investigation of forms and language required by it in the superimposition and arrangement of the various plates; the quality of graphic purity illuminated by colour that is inherent in the medium: these are the reasons that explain Sutherland's passion for lithography and his ability to obtain from it such intensely poetic results.

Important at the time he began to visit France was the influence of Picasso and Matisse, whom he was first to meet in 1947; Picasso's distorting violence and Matisse's sense of space and colour fascinated Sutherland, and he knew how to absorb these elements and master them completely within the atmosphere, the vision and the structures of his own world, which remained English and northern. The two lithographs done in 1948, *Maize* (49) and *Turning Form* (50), and the 1950 work entitled *Articulated Forms* (54) present new objects and new metamorphoses: the great ears of maize, the

pumpkins, the trellis-work of the pergola, the roots and segmented trunks of the palm-trees: these can become a monstrous serpent stretching arrogantly over the landscape, a great shark; perhaps – if they are smaller – worms or larvae. In these lithographs the technique has not yet attained the supreme refinement of later years, but maybe it is with just such violence and summariness in his graphic work that Sutherland endeavours to portray the power of the image and the need for evidence and expressive synthesis that are typical of his painting in those years, for example works like *Thorn Trees*, *Thorn Head* and *Palm Palisade*. *Maize* is the work of a visionary realist: its hard, violent, cruel forms, its opaque, burning colour and the absolute novelty of the image make it as much a masterpiece as the paintings just mentioned.

The habit of living and working on the Côte d'Azur had another consequence for Sutherland's work, or at least coincided with a change in it. At that distance from Wales he no longer painted landscapes in the proper sense of the term; taking the new objects that confronted him – stones, palms, leaves, roots – and using them separately or in conjunction, he observed them in a completely original way and created new forms; it was more or less about this time, too, that he began to refer to these objects, even in some of his titles, as 'forms', thus indicating that they had become protagonists of the work. But it was in his Trottiscliffe studio in Kent, in 1949, that he conceived the 'standing forms'; indeed, though the natural objects he combines to produce these forms are from the south, and though the flowering hedges and the fences against which they rise, or the grasses on which they sometimes stand, seem to be those of Provence, the atmosphere, the light, the mystery and the meaning are not southern but northern.

For five years Sutherland devoted himself to working out these forms. This period, one of his most powerful and original, is documented in his graphic work by eight lithographs that can be divided into two groups, one made up of three 'standing forms' done in 1950 (51–53), and the other consisting of the 1953 *Three Figures in Garden* (55), *La petite Afrique* (56), *Predatory Form* (57), *Three Standing Forms in Black* (58) and *Bird* (59), this last one reminiscent of *Origins of the Land*, painted in 1951. In comparison, the 'standing figures' or 'reclining figures' of Moore and the 'shouting men' by Bacon do not stand up well. In Sutherland's 'figures' we find the symbols, the dramatic and poetic reality, of the 1950s, that tragic decade of the cold war; in them we see the masterpieces of the shaken heart of the century.

The 'standing forms' are also present, as protagonists, in *Origins of the Land*, which marks the culmination of his pictorial investigation in those years; within that framework the forms indicate the origins and continuity of the land, the outset and growth, birth and evolution, of life itself and they are all wrapped in the yellow and violet light of an eternal sun. Among his graphic works, the 'standing forms', until 1953, were almost always engraved in black and white, as were *La petite Afrique* and *Predatory Form*, which are also 'standing forms', as though by making them emerge from the void Sutherland wished to indicate more clearly and incisively their bodies beaten by the light, rendering them still more wraith-like and dramatic.

Considered as a group the 'standing forms' constitute a population of monstrous, fascinating beings; they are the forms of an inter-medium or transition between trees and the human figure, combining the essence and the representation of both; they are the symbolic forms of erection, of the upward tendency, or perpendicularity, and at the same time of the solid, ponderous immanence of the man-tree; they are mysterious presences, the giants of some cosmogony of the organic world. In their heavy, articulated bodies they convey the sense of growth, of the slow accumulation of the rings in a tree trunk or the constant renewal of the human cells.

Though they are richer in plastic strength than any of Sutherland's other works, they are not sculptures. Their material is organic, not stone, and it indicates the point of conjuncture at which all things that are organic co-exist and share the same destiny. They are totems of anguish from which all sense of the sacred has departed. Thus they may be regarded as extraordinary modern examples of that perpendicularity of which Pevsner speaks, with reference to medieval architecture, as one of the characteristics of 'English-ness'. Sutherland calls them 'forms', and he says that they have no ulterior meaning; yet it would be difficult to find images richer in significance. In his ability to combine great pictorial poetry with images of man enmeshed and struggling with the arduous problems of contemporary life, he is virtually unique among modern artists.

In 1949, the year he initiated the 'standing forms', Sutherland also painted the *Portrait of Somerset Maugham*, the first of a series of true portraits, often of great beauty as paintings, that still continues. This new departure might seem rather disconcerting, but it is so only to those who regard modern art as something confined to the aesthetic moulds of the theorists; not for those

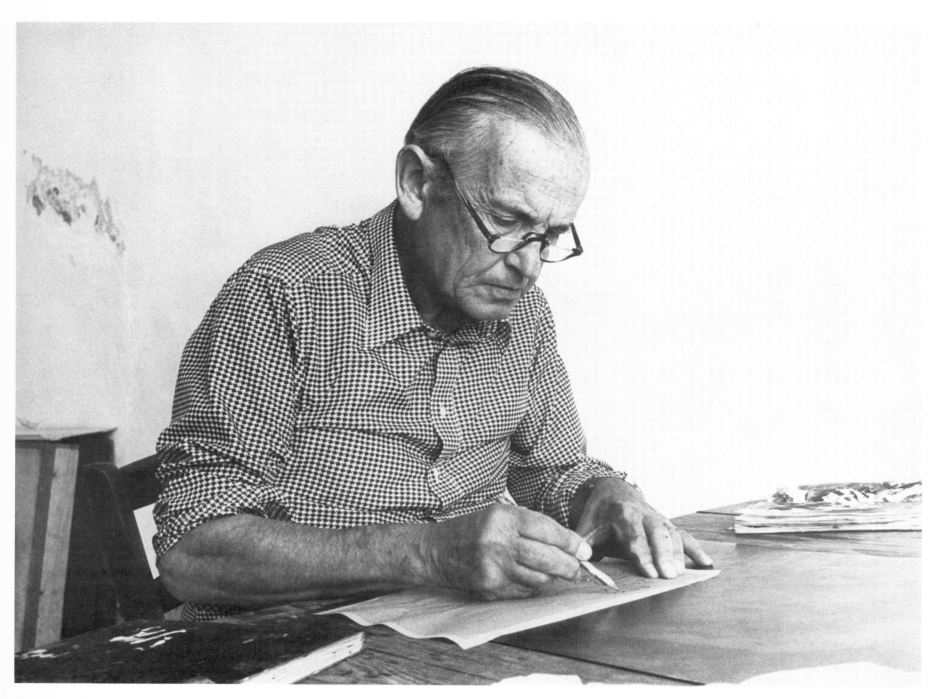

Graham Sutherland in his *atelier* at Menton

who judge art as poetry, after the example of Nicolas de Staël who, even from the standpoint of his own non-figurative approach, declared 'Le portrait, quand-même, c'est un sommet de l'art.' The portraits of Maugham and of Edward Sackville-West (1953–54) are certainly 'sommets de l'art'; and they are also, if properly regarded, 'standing forms'. When Sutherland in 1953 drew Maugham's face again in three different lithographic versions, he created not only a closed, humanly suffering and truthful image, but also an organic form analyzed in its furrowings, its protuberances and the intricacy of its shading, a form that seems to be the forerunner of the *Conglomerate* (113) of 1970. There is no difference between Maugham's head, as a realistic portrait, and an object discovered by Sutherland in the depths of a wood or on the shores of an estuary; the wrinkles and the locks of hair correspond to the veinings of a beetle's shard or the striations of a stone. Sutherland captures the essence of an insect, a rock, or a face in exactly the same way; as natural, organic forms in which the way they correspond to life is revealed to the naked eye.

For nearly a decade after this Sutherland turned his attention only intermittently to graphic art. There were the years taken up by his work on the great tapestry of *Christ in Glory in the Tetramorph* for Coventry Cathedral; early in 1953 he began this project, which was to occupy him directly, in the execution of the successive cartoons, until 1958 and indirectly, in supervising the weaving of the tapestry itself, until 1962. During this period he also did a number of paintings, including such important works as *Thorn Cross* in 1954, *Toad II* in 1958–59, *Dark Entrance* in 1959 and *Machine on Black Ground* in 1962.

Characteristic of Sutherland's work at this time is the increasingly frequent appearance of animals, in a sort of prelude to *A Bestiary*; indeed, in *Hanging Form, Owl and Bat* (63), which is one of the two lithographs done in 1955 and exists in three different versions, we have, as indicated in the title, both owl and bat. This work, printed at the *atelier* of Fernand Mourlot in Paris with great skill and delicacy, is particularly fascinating in the lightness of the harmony between a pale green, a dark green, a very subtle violet and the splendour of the blacks, as also in the co-existence of different spatial functions, in the parallelism between the hanging, barely oscillating form on the field or on the green waters, and the bats, which are also hanging forms, and in the contrast with the owl, peering forth from his dark, nocturnal dwelling-place. In this lithograph – and I refer to the third version

come from the real world; but taken out of nature, freed from their context, they are presented in isolation, emerging against a neutral background, in most cases placed on a base as though on a pedestal. They stand out boldly on the print, occupying practically all the space, and in the contrast between their almost completely realistic conformation and their solitary, timeless presentation they give the whole ensemble a hallucinatory feeling, as though of magic evocations that have become specific, imminent, real. *A Bestiary*, indeed, even though every print possesses its independence, its meaning and its own completeness, can only be known and understood in the entirety of its twenty-six images. This series brings together many themes and ideas that are constants of Sutherland's world, and it repeats, this time in a coherent sequence, the profound significance of that world, which is projected, as we have seen, on two levels: that of the exposition of form absolute in itself and that of the relationship, symbolic or atmospheric, with the contemporary history of mankind.

One of the motifs that we find for the first time in *A Bestiary* – and one that was to be repeated and developed in the artist's subsequent graphic and pictorial work – is that of a form placed inside a structure that contains and confines it, a structure that is itself another form, usually circular or elliptic. This occurs in *Beetles I* (82), on the left of the print, where four insects, or 'forms' of insects, are shown enclosed in black bubbles; in *Ram's Head* (with rocks and skeletons) (88), where a ram's skull and skeleton are entombed, as it were, in two cavities in a stone casket; in *Armadillo* (89), in which the motif is represented by the whole of the image, the armadillo within its shell, seen in a perspective that gives the impression of the animal being hidden in a ball of bone; and, finally, in *Emerging Insect* (103), which represents an insect just coming out of the interior of a circular stone, with some of its body still inside. This motif recalls, and is probably derived from, the forms enclosed in the interior of a wood; like the latter, it conveys the feeling of a protected hiding-place, of the need for shelter, but at the same time of imprisonment, of the absence of freedom. It also indicates the natural law of the mutual permeation of forms; of friendship, or love, between forms. It is essentially a sexual metaphor. At the centre of the green stone in *Emerging Insect*, indeed, we find a representation in black and white of the Tao symbol, i.e. the union between the Yin and Yang elements. The same motif, though slightly varied and on a larger scale, is intended to refer to the theme of the prisoner, as in *Toad I* (91) and *Chained Beast* (108).

Another motif that recurs more than once in *A Bestiary* is that of the apparition. *Lion* (84) and *Ram's Head* (85) are to such a degree 'negatives', white images against the surrounding black, that they seem to emerge, like phantoms evoked by the light, from some mysterious, unfathomable depths, from the very night of time, from the great void of the subconscious or the darkness of fantasy. And the *Chauve-souris in a Looking-glass against a Window* (97) is a true apparition; it suggests a spectator looking in a mirror which reflects a vision of a bat against a broken wire-netting covering of a window, as though in the adventure of an Alice no longer trusting and marvelling but frightened and tragic.

Also present in *A Bestiary* is the motif of the ancient, original, primeval forms that still survive, unknown and unseen, in the modern world, the atmosphere of the 'origins of the land': insects that maintain their monstrousness of antennae, of stings, of shards (*Beetles I* and *Beetles II*) (82, 83), or of antennae in the shape of seeds – a kind of camouflage. *Insect* (simulating seeds) (105), which are unmodified continuations of the most ancient of forms; the fossils of *Ram's Head*; the great bird ponderously taking wing over the desert, *Bird about to take Flight* (95); or *Hybrid* (109), which is like some creation of archaeology-fiction.

In the print entitled *Three Organic Forms* (101) there is the motif of the organic growth that takes place layer by layer, cell by cell, until by accumulation and elevation it forms three 'figures' that correspond, in all their meanings, to the 'standing forms'; here, however, they are not presented against a free-standing wall, but in the interior of a room or other closed space, in accordance with the motif of constriction or imprisonment that, as has been shown, runs right through *A Bestiary*, and from which there emanates at intervals, at those moments when that motif is clearest, a sensation of fear.

Thus we see that *A Bestiary*, which might seem to be a long, happy series of representations of the organic and animal world in its natural state, is in fact extremely rich in profound motivations that give it a life beyond appearances. From the menacing presence of the animals; from the magic of the apparitions; from the ideas of closed space and imprisonment; from the crazed, noiseless flight of the bats in the cellar against that window with the broken bars, which recalls the glass shattered by the devil's hooves in Grünewald's panel of St Anthony in the Isenheim Altar-piece; from the disquieting spectacle of the ants swarming over the cross-shaped tree, *Ants*

(93); from the motif of the primeval forms resurgent or surviving; from the cruelty of the hooked or jagged forms of the birds, the horns, the teeth, the claws, the bones: from all these things, in short, a feeling of anguish is born, a fearful, hidden reality; the image, discovered in its shadow, suddenly revolts against man and becomes a dissertation, however indirect, on man's insecure and defenceless condition. Here it finds its moral basis and thus attains to the ancient force of the medieval bestiaries.

To all the foregoing I should add a mention of the three *Sheet of Studies* (98, 99, 100), one devoted to 'heads', another to 'organic forms' and the third to 'comparisons: machines and organic forms'. In these prints, all three very beautiful compositions, Sutherland gives us an exposition of his poetry of correspondences; in fact, they are a sort of sample-book of the formal potentiality that is contained in natural objects, and of the relationship of form, and, therefore, of meaning, that exists between one kingdom and another, between one territory of nature and the next, between a man, 'found' objects and artefacts. A stone is transformed into a human head; between a machine and an organic form there is no difference but a reciprocal power of substitution, and hybrids can be born that belong simultaneously to both series. The hybrid, indeed, is yet another of the motifs in *A Bestiary* (one of the prints is even entitled *Hybrid*), with all the great wealth of meaning it implies; it may even contain an allusion to hermaphroditism.

While *A Bestiary* was still in progress, Sutherland returned in 1967 to Wales for the first time in years, at the request of the Italian director Pier Paolo Ruggerini who was making a film about his work. This return certainly seems to have been a most important event in his life; for Sutherland it was a sort of way back to his origins, and it marked the beginning of a period in his career that has lasted from then till the present. During these years all the artist's work has again found its inspiration in Wales; it has been a great new phase of rapport with nature as landscape. And yet we cannot say that these works – paintings, water-colours or lithographs – are landscapes, or at least only very rarely; almost all of them, on the contrary, present a form that, emerging from its natural context, becomes, like a kind of 'figure', the protagonist of the composition. It is a form – a tree, a rock, a root – that contains in itself the feeling of the landscape, the sense of its hidden structure, its phantom; and at the same time it makes an obscure allusion or becomes a symbol of human feelings, of human facts and fears.

34

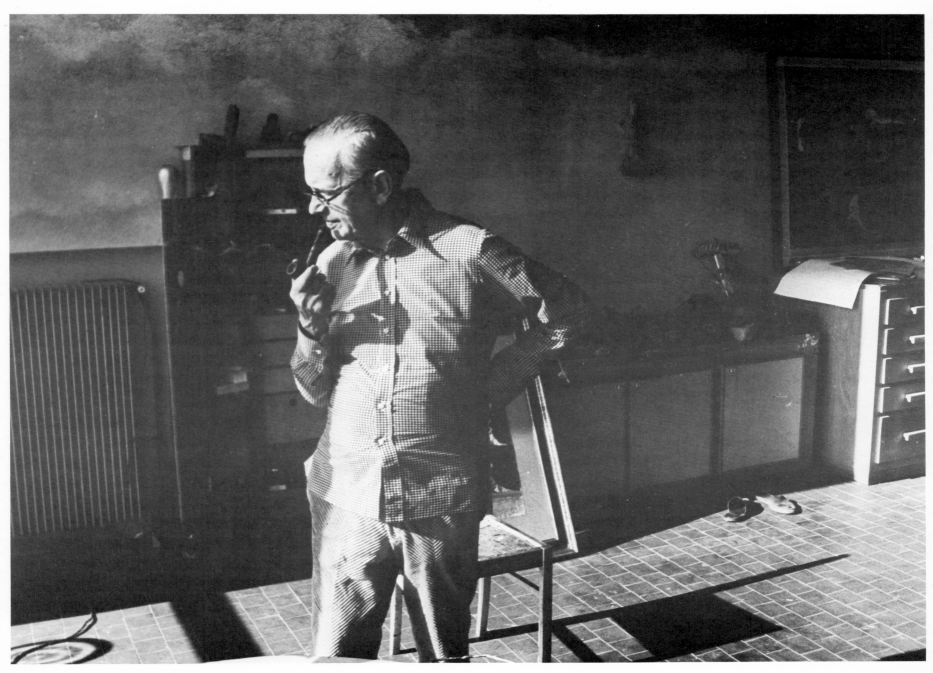

Graham Sutherland in his *atelier* at Menton

It becomes a 'figure' in the same way as the animals in *A Bestiary* or all the other objects and forms in the artist's previous works. And in this sense there is no break or contradiction; Sutherland's poetic inspiration is always the same, only poetry is constantly reborn on new inventions, new stimuli.

Sutherland continues to go on his rambles up hill and down dale, across the moors and along the estuary; he still goes into the woods, observes the rocks, with his sketch-book always in his pocket, and stops short before the wonder of a form he has discovered, whenever he has what he calls an 'original and genuine encounter'. As he says himself: 'I make notes following the first "frisson" of an encounter. Gradually an idea emerges: there is the knowledge that, almost in spite of myself, something significant has arrived . . . The wonder is awakened: for me the objects have to be of a distant and recondite order in order to increase . . .' In that distance and obscurity lies the whole creative space of Sutherland; it is there that his inventions are born, his metamorphoses formed, his visionary powers exercised; it is that distance that enables him to reproduce reality, by re-inventing it completely.

In Wales this process has its greatest possibilities of development, for there, amid the waters and the plants, the raw elements of Sutherland's figurative language lie scattered, the elements that appeal to his 'inborn predilection'; in that land there are already all the shadows, the structures, the ancient sense of time and the modern mystery of things that will be re-born in his work. In Sutherland's own words: 'From the first moment I set foot in Wales, I was obsessed. I have worked there, particularly in Pembrokeshire, every year since 1934 – with one long and regrettable gap, brought about by the fact that I thought I had exhausted what the country-side had to offer both as a "vocabulary" and an inspiration. I was sadly mistaken; and in the last ten years I have made up for it by continuing my visits in order to make my studies and to soak myself in the curiously charged atmosphere, at once both calm and exciting, to meet the people, so kind and optimistic, and to benefit on good days from the extraordinarily clear and transparent light.'

From the moment of his return to Wales, in the wake of the happy experience of *A Bestiary*, Sutherland continued to engage in graphic work, and this activity has gone on without any further interruptions since then, simultaneously with his painting. The following three lithographs were done in 1970: *Object on an Estuary Shore* (111), *Rock Form* (112) and

Conglomerate (113). In his new Welsh period Sutherland very frequently draws the inspiration for his forms from rocks; this new element of the rocks has by now become another of his most fascinating and significant motifs and is of an importance similar to that of the 'standing forms' or the 'wood interiors'. Among various other examples there are the rocks in *Boat-shaped Form*. the *Oval Rock*, the very beautiful *Conglomerate* (113) and the two gouaches entitled *Rock Fortress*, as well as the *Study of a Rock Face in the Estuary at Sandy Haven* from the 1970 sketch-book, the *Stone Towers*, and, among the lithographs, the 1972 *Three-headed Rock* (131), *Field of Rocks with Candle* (142), *The Cathedral II* (161), *Flames in a Rock Form II* (169), both 1975 works, and *Fossil with Rocks and Flames* (170).

The rock is the most ancient part of the earth; modelled by the events of natural history, by winds, rains, frosts and earthquakes, it guards and hands down the signs of that history; eroded and splintered, yet stable, it is like a skeleton on the earth's surface, a resistance, a solidity; the rock is also a great reserve of forms, forms that reflect the writing of time and the fantasy of man, the rock's own inner structure and the feeling of the man who observes it. As we know by now, in the work of Sutherland there is always some element, be it object, form or 'figure', that is destined to emerge in the environment that surrounds and protects it, which becomes the centre of the interest and significance of the image: the forms in a wood, isolated by the light, the 'standing forms', the thorn crosses, the machines, the animals in *A Bestiary*; now it is the turn of the rocks.

They have a sense of emergence, but they are not plastic; the 'standing forms' might make one think of sculpture, but the rocks are wholly pictorial; they have lost nothing of the roughness, aridity and massiveness that were their natural qualities, though now they also display the shadows, the fissures, the lines of force, the stratifications and the colours that transform them into extraordinary poetic inventions. Combining in one and the same image solidity and lightness, coherence and splintering, the aridness of their substance and the gaiety of their colour, they are excellent representatives of this period in Sutherland's career that has now lasted almost ten years, a period of profound, conscious maturity, of serene, essential thought. The violence has been removed, the cruel aggression of the forms exhausted, the drama has become more inward. But that second view, that 'double' of the image, the disquieting, nameless phantom, has remained quite intact; the only difference is that now it inhabits the work with a more serene,

intimate and poetic presence; the anguish has been diffused into a deeper sadness; the metaphorical relationship with life has not been interrupted. On the yellow, pink and blue rocks of Wales the natural history of the earth is written, but also the history of mankind. In the language of poetry those images are still the truest, most enduring signs and symbols of contemporary existence.

The *Oval Rock*, the *Rock Fortress* and the admirable *Conglomerate* (113) form a new embodiment of the motif of the enclosing form: oval, rectangular or round, these rocks that rise in grandeur against the background of a hill or a wood surround an almost chaotic collection of other forms, dark, empty sockets, emergent areas of brighter colour, filaments, fissures, intertwinings of light and shade, gilded splendours, sinuous blacks. It is the sense of life enclosed in a womb of stone, the motif of penetration and thrusting; and it is also the splintering of forms that corresponds to the splintering of the psyche, an organic chaos that mirrors the chaos of existence. Within the reduced, concluded form of the rock stretches a vast, mysterious landscape, and on its surface we see incisions that sometimes seem to be the many-faceted splendour of a precious stone, and sometimes a pale, limitless hell.

In 1971 Sutherland published a series of six lithographs (the engraving was carried out at the Teodorani workshop in Milan) entitled *La Foresta, Il Fiume, La Roccia* (121ff.) in which the rock and tree motifs are combined. Against a dark sky a rock gleams in the night, a rock that is a tangle of chalky lines and streaks of light, wasted by time, corroded by rust, splintered by frost, as old as an Egyptian tomb or a megalithic dolmen. Against the dark-green counterglow of a hedge, resting on the still luminous plane of the earth in the enclosed space, a great stone form stands like an idol presiding over some mysterious rite. Like aerial roots, the streaming branches of a smooth, moon-blanched tree are twisted by a menacing gust of wind. From the water of the river emerges a form that sprawls in the distant sun. In the green light of the forest trunks, mosses and roots are mingled in an obscure entanglement.

In 1973 Sutherland created two large etchings with these same forms of trees and rocks. Black and white, suddenly rediscovered, give a new dramatic quality that, thanks to the technical skill that adapts to every subtlety, is enabled to play its part in the very complex scene between the forest and the river. The two prints complement each other: one, *Picton*

(135), is a night scene in which the empty, velvety wall of the sky flaunts its dark banners over the landscape and vibrates through the 'thousand luminous eyes' that peer down from the mesh of graphic lines; the other, *Hybrid* (136), is a day scene in which three salient points of light – the sun, the candle and the brazier – diffuse a clarity that brightens and burnishes everything in sight; the protagonists of the scene are the smooth, twisted, leafless trees that rear up in the air like monstrous animals; there is still a vaguely totemic air about the whole, but these forms seem rather the idols of some savage, desperate ritual, the immobile monuments that symbolize a destiny of dissolution and death, of a return to the desert and primeval silence, as if that oval stone, closed in the night scene and open in the day scene, was meant to be an indication of the dried-up heart of the world. Here once again Sutherland, pursuing natural forms with obsessive obstinacy and reading the 'Egyptian hieroglyphs' of nature, as Constable called them, interprets the drama of obscure years.

The period 1973–75 was one of intense activity in graphic work. Sutherland created about thirty prints altogether; apart from the two etchings, he did some aquatints and a great number of lithographs. The aquatint technique helped him to express the real essence of form, line and colour, and he made good use of it in creating homogeneous backgrounds – in black; *Field of Rocks with a Candle (Campo di rocce)* (142), done for the Venice Campiello Prize to authors (the title is a play on the word *campiello*); green, *Bird and Split Rock* (145); or yellow, *Form in a Desert I* (144) – which convey a sense of vastness. In these last two prints, which are unusually large and splendidly engraved, the immobile sun in an indifferent sky, the desert of the earth, the bird with wings outstretched like a huge skeleton and the splintered rock combine to evoke an image of desolation, as though some final desiccation had taken away the drama and life of all created things.

Particularly rich graphic works are *The Cathedral I* and *II* (160–61) where the carefully arranged and superimposed rocks rise up to form a luminous, fantastic building, but corroded, abandoned, inhabited only by darkness and fire. A splendid construction of greys, blacks and yellows forms *Tower of Birds* (158) over which broods the fearful atmosphere of the window seen against the light. In *Bird and Split Rock* the rocks burn with red and yellow flames; the air is invaded by the parched red, pink and black of a little furnace in which we see, presented one after the other, the themes of elevation and enclosure: the trees spiralling upwards, the rounded shape of

the fossil, the skeletonized bird, the burning rock. The flame motif is one that recurs frequently in Sutherland's work. It first appeared in the *Furnaces*, was repeated in the *Braziers* and even figured in *A Bestiary*, in the print entitled *Cynocephalus* (94); and what, I might add, were the red and yellow hillsides in the Welsh landscapes of 1940 and 1945 if not tongues of flame? Flames are destructive forces, but also signs of life; they burn like hell and passion. Behind these sharp, spreading forms the memory of Blake is ever present; the shade of the great poet seems to be watching from a distance, with his visions, his myths, his doubts, and his ability to assimilate contraries.

The beauty of Sutherland's most recent images is 'timeless', as is that of all poets, rough, solitary and intense; in that beauty his work continues.

ROBERTO TASSI

The Plates

1a SYLPHIDES
Drypoint, 1922
Size: $3\frac{3}{4}'' \times 4\frac{7}{8}''$; 9.4 × 12.2 cm
Black
Edition: no edition printed
Printer: the artist

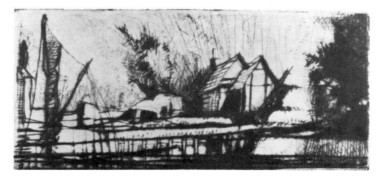

1b ARUNDEL
Drypoint, 1922
Size: $1\frac{5}{8}'' \times 3\frac{3}{4}''$; 4.25 × 9.4 cm
Black
Edition: no edition printed
Printer: the artist

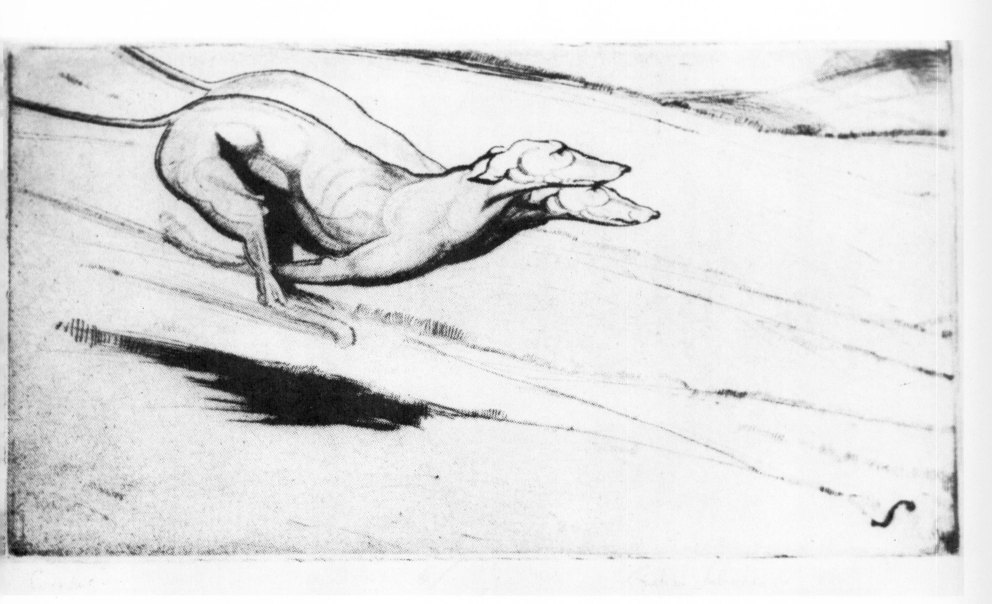

2 COURSING (Greyhounds)
Drypoint, 1922
Size: $5\frac{3}{8}'' \times 9\frac{1}{2}''$; 13.6 × 24 cm
Black
Edition: 3 trial proofs only
Printer: the artist

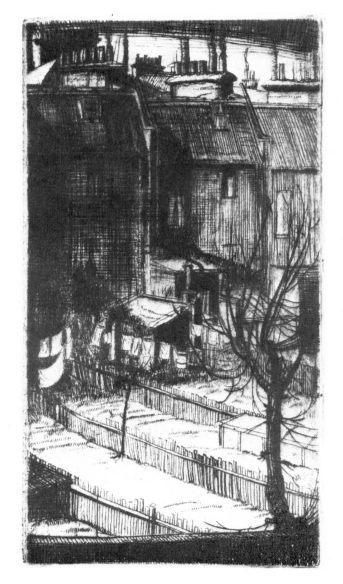

3 STUDY OF HOUSES (New-Cross Backs)
Etching, 1922
Size: $6\frac{1}{2}'' \times 3\frac{3}{8}''$; 15.2 × 7.6 cm
Black
Edition: 5
Publisher: not published
Printer: the artist

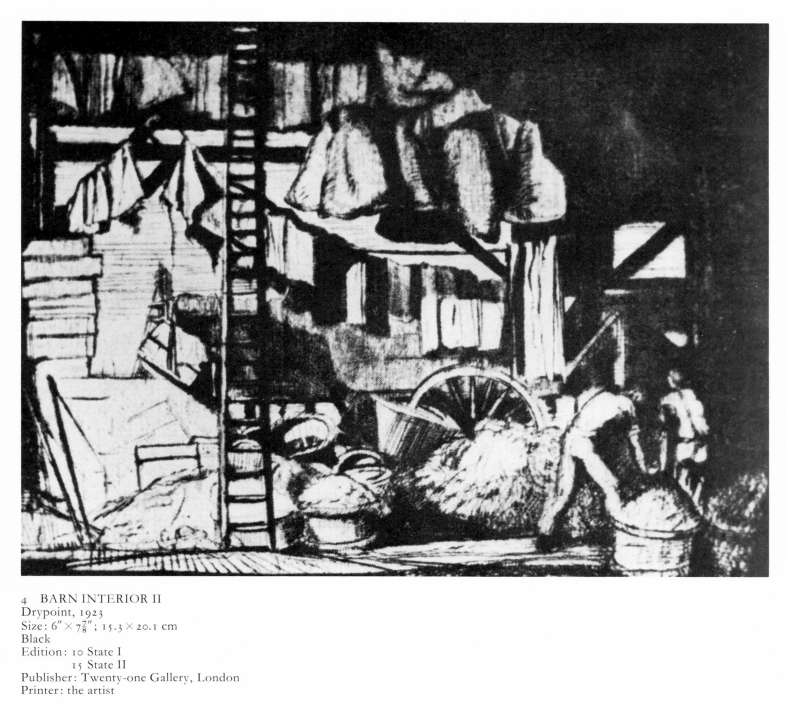

4 BARN INTERIOR II
Drypoint, 1923
Size: 6″ × 7⅞″; 15.3 × 20.1 cm
Black
Edition: 10 State I
 15 State II
Publisher: Twenty-one Gallery, London
Printer: the artist

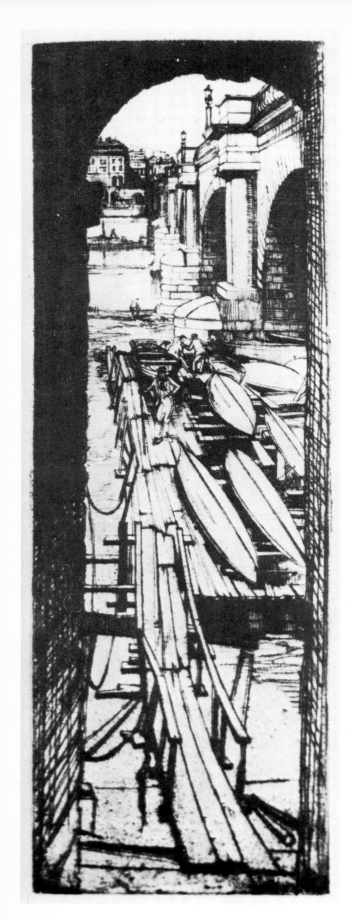

6 LITTLEHAMPTON II
Drypoint, 1923
Size: $2\frac{7}{8}'' \times 3''$; 7.2 × 7.4 cm
Black
Edition: 6
Publisher: Twenty-one Gallery, London
Printer: the artist

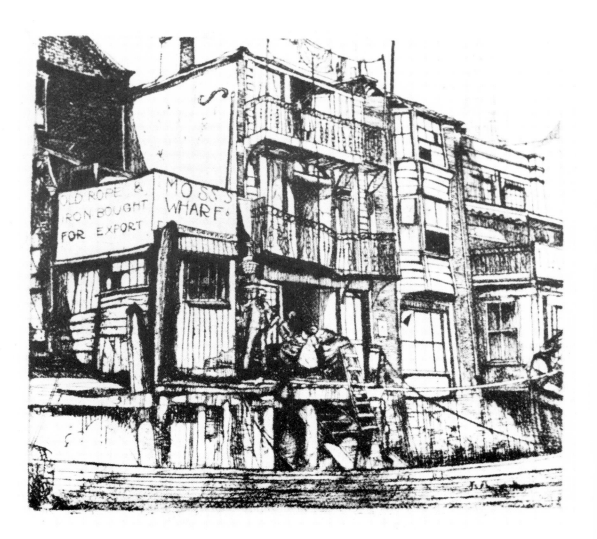

5 WATERLOO BRIDGE
Etching, 1923
Size: $10\frac{3}{8}'' \times 3\frac{7}{8}''$; 26.3 × 9.8 cm
Black
Edition: 6 State I
 21 State II
Publisher: Twenty-one Gallery, London
Printer: the artist

7 GREENWICH
Etching, 1923
Size: $5\frac{1}{2}'' \times 6''$; 13.8 × 15.2 cm
Black
Edition: 20 State I
 18 State II (reproduced)
 artist's proofs included
Publisher: Twenty-one Gallery, London
Printer: the artist

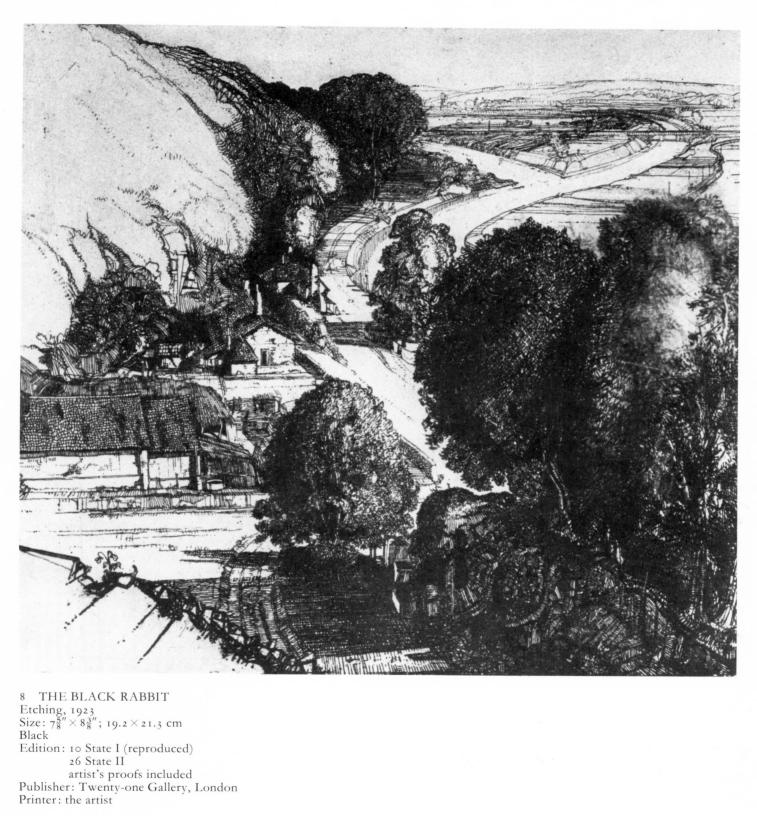

8 THE BLACK RABBIT
Etching, 1923
Size: $7\frac{5}{8}'' \times 8\frac{3}{8}''$; 19.2 × 21.3 cm
Black
Edition: 10 State I (reproduced)
 26 State II
 artist's proofs included
Publisher: Twenty-one Gallery, London
Printer: the artist

9 WARNING CAMP
Etching, 1924
Size: $5\frac{1}{8}'' \times 6\frac{1}{8}''$; 13 × 15.5 cm
Black
Edition: 6 State I
 56 State II
Publisher: Twenty-one Gallery, London
Printer: the artist

10 THE SLUICE GATE
Etching, 1924
Size: $5\frac{1}{2}'' \times 5\frac{1}{4}''$; 14 × 13.3 cm
Black
Edition: 2 State I
 1 State II
 10 State III
 56 State IV
 some artist's proofs of State III and IV
Publisher: Twenty-one Gallery, London
Printer: the artist

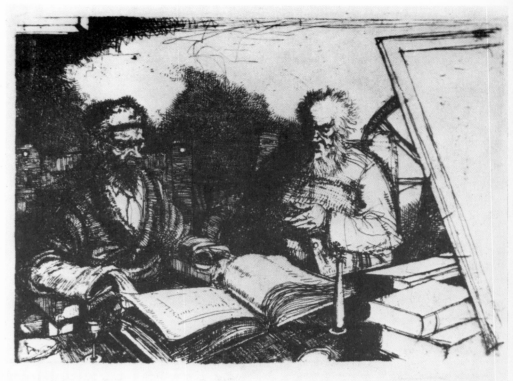

12 THE PHILOSOPHERS
Etching, 1924
Size: $5\frac{3}{4}'' \times 7\frac{3}{4}''$; 14.7 × 19.7 cm
Black
Edition: 3
Publisher: Twenty-one Gallery, London
Printer: the artist
Test piece for the Prix de Rome

11 ADAM AND EVE (THE EXPULSION
FROM EDEN)
Etching, 1924
Size: $8'' \times 6\frac{1}{8}''$; 20.3 × 15.7 cm
Black
Edition: 12
Publisher: Twenty-one Gallery, London
Printer: the artist
Test piece for the Prix de Rome Final

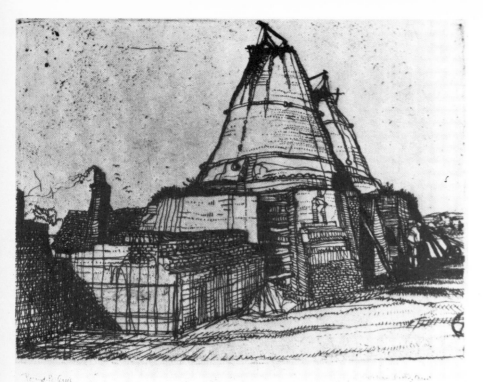

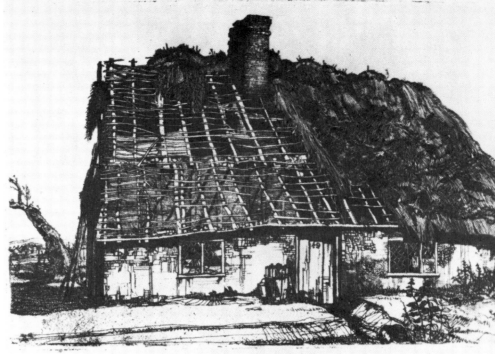

13 POLING POTTERIES
Etching, 1924
Size: $4\frac{1}{2}'' \times 5\frac{1}{2}''$; 11.5 × 14 cm
Black
Edition: 19 including artist's proofs
Publisher: Twenty-one Gallery, London
Printer: the artist

14 NUMBER FORTY-NINE (No. 49)
Etching, 1924
Size: $6\frac{7}{8}'' \times 9\frac{3}{4}''$; 18 × 25.2 cm
Black
Edition: 15 State I
 5 State II
 60 State III
 some artist's proofs included (I and III)
Publisher: Twenty-one Gallery, London
Printer: the artist

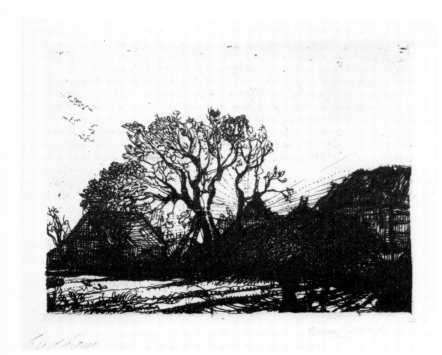

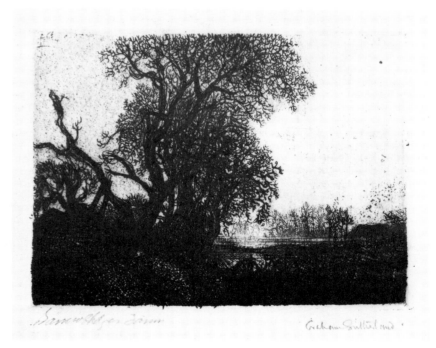

15 CUDHAM, KENT
Etching, 1924
Size: $3\frac{1}{8}'' \times 4''$; 8 × 10 cm
Black
Edition: 42 including some artist's proofs
Publisher: Twenty-one Gallery, London
Printer: the artist

16 BARROW HEDGES FARM
Etching, 1924
Size: $3\frac{1}{8}'' \times 4\frac{1}{8}''$; 8 × 10.5 cm
Black
Edition: 46, some artist's proofs not included
Publisher: Twenty-one Gallery, London
Printer: the artist

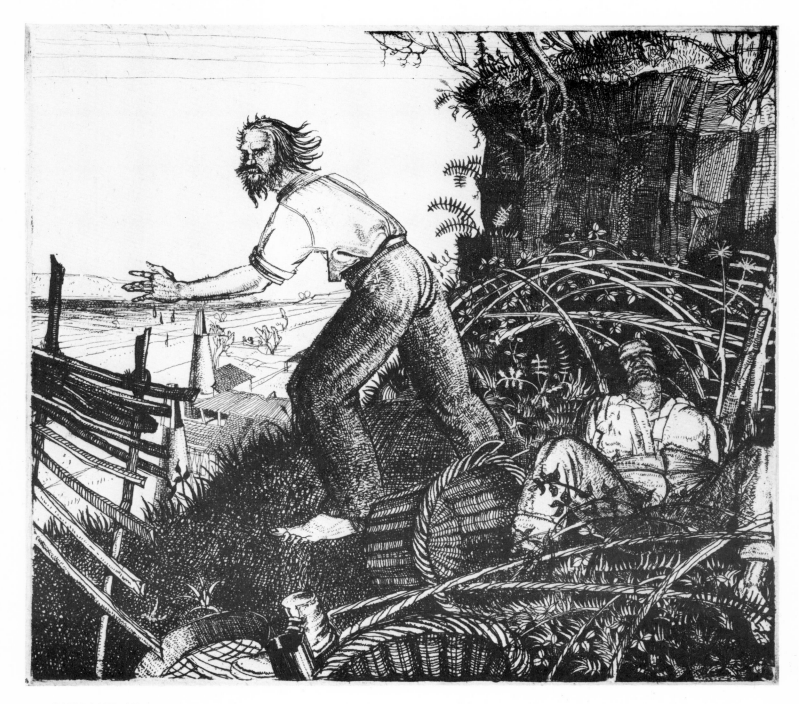

17 CAIN AND ABEL
Etching, 1924
Size: 7″ × 7½″; 17.9 × 19.2 cm
Black
Edition: 12
Publisher: Twenty-one Gallery, London
Printer: the artist

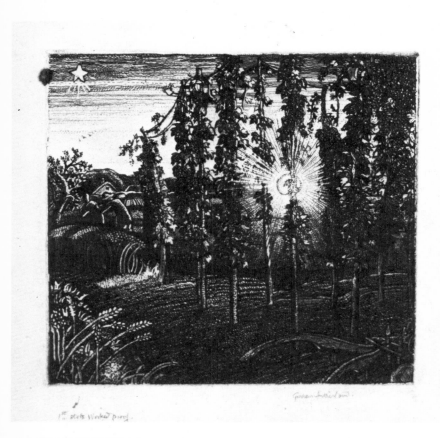

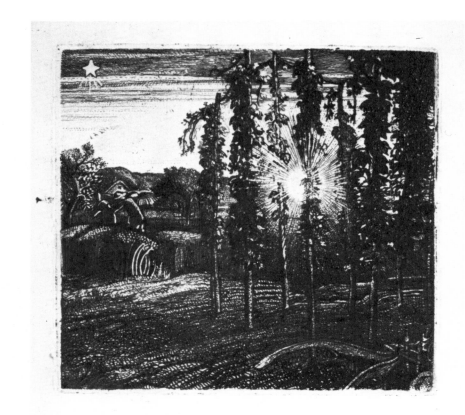

18 CRAY FIELDS I (1st state)
Etching, 1925
Size: $4\frac{3}{4}'' \times 4\frac{7}{8}''$; 12 × 12.5 cm
Black

19 CRAY FIELDS VI
Etching, 1925
Size: $4\frac{3}{4}'' \times 4\frac{7}{8}''$; 12 × 12.5 cm
Black
Edition: 3 State I
 2 State II
 2 State III
 2 State IV
 2 State V
 85 State VI (reproduced)
 including some artist's proofs
Publisher: Twenty-one Gallery, London
Printer: the artist

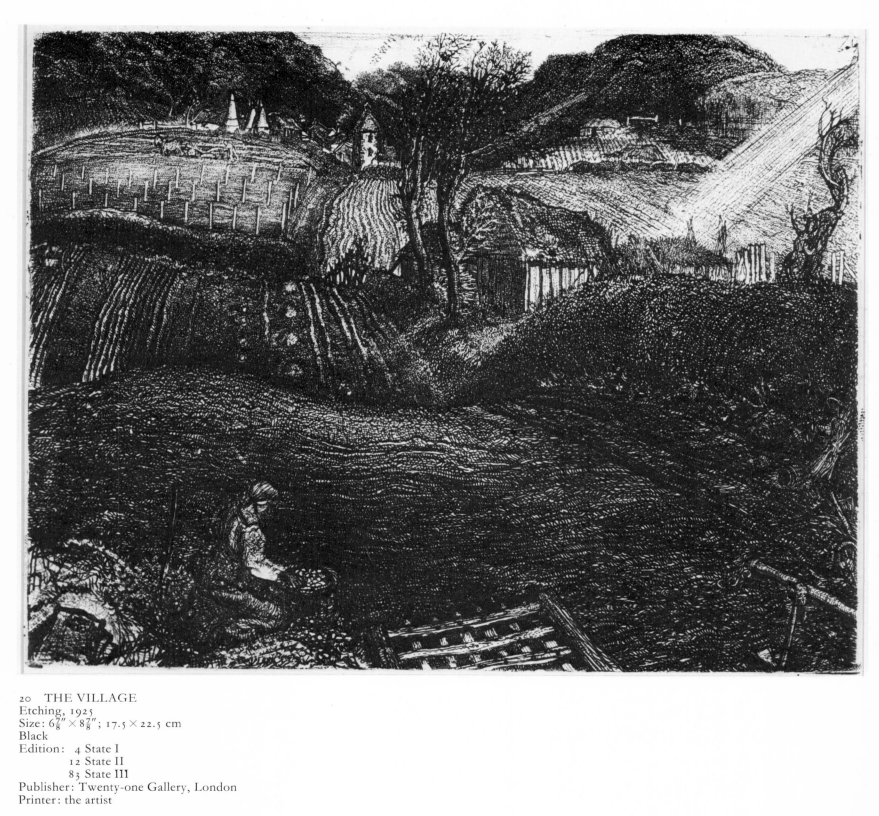

20 THE VILLAGE
Etching, 1925
Size: $6\frac{7}{8}'' \times 8\frac{7}{8}''$; 17.5 × 22.5 cm
Black
Edition: 4 State I
 12 State II
 83 State III
Publisher: Twenty-one Gallery, London
Printer: the artist

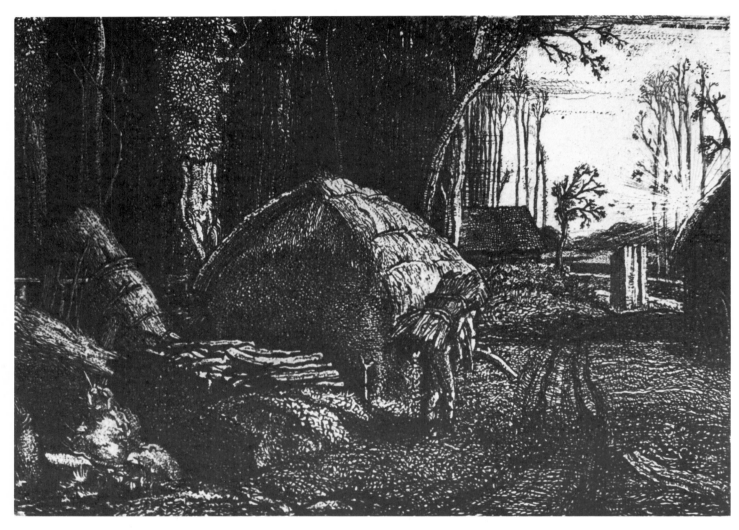

21 PECKEN WOOD
Etching, 1925
Size: $5\frac{3}{8}'' \times 7\frac{3}{8}''$; 13.5 × 18.9 cm
Black
Edition: 1 State I
 2 State II
 85 States III, IV, V
 including some artist's proofs
Publishers: Twenty-one Gallery, London
Printer: the artist

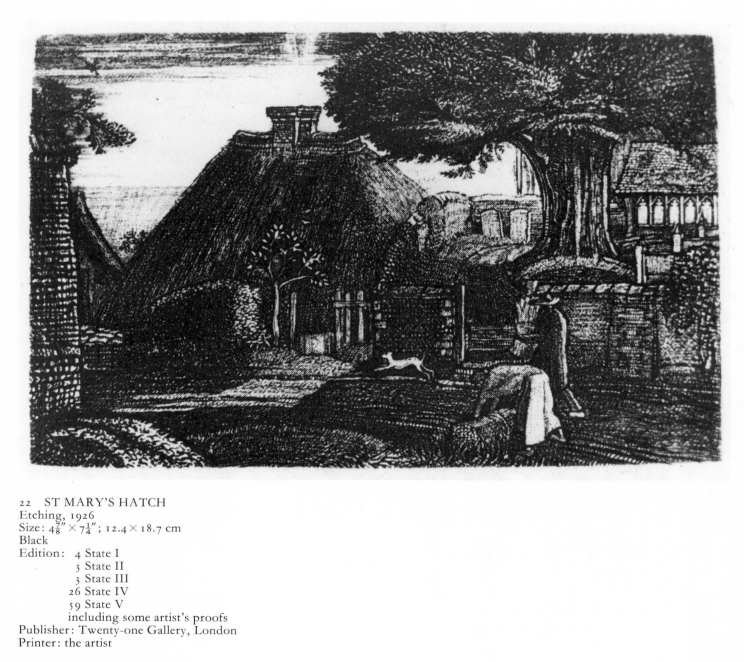

22 ST MARY'S HATCH
Etching, 1926
Size: $4\frac{7}{8}'' \times 7\frac{1}{4}''$; 12.4 × 18.7 cm
Black
Edition: 4 State I
 3 State II
 3 State III
 26 State IV
 59 State V
 including some artist's proofs
Publisher: Twenty-one Gallery, London
Printer: the artist

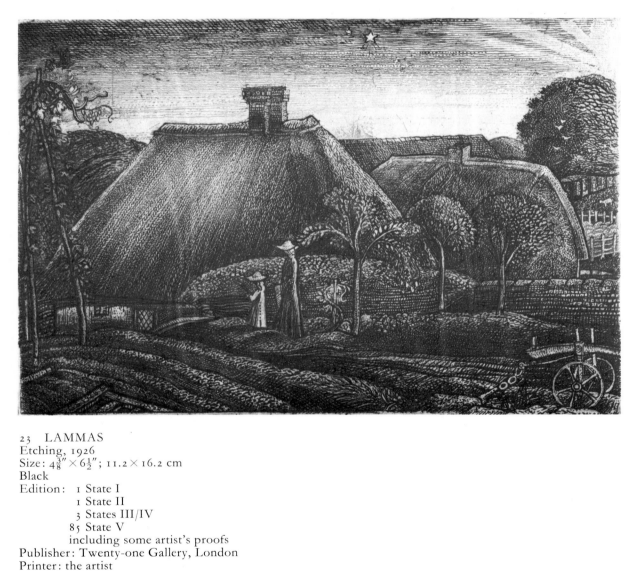

23　LAMMAS
Etching, 1926
Size: $4\frac{3}{8}'' \times 6\frac{1}{2}''$; 11.2 × 16.2 cm
Black
Edition:　1 State I
　　　　　1 State II
　　　　　3 States III/IV
　　　　85 State V
　　　　　including some artist's proofs
Publisher: Twenty-one Gallery, London
Printer: the artist

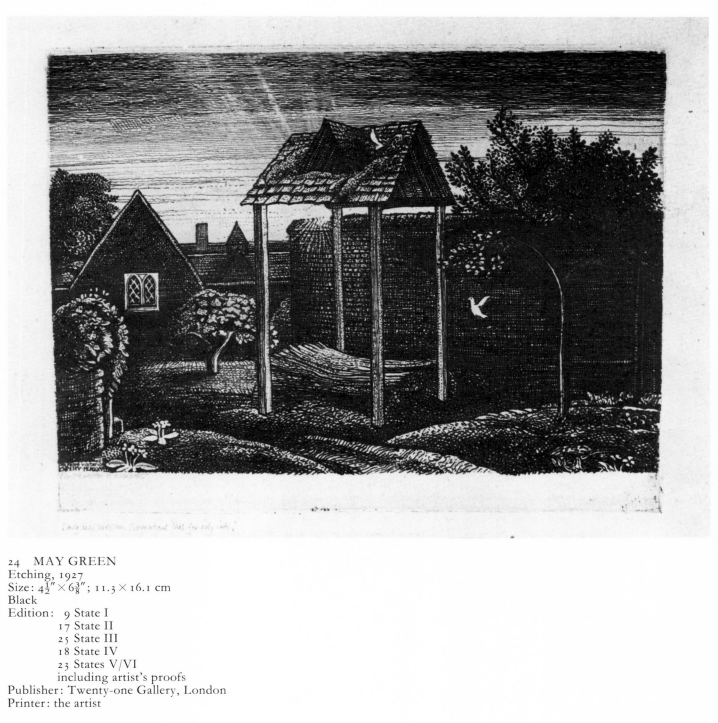

24 MAY GREEN
Etching, 1927
Size: $4\frac{1}{2}'' \times 6\frac{3}{8}''$; 11.3 × 16.1 cm
Black
Edition: 9 State I
 17 State II
 25 State III
 18 State IV
 23 States V/VI
 including artist's proofs
Publisher: Twenty-one Gallery, London
Printer: the artist

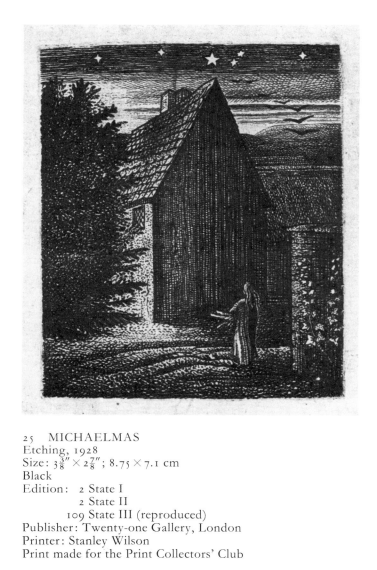

25 MICHAELMAS
Etching, 1928
Size: $3\frac{3}{8}'' \times 2\frac{7}{8}''$; 8.75 \times 7.1 cm
Black
Edition: 2 State I
 2 State II
 109 State III (reproduced)
Publisher: Twenty-one Gallery, London
Printer: Stanley Wilson
Print made for the Print Collectors' Club

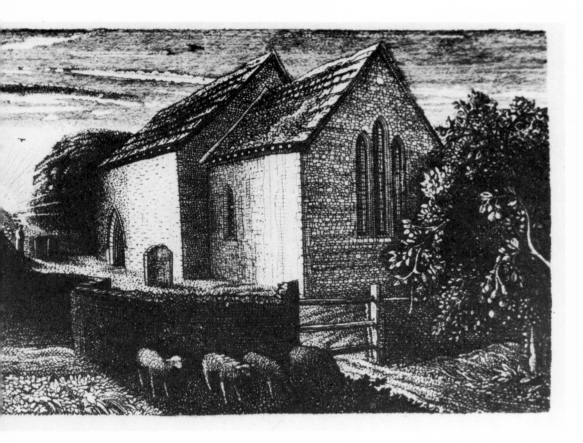

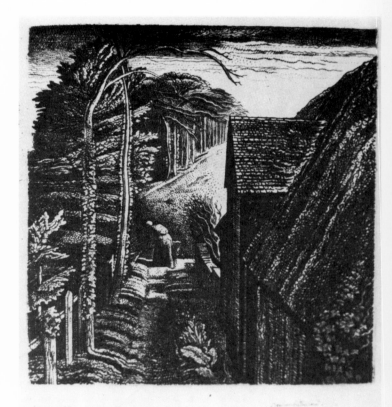

26 THE MEADOW CHAPEL
Etching, 1928
Size: $4\frac{1}{2}'' \times 6''$; 11.4 × 15.4 cm
Black
Edition: 1 State I
 3 State II
 2 State III
 1 State IV
 5 State V
 2 State VI
 1 State VII
 2 States VIII/IX/X/XI
 83 State XII (published and reproduced)
Publisher: Twenty-one Gallery, London
Printer: the artist

27 HANGER HILL
Etching, 1929
Size: $5\frac{1}{2}'' \times 5\frac{1}{4}''$; 14.1 × 13.2 cm
Black
Edition: 1 State I
 3 State II
 2 State III
 6 State IV
 5 State V
 77 State VI (reproduced) including
 artist's proofs
Publisher: Twenty-one Gallery, London
Printer: the artist

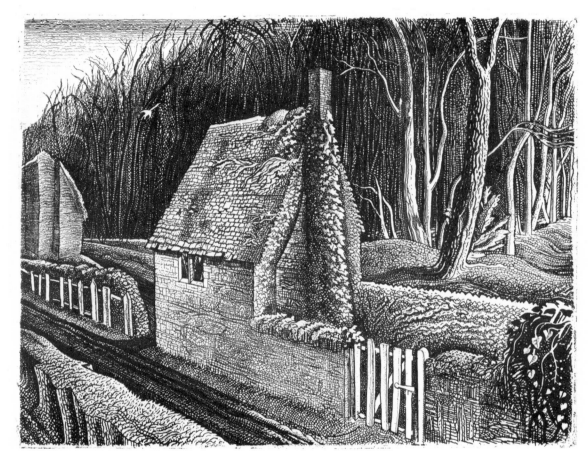

28 COTTAGE IN DORSET, 'WOOD END'
Etching, 1929
Size: $5\frac{5}{8}'' \times 7''$; 14.3 × 18 cm
Black
Edition: 60
Publisher: the artist in 1930
Printer: the artist

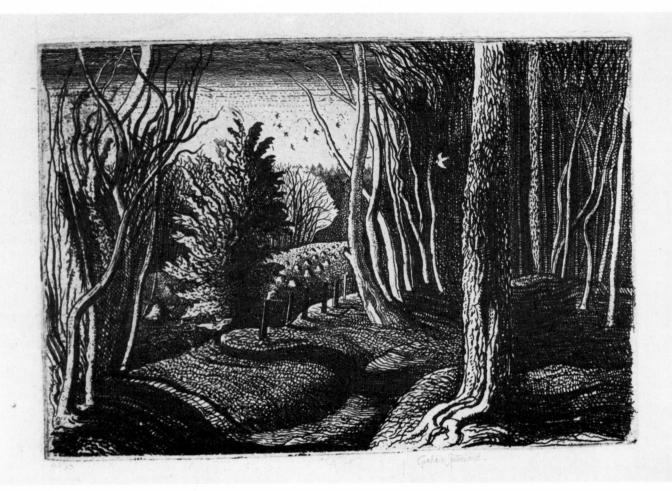

29 WOOD INTERIOR
Etching, 1929/30
Size: $4\frac{3}{4}'' \times 6\frac{3}{8}''$; 12 × 16.2 cm
Black
Edition: 6 State I
 60 State II (reproduced) including
 artist's proofs
Publisher: Twenty-one Gallery, London
Printer: the artist

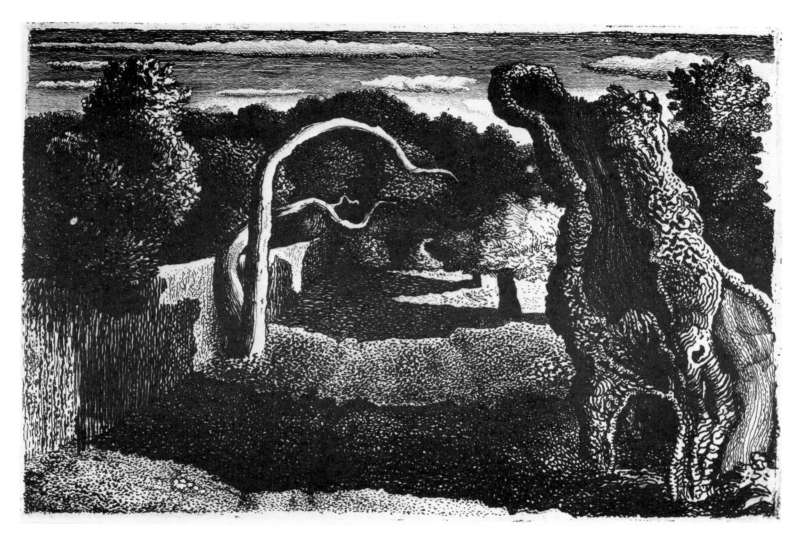

30 PASTORAL
Etching and engraving, 1930
Size: $5\frac{1}{8}'' \times 7\frac{5}{8}''$; 13×19.5 cm
Black
Edition: trial proofs only, new prints in 1973
Printer: the artist

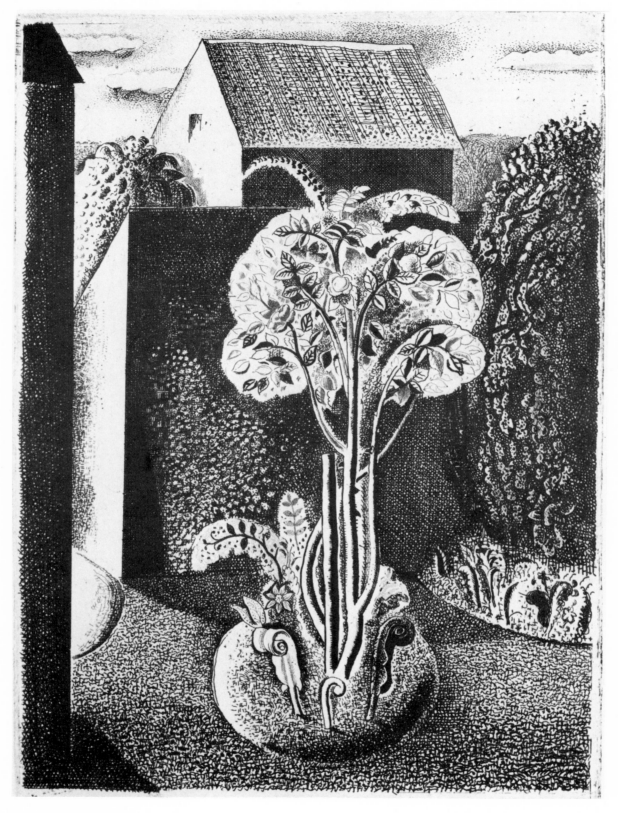

31 THE GARDEN
Etching, 1931
Size: $8\frac{1}{2}'' \times 6\frac{1}{8}''$; 21.7 × 15.6 cm
Black
Edition: 30
Printer: the artist

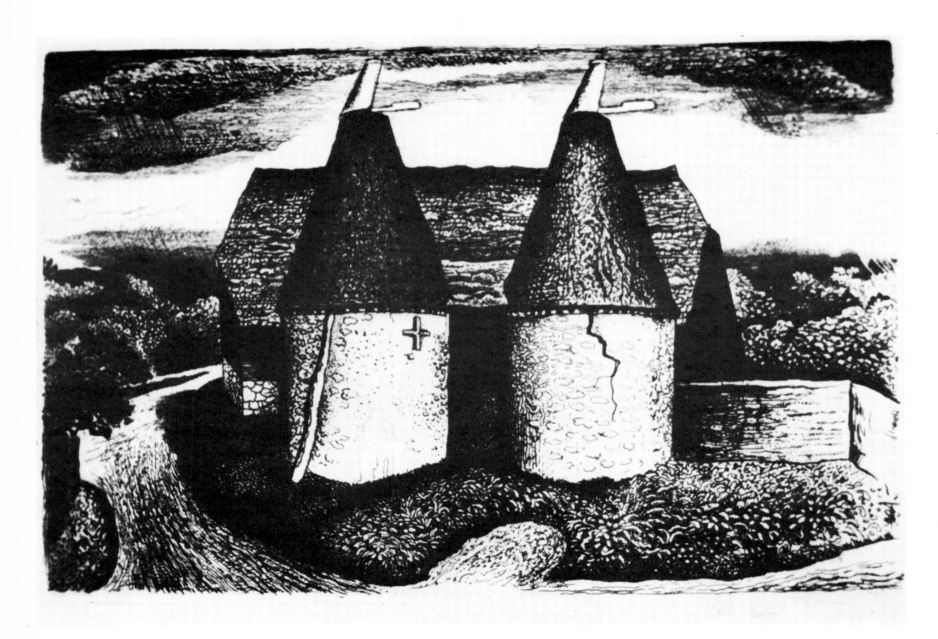

32 OAST HOUSE
Etching, 1932
Size: $6\frac{3}{4}'' \times 10\frac{3}{8}''$; 17.3 × 26.4 cm
Black
Edition: no edition printed, only
trial proofs
Printer: the artist

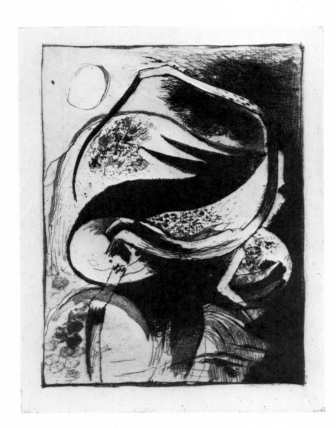

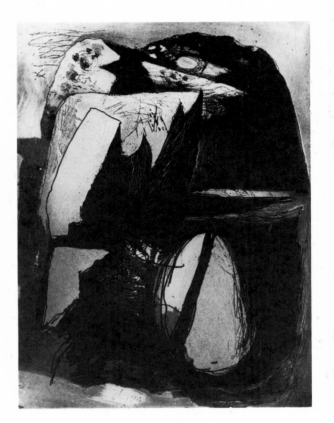

33 CLEGYR-BOIA I (Landscape
in Wales)
Etching and aquatint, 1936
Size: $7\frac{7}{8}'' \times 5\frac{7}{8}''$; 20 × 14.9 cm
Black
Edition: *c.* 1000 and a few artist's
proofs
Publisher: Curwen Press in
Signature No. 9, 1938
Printer: Walsh, London

34 CLEGYR-BOIA II (Landscape
in Wales)
Etching and aquatint, 1936
Size: $8\frac{1}{4}'' \times 5\frac{7}{8}''$; 20 × 14.9 cm
Black
Edition: no edition printed. One
proof exists in the collection of Mrs
Sue Simon
Printer: Walsh, London

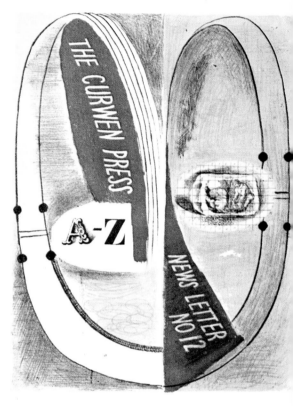

35 THUNDER SOUNDING
Lithograph, 1935
Size: 4″×6⅞″; 10×17.5 cm
Black
Edition: 250
Printer: Curwen Press, London
Christmas card for Robert Wellington, none of
them signed

36 A–Z
Lithograph, 1936
Size: 10¼″×7½″; 26×19 cm
Black, red
Publisher: Curwen Press,
London
Printer: Curwen Press, London
Cover for Newsletter No. 12,
The Curwen Press, June 1936

37 THE SICK DUCK
Lithograph, 1937
Size: $19\frac{1}{4}'' \times 30\frac{3}{8}''$; 49×77 cm
5 colours
Edition: 400
Publisher: *Contemporary Lithographs* (Robert
 Wellington School Prints)

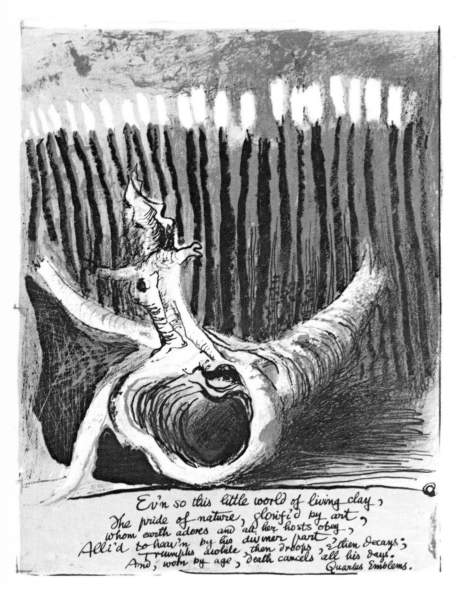

Ev'n so this little world of living clay,
The pride of nature, glorifi'd by art,
whom earth adores and all her hosts obey,
Alli'd to heav'n by his diviner part,
Triumphs awhile, then droops, then decays,
And, worn by age, death cancels all his days.
Quarles Emblems.

So have I seen th' illustrious prince of light
Rising in glory from his ocean* bed,
And trampling down the horrid shades of night,
Advancing more and more his conqu'ring head;
Pause first, decline it cough begin to shroud
His fainting brows within a coal black cloud (*Saffron colour)

46 and 47 3 ILLUSTRATIONS TO FRANCIS
QUARLES 'HYROGLYPHICS'
Lithographs, 1943
Size: A $9\frac{5}{8}'' \times 7\frac{1}{4}''$; 24.5 × 18.5 cm
B $9\frac{5}{8}'' \times 7\frac{1}{4}''$; 24.5 × 18.5 cm
4 colours
Edition: 50 sets numbered and signed by the
artist
Publisher: Nicholson & Watson, London
Printer: Waterlow, London
Unsigned edition published in Poetry London
Vol. 2, No. 9, printed from the original stones,
folded in the middle

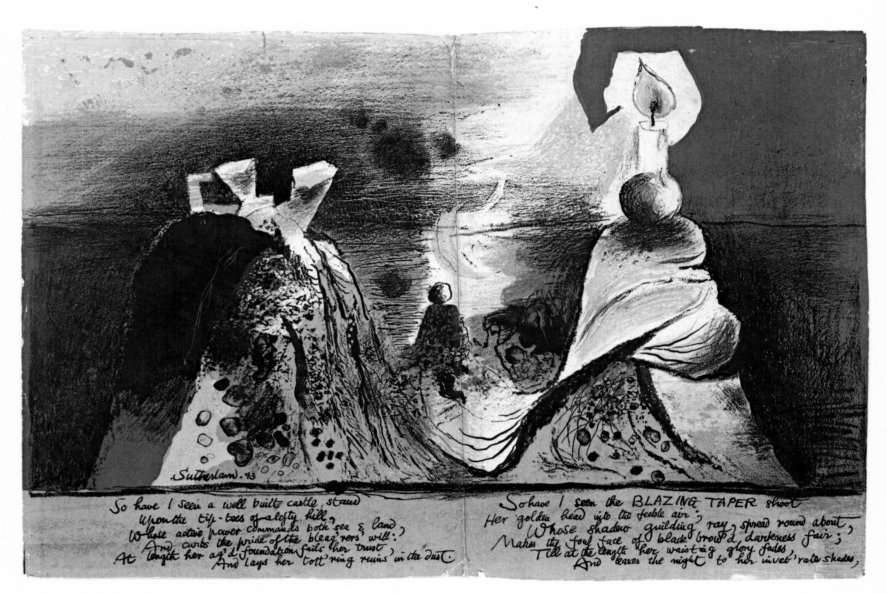

Within the illustration:

So have I seen a well built castle stand
Upon the tip-toes of a lofty hill,
Whose active power commands both sea & land,
And curbs the pride of the bleag'rers' will:
And length her ag'd foundation fails her trust,
And lays her tott'ring ruins in the dust.

So have I seen the BLAZING TAPER shoot
Her golden head into the feeble air;
Whose shadow guilding ray, spread round about,
Makes the foul face of black brow'd darkness fair;
Till at the length her wasting glory fades,
And leaves the night to her inveterate shades,

Sutherland. 43

48 ILLUSTRATION TO FRANCIS
QUARLES 'HYROGLYPHICS'
Lithograph, 1943
Size: 9⅝″ × 14⅝″; 24.5 × 37 cm
4 colours
Edition: 50 sets numbered and signed by the
 artist in a set together with A and B
Publisher: Nicholson & Watson, London
Printer: Waterlow, London
An unsigned edition was published together with
A and B in Poetry London
Vol. 2, No. 9, printed from the original stones,
folded in the middle

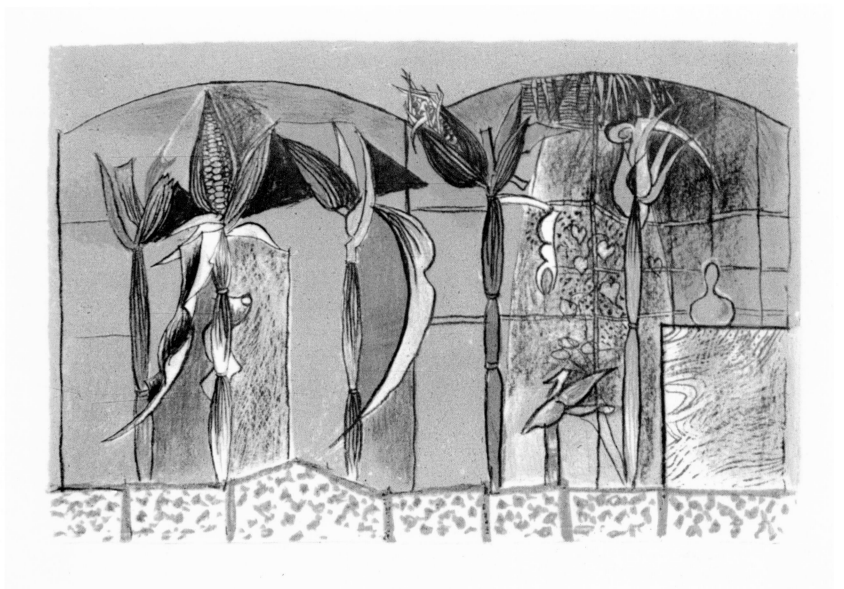

49 MAIZE
Lithograph, 1948
Size: 15″ × 21½″; 38 × 54.5 cm
4 colours
Edition: 60 plus a few artist's proofs
Publisher: Redfern Gallery, London
Printer: Ravel, Paris

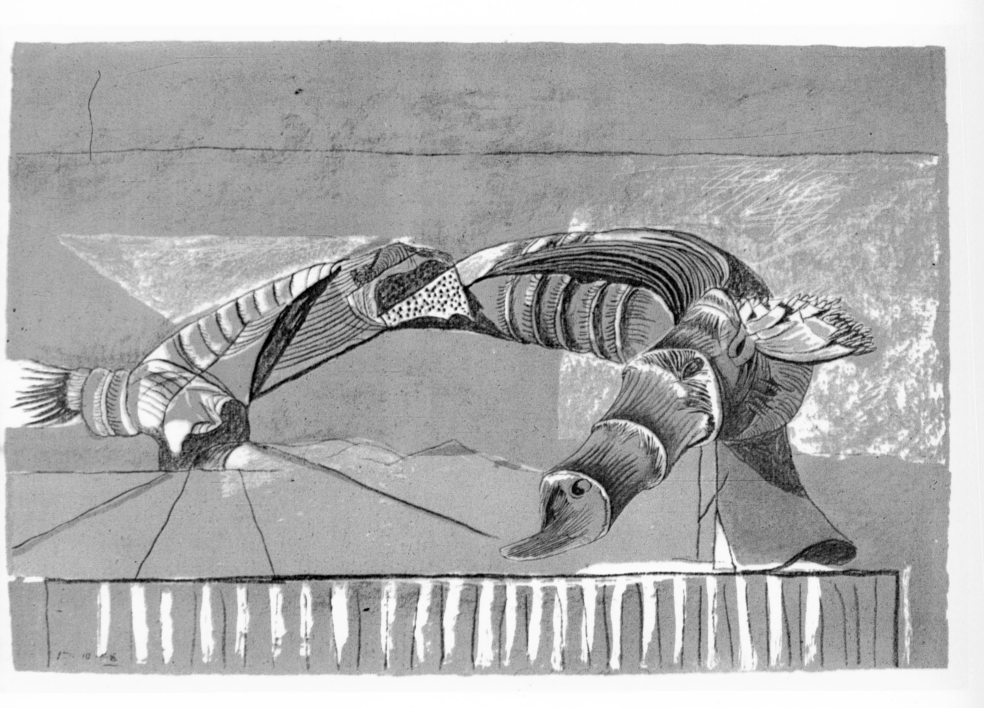

50 TURNING FORM
Lithograph, 1948
Size: $15\frac{3}{8}'' \times 23\frac{1}{8}''$; 39×56.5 cm
4 colours
Edition: 60 plus 6 artist's proofs
Publisher: Redfern Gallery, London
Printer: Ravel, Paris

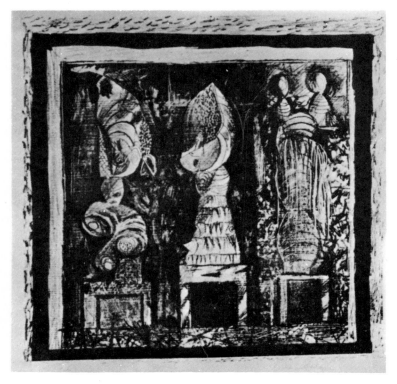

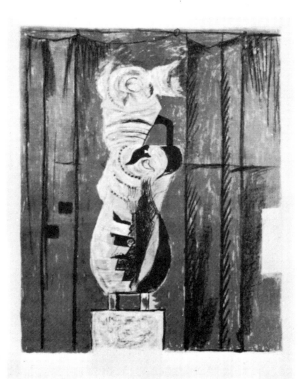

51 THREE STANDING FORMS
Lithograph, 1950
Size: $17\frac{7}{8}'' \times 17\frac{1}{2}''$; 45.4 × 44.5 cm
Black
Edition: 3 impressions only, stone was ruined
Printer: Royal College of Art, London

52 STANDING FORM AGAINST A
CURTAIN
Lithograph, 1950
Size: $22'' \times 16\frac{3}{8}''$; 56 × 41.5 cm
4 colours
Edition: trial proofs only (?)
Printer: Clarin, Paris

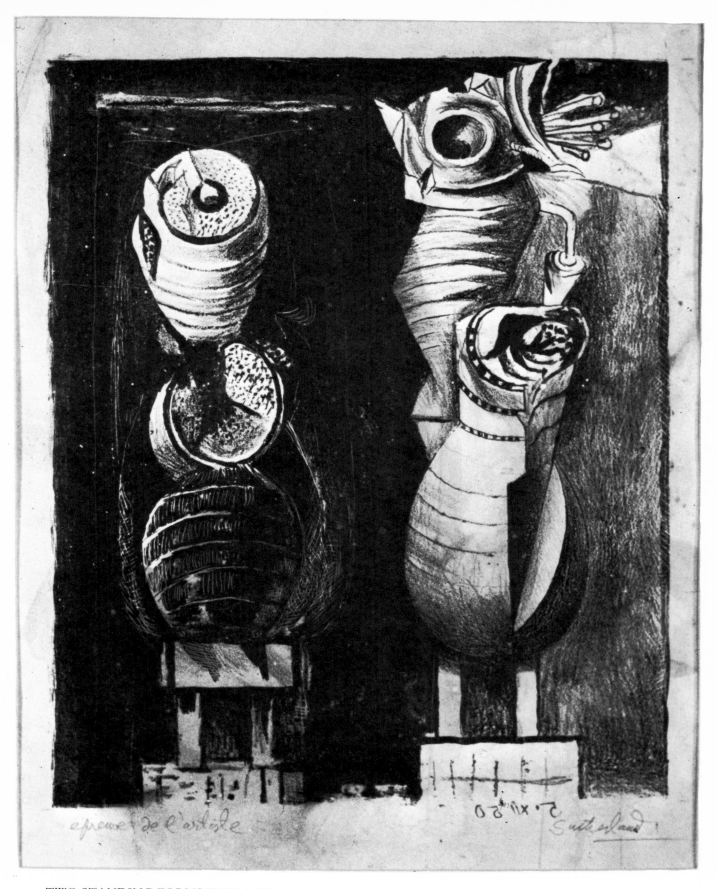

epreuve de l'artiste *2.xii.50*
 Sutherland

53 TWO STANDING FORMS IN BLACK
Lithograph, 1950
Size: $13\frac{3}{8}'' \times 11''$; 35×27 cm
Black
Edition: only 4 impressions, as stone deteriorated
Printer: Curwen Press, London

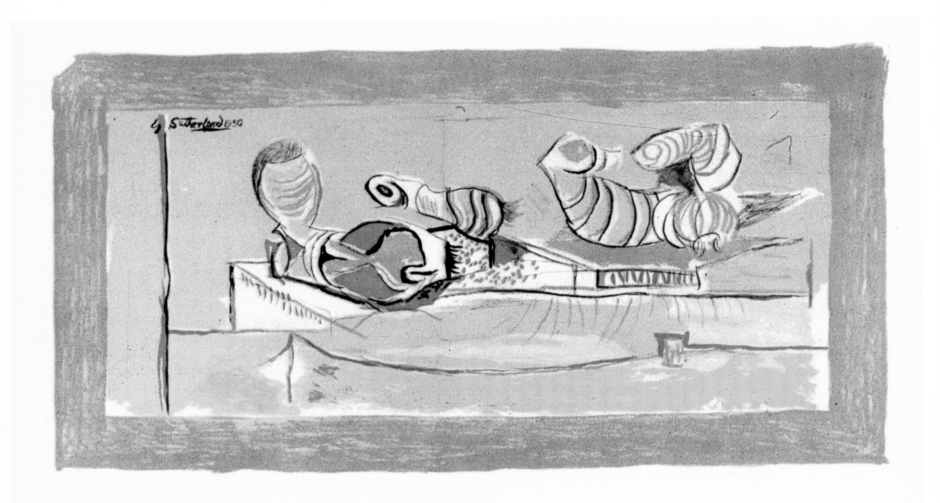

54 ARTICULATED FORMS (pink back-
ground). Forms on a terrace
Lithograph, 1950
Size: $11\frac{7}{8}'' \times 23''$; 30 × 52.25 cm
5 colours
Edition: 60, signed and numbered by the artist,
 and 6 artist's proofs
Publisher: Redfern Gallery, London
Printer: Curwen Press, London

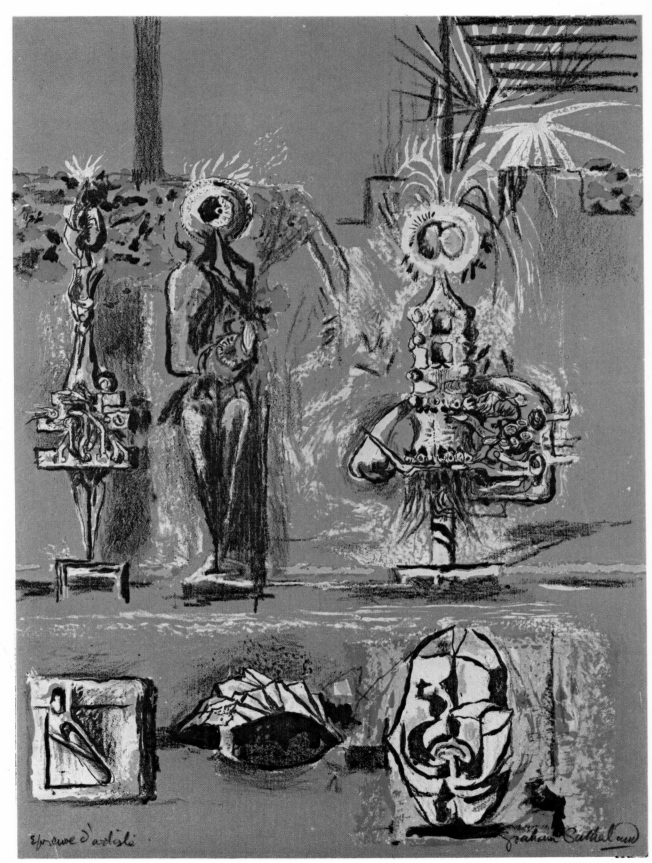

55 THREE FIGURES IN A
GARDEN
Lithograph, 1953
Size: 9⅞″ × 8½″; 29.5 × 21.5 cm
5 colours
Edition: 3 State I
 135 State II, signed and
 numbered by the artist, and 10
 artist's proofs (reproduced)
Publisher: W. Heinemann Ltd, London
Printer: Fernand Mourlot, Paris
The published edition has been loosely
added to the limited edition of *150
Years of Artists' Lithographs* by Felix H.
Man

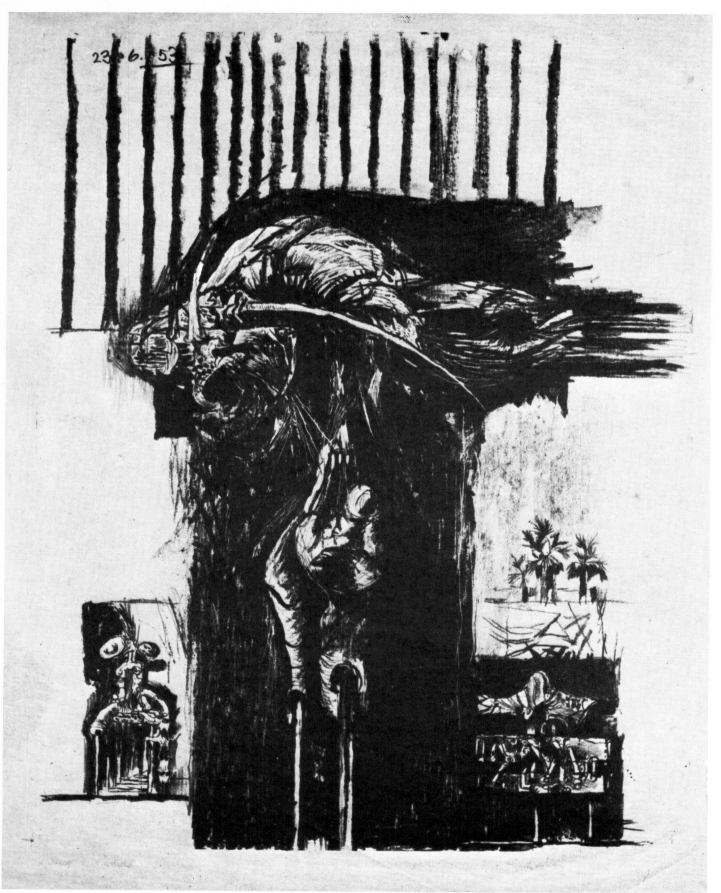

56 LA PETITE AFRIQUE
Lithograph, 1953
Size: $22\frac{5}{8}'' \times 17\frac{3}{8}''$; 57.5 × 44 cm
Black
Edition: 25 and 4 artist's proofs
marked in the stone: J 23-6-53,
printed on large Japan, signed
Publisher: Redfern Gallery,
London
Printer: Curwen Press, London

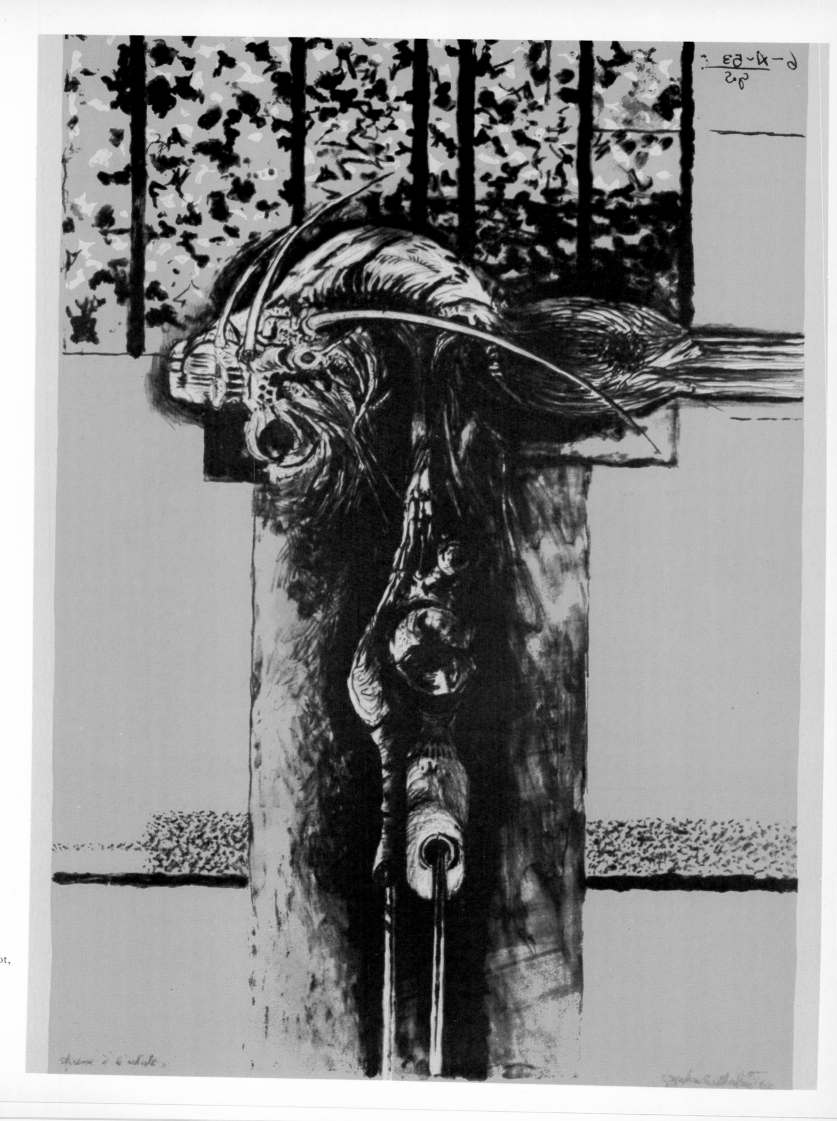

57 PREDATORY
FORM
Lithograph, 1953
Size: 29¾″ × 21¼″;
75.5 × 54 cm
2 colours
Edition: 75 signed and
numbered
Publisher: Redfern
Gallery, London
Printer: Fernand Mourlot,
Paris

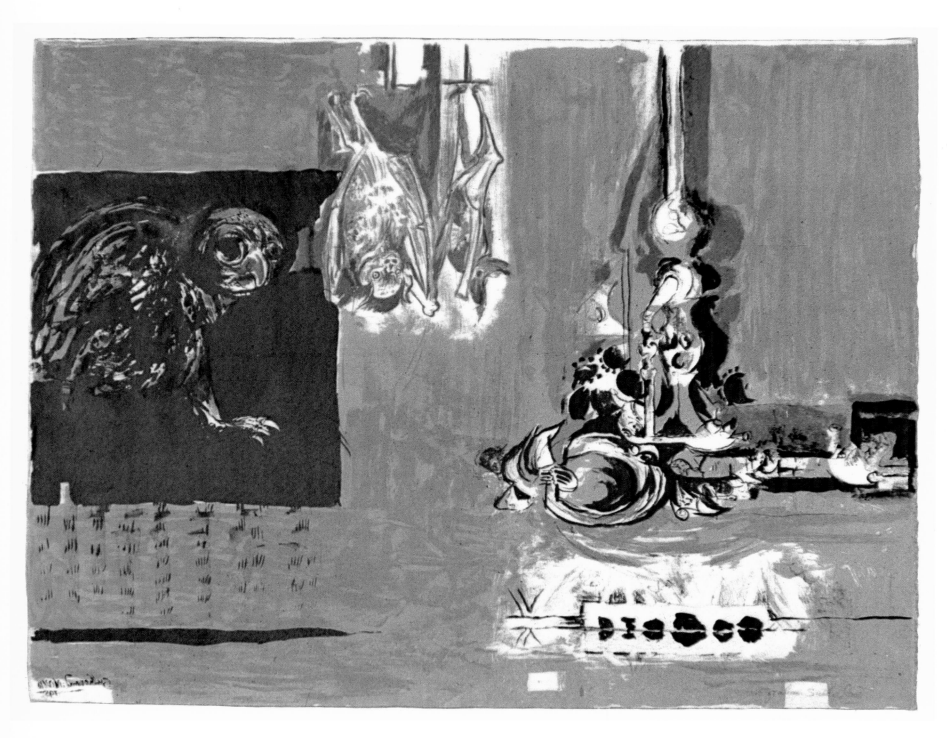

65 HANGING FORM, OWL AND BATS
Lithograph, 1955
Size: 20″ × 26″; 51 × 67 cm
4 colours
Edition: 25 artist's proofs, signed and marked as
 such
 75 numbered and signed
Publisher: Berggruen & Cie, Paris (the 25
 artist's proofs)
 Fernand Mourlot, Paris (75 expl.)
Printer: Fernand Mourlot, Paris

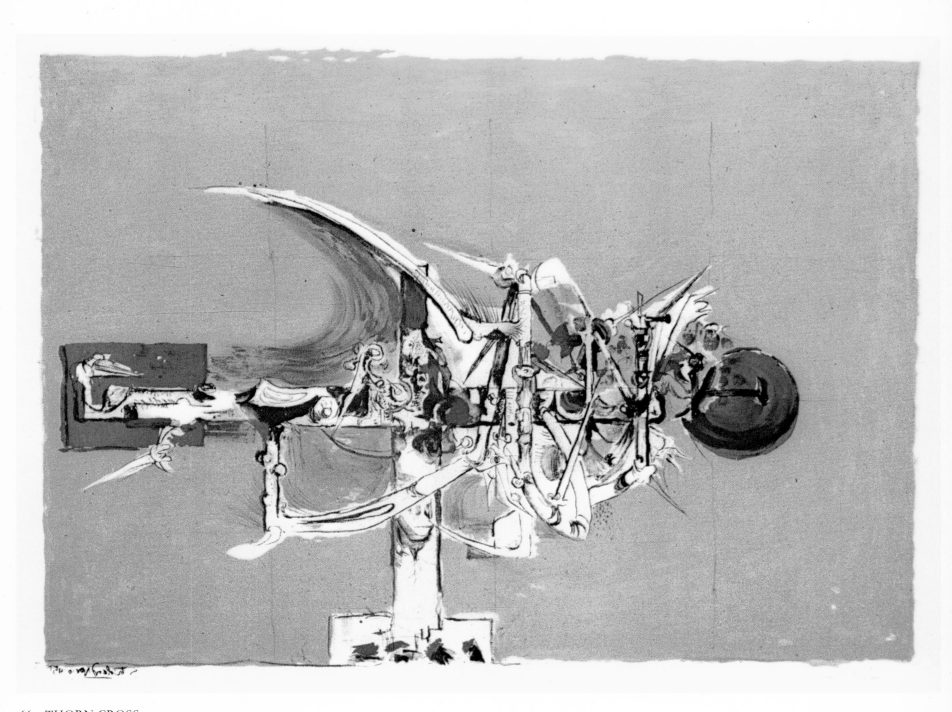

66 THORN CROSS
Lithograph, 1955
Size: $18\frac{3}{4}'' \times 25\frac{1}{4}''$; 47.5 × 64 cm
3 colours
Edition: 100 expl. signed and numbered by the
 artist, 10 artist's proofs
Publisher: Berggruen & Cie, Paris
Printer: Fernand Mourlot, Paris

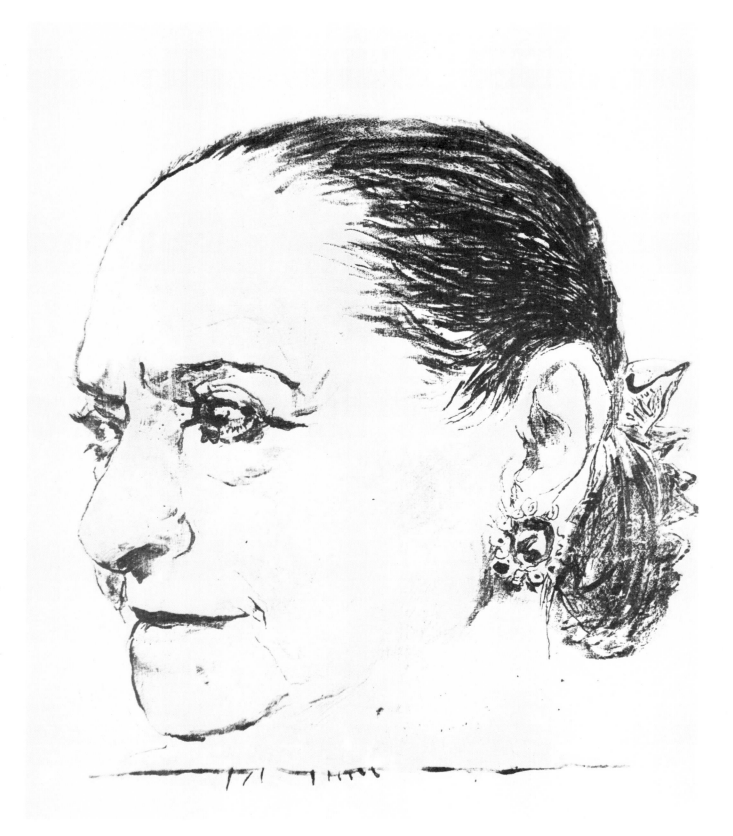

67 PORTRAIT OF HELENA RUBINSTEIN I
Lithograph, 1960
Size: $11\frac{3}{4}'' \times 10\frac{7}{8}''$; 31×27.6 cm
Litho ink and chalk on transfer paper intended to
be laid down on stone
Edition: trial proofs only
Printer: Curwen Studio, London

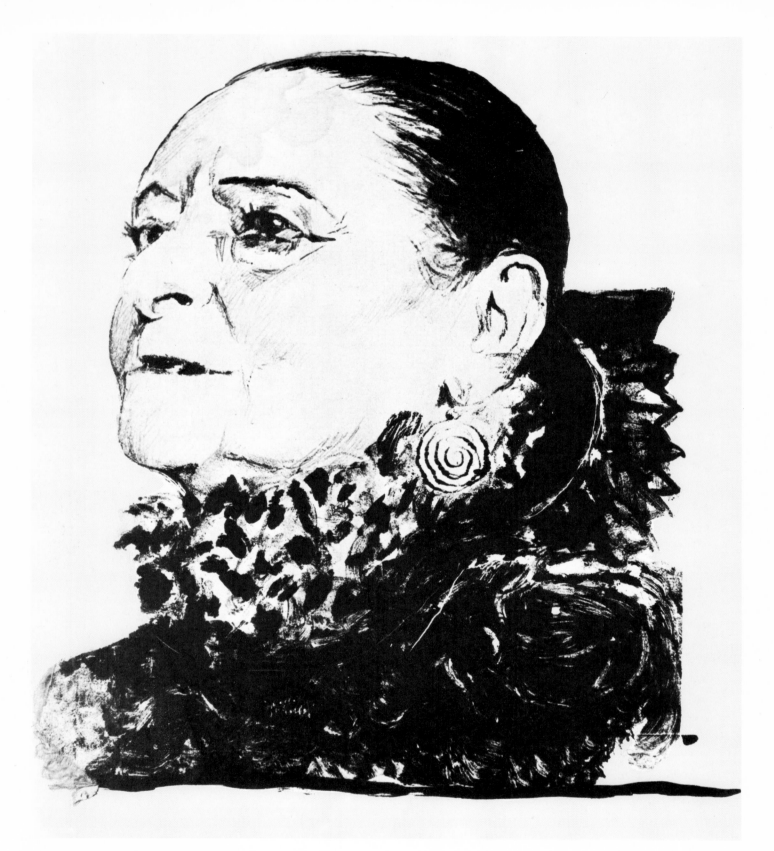

68 PORTRAIT OF HELENA RUBINSTEIN II
Lithograph, 1960
Size: $8\frac{7}{8}'' \times 9\frac{7}{8}''$; 22.4 × 25 cm
Black
Edition: trial proofs only
Printer: Curwen Studio, London

Graham Sutherland in 1959

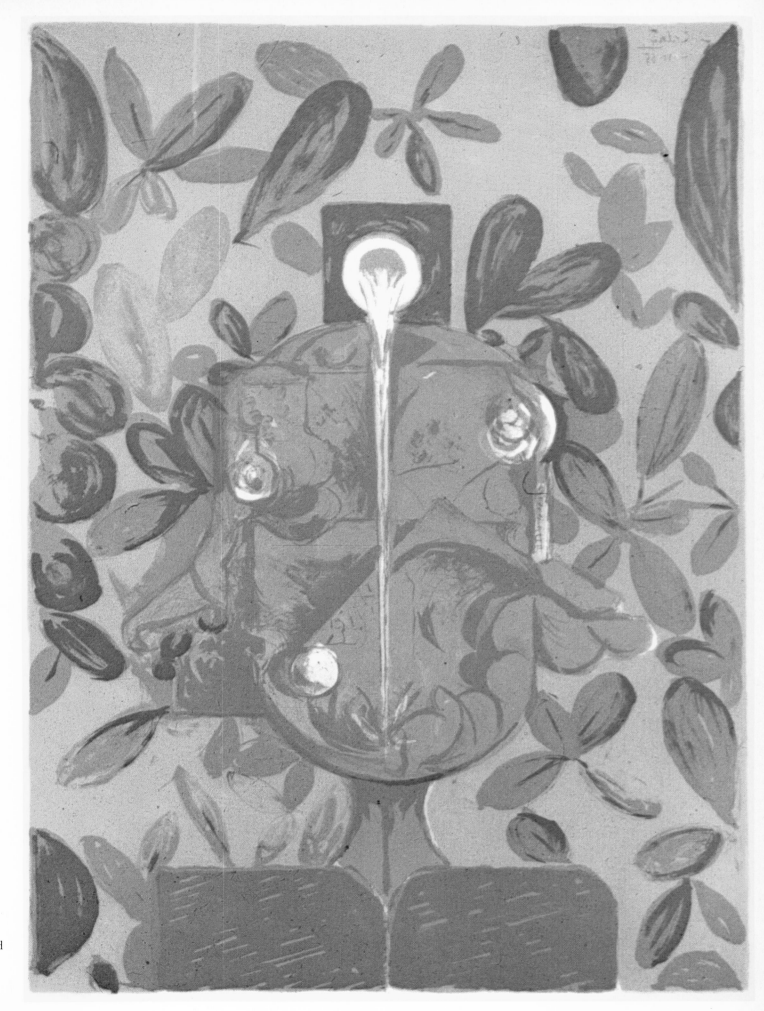

71　THE FOUNTAIN
Lithograph, 1965
Size: 28½″ × 20½″; 72.5 × 51.5 cm
4 colours
Edition: 55 signed and numbered
by the artist, and artist's proofs
Publisher: Marlborough Fine
Art Ltd, London
Printer: Fernand Mourlot, Paris

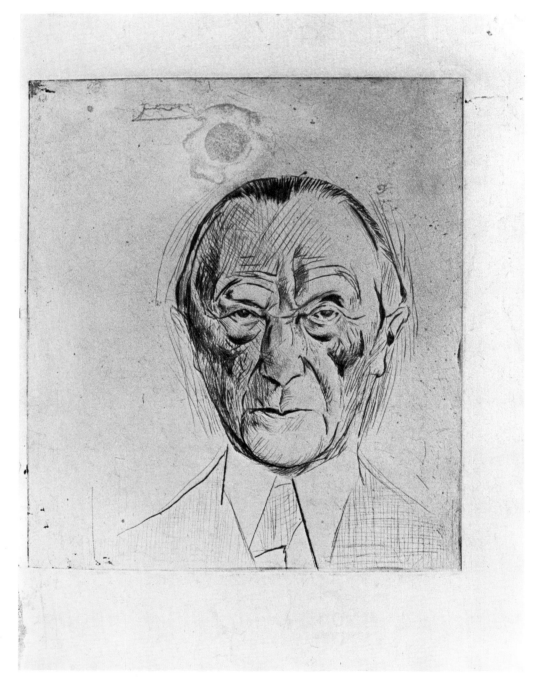

72 PORTRAIT OF DR KONRAD
ADENAUER
Drypoint, 1965
Size: $11\frac{7}{8}'' \times 10''$; 30.2 × 25.3 cm
Edition: only a few prints exist, also the plate

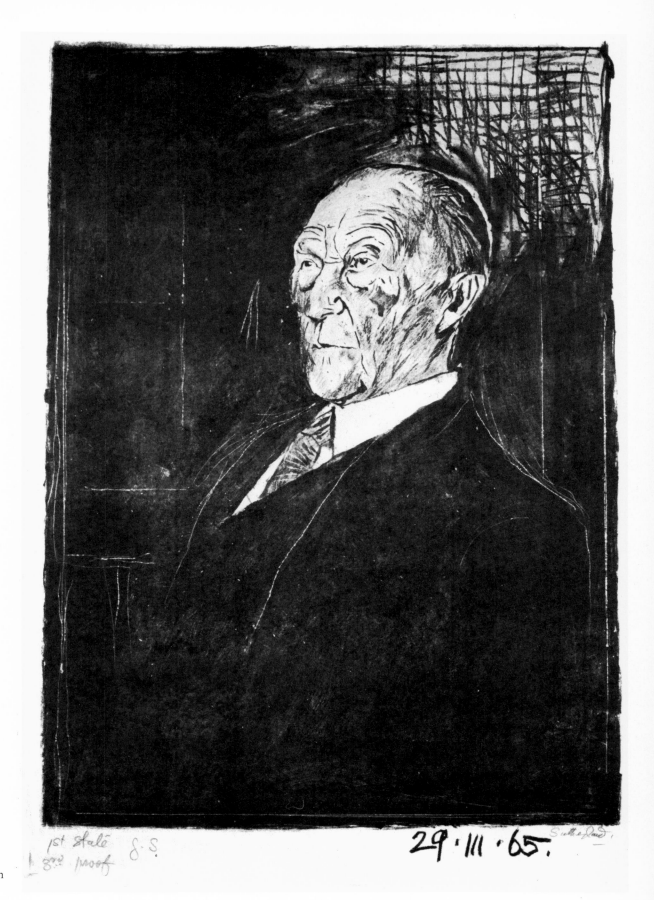

29·III·65.

1st state
2nd proof S.S.

73 PORTRAIT OF DR KONRAD
ADENAUER
Lithograph, 1965
Size: 22⅞" × 15⅜"; 58 × 39 cm
Black
Edition: 50 (?)
Publisher: Fischer Fine Art Ltd, London
Printer: J. Wolfensberger, Zurich

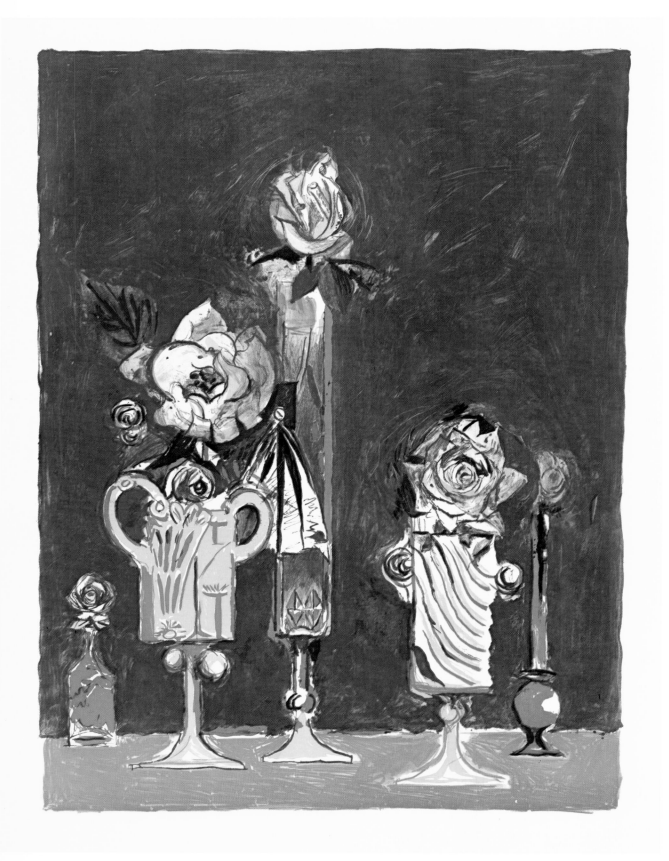

74 ROSES
Lithograph, 1966
Size: $25\frac{3}{4}'' \times 19''$; 65.5 × 48.5 cm
4 colours
Edition: 50 and 15 artist's proofs, signed
Publisher: Olivetti S. A., Italy
Printer: Emil Matthieu, Zurich

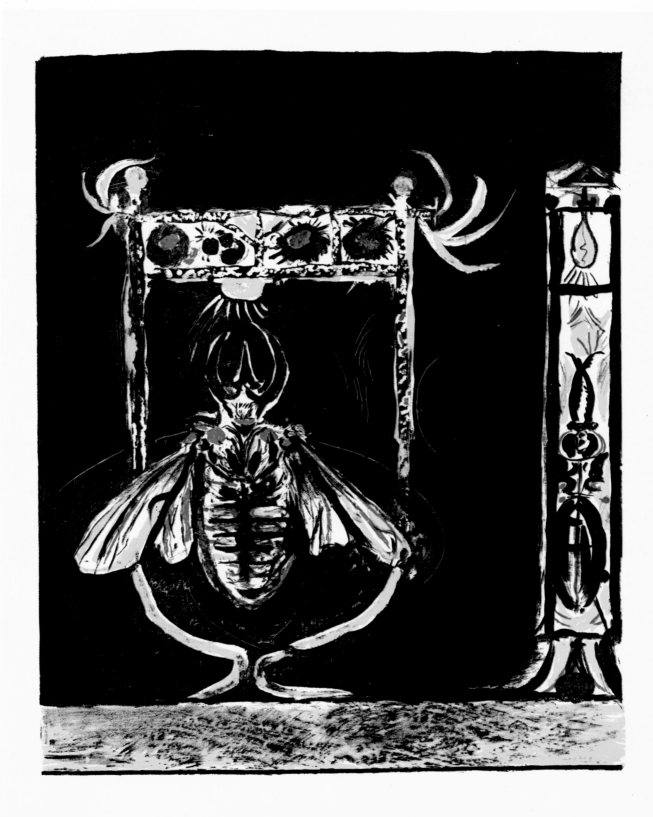

75 INSECT
Lithograph, 1967
Size: 27¾″ × 19⅝″; 70.5 × 49.8 cm
3 colours
Edition: 50 signed and a few
artist's proofs; given by the artist
in aid of Florentine Recovery
Publisher: Edizione d'Arte,
Florence
Printer: J. Bisonte, Florence

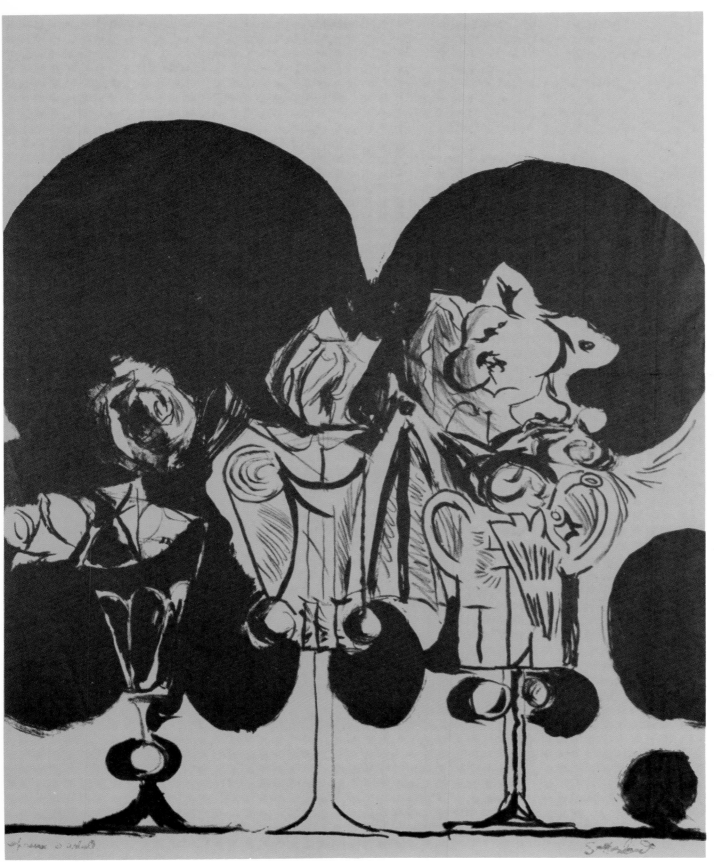

80 ROSES
Lithograph, 1967
Size: 20½″ × 22⅝″; 52 × 57.5 cm
Black
Edition: 25 printed for the
artist on a variety of paper, of
different colours, some prints
are printed in blue instead of
black, signed in pencil by the
artist
Printer: Upiglio, Milan

A BESTIARY AND SOME CORRESPONDENCES

A series of 26 original colour lithographs, 1965–68 (25 plates and one frontispiece), published in an edition of 70 copies for sale, plus 10 copies for the artist.

The Édition de Tête (1–6) contains in addition one original gouache, in leather covered Solander box.

The standard edition (7–70) with the 25 plates and title page, all numbered and signed by the artist, is in a linen-covered portfolio.

81 FRONTISPIECE TO A BESTIARY
Lithograph, 1968
Size: 19¼″ × 12⅝″; 49 × 32 cm
2 colours
Edition: 70 and 10 artist's proofs
Publisher: Marlborough Fine Art Ltd, London
Printer: Fernand Mourlot, Paris

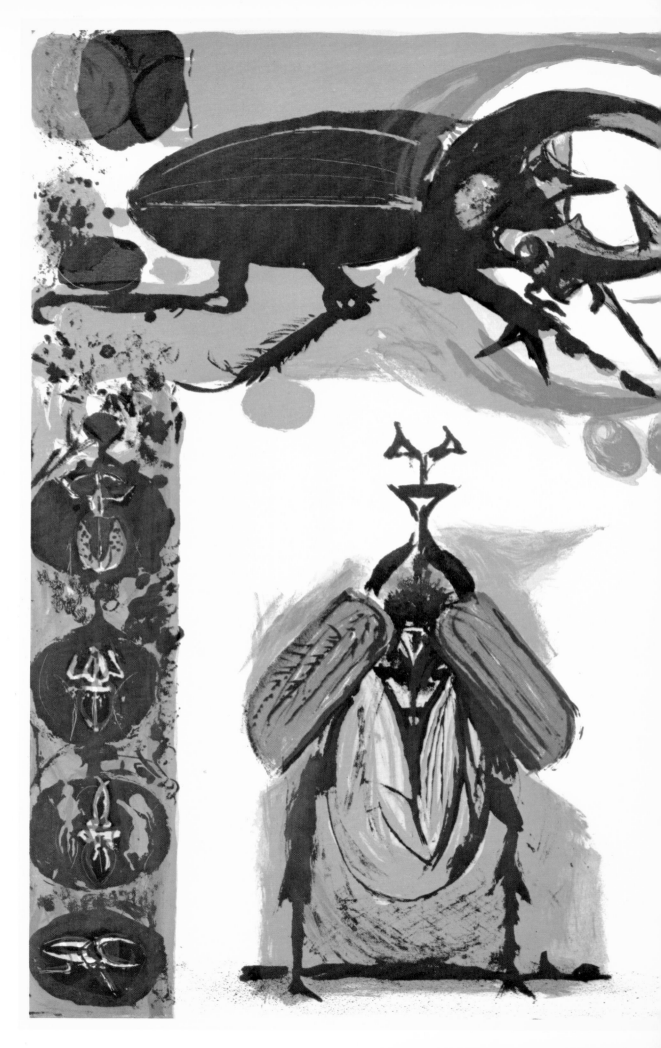

82 BEETLES I
Lithograph, 1967
Size: 19⅞″ × 26⅛″; 50.0 × 66.5 cm
5 colours
Edition: 70 and 10 artist's proofs
Publisher: Marlborough Fine Art Ltd, London
Printer: Fernand Mourlot, Paris

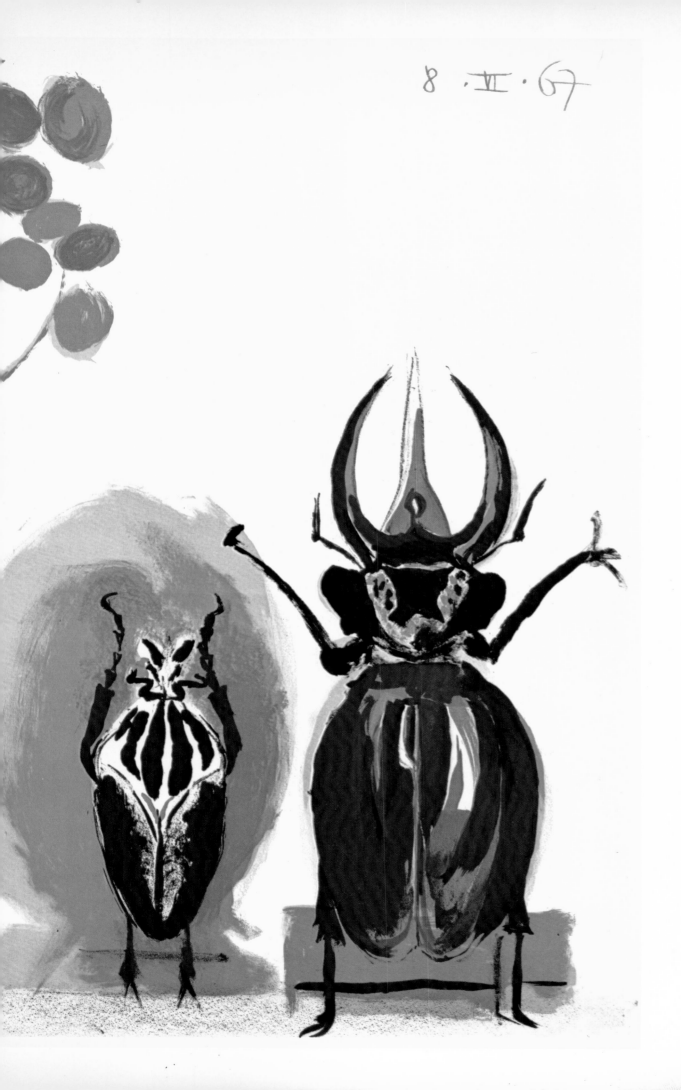

8 · Ⅵ · 67

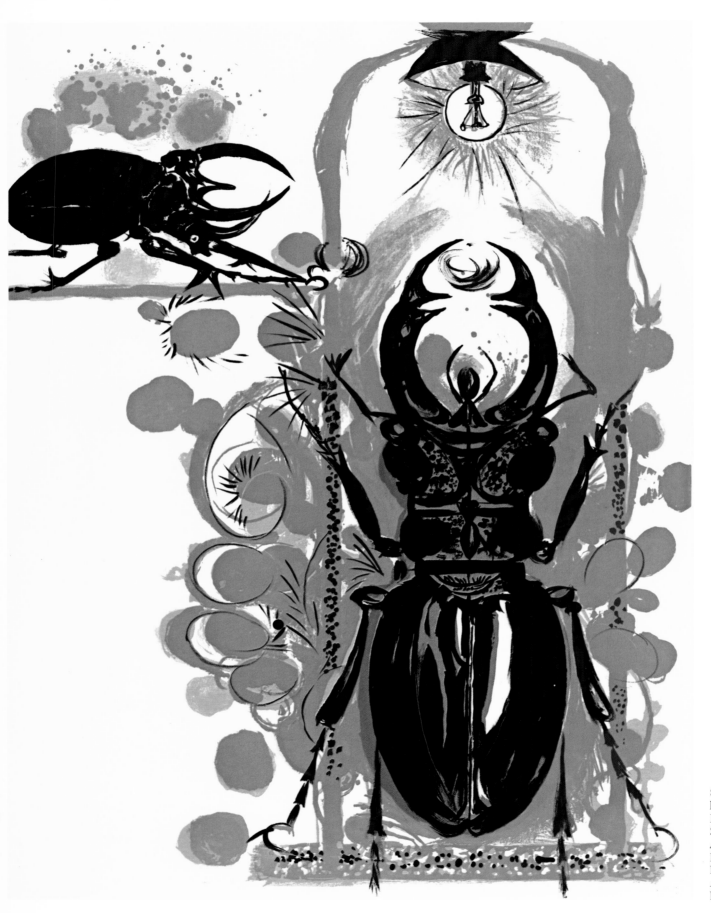

83 BEETLES II (with electric lamp)
Lithograph, 1968
Size: $25\frac{1}{2}'' \times 19\frac{7}{8}''$; 65×50.5 cm
4 colours
Edition: 70 and 10 artist's proofs
Publisher: Marlborough Fine
Art Ltd, London
Printer: Fernand Mourlot, Paris

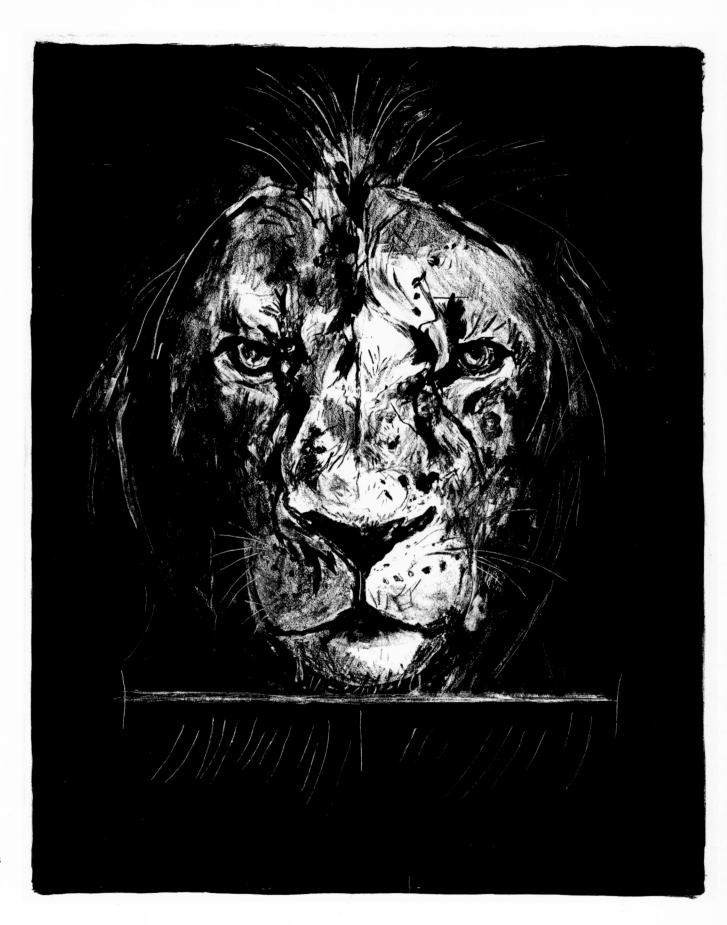

84 LION
Lithograph, 1968
Size: $25\frac{1}{4}'' \times 19\frac{1}{2}''$; 64 × 49.5 cm
Black
Edition: 70 and 10 artist's proofs
Publisher: Marlborough Fine
Art Ltd, London
Printer: Fernand Mourlot, Paris

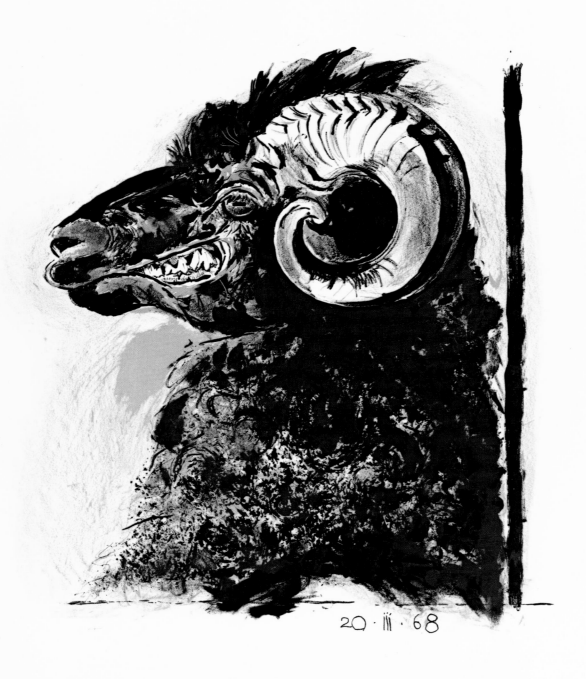

87 RAM'S HEAD (facing left)
Lithograph, 1968
Size: $17'' \times 15\frac{3}{8}''$; 43×39 cm
2 colours
Edition: 70 and 10 artist's proofs
Publisher: Marlborough Fine
Art Ltd, London
Printer: Fernand Mourlot, Paris

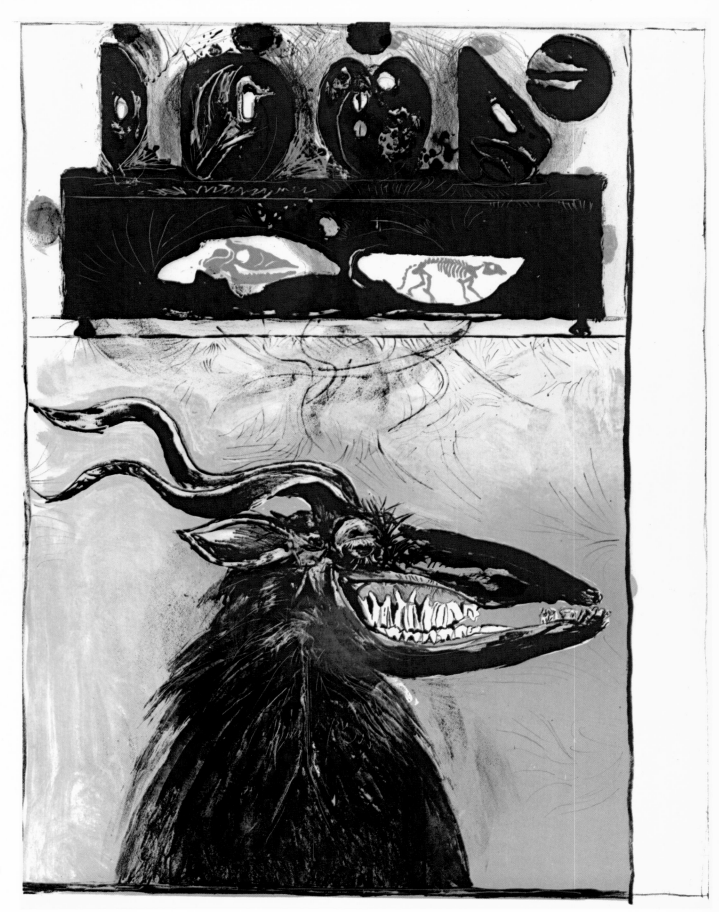

88 RAM'S HEAD (with rocks
and skeletons)
Lithograph, 1968
Size: $25\frac{3}{4}'' \times 19\frac{3}{4}''$; 65.5 × 50 cm
3 colours
Edition: 70 and 10 artist's proofs
Publisher: Marlborough Fine
Art Ltd, London
Printer: Fernand Mourlot, Paris

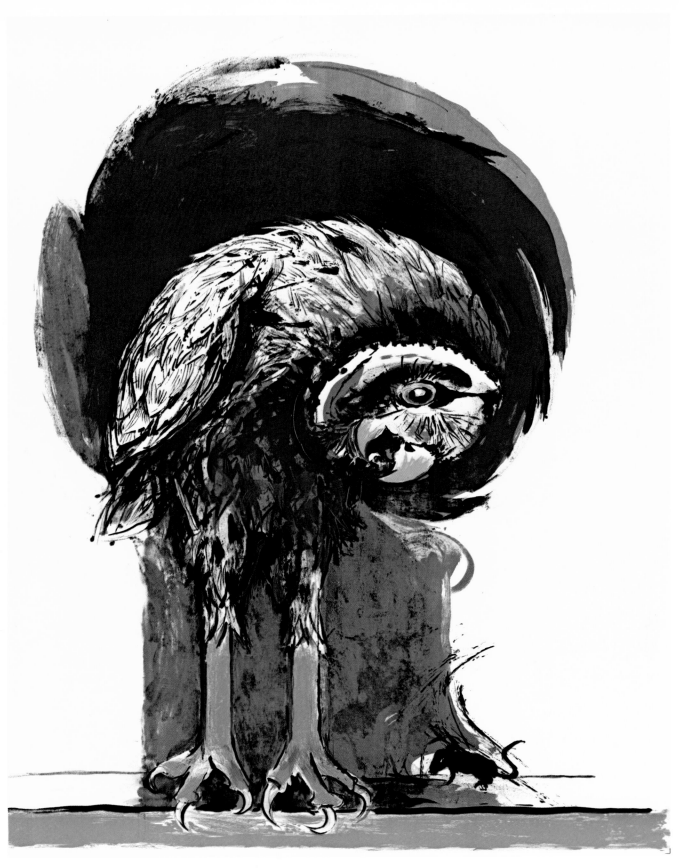

92 BIRD AND MOUSE
Lithograph, 1968
Size: 26″ × 20″; 66 × 51 cm
5 colours
Edition: 70 and 10 artist's proofs
Printer: Fernand Mourlot, Paris

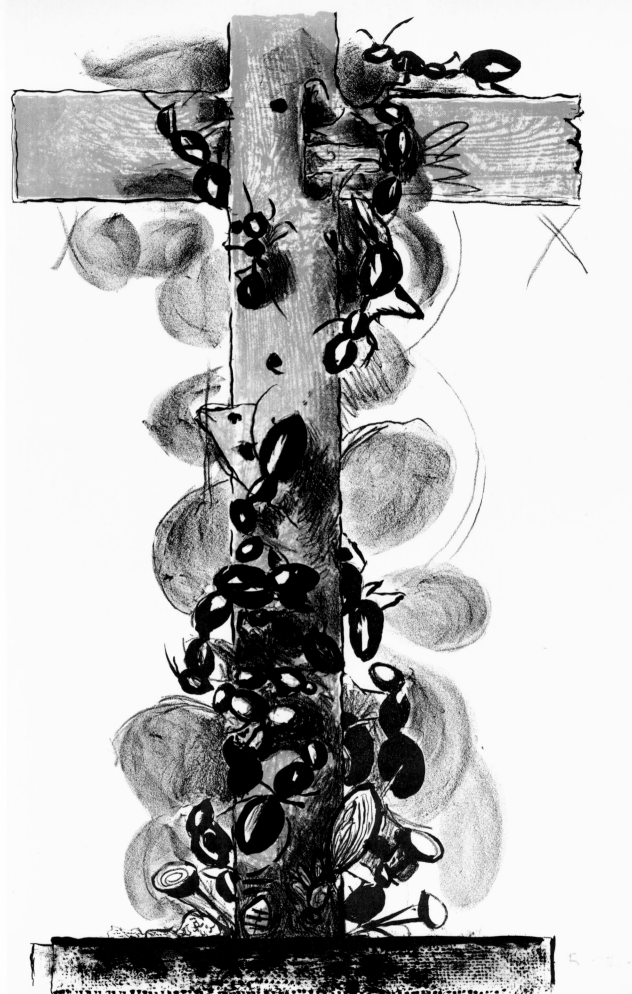

93 ANTS
Lithograph, 1968
Size: 25¼″ × 19⅝″;
64 × 49.75 cm
2 colours
Edition: 70 and 10
artist's proofs
Publisher: Marl-
borough Fine Art
Ltd, London
Printer: Fernand
Mourlot, Paris

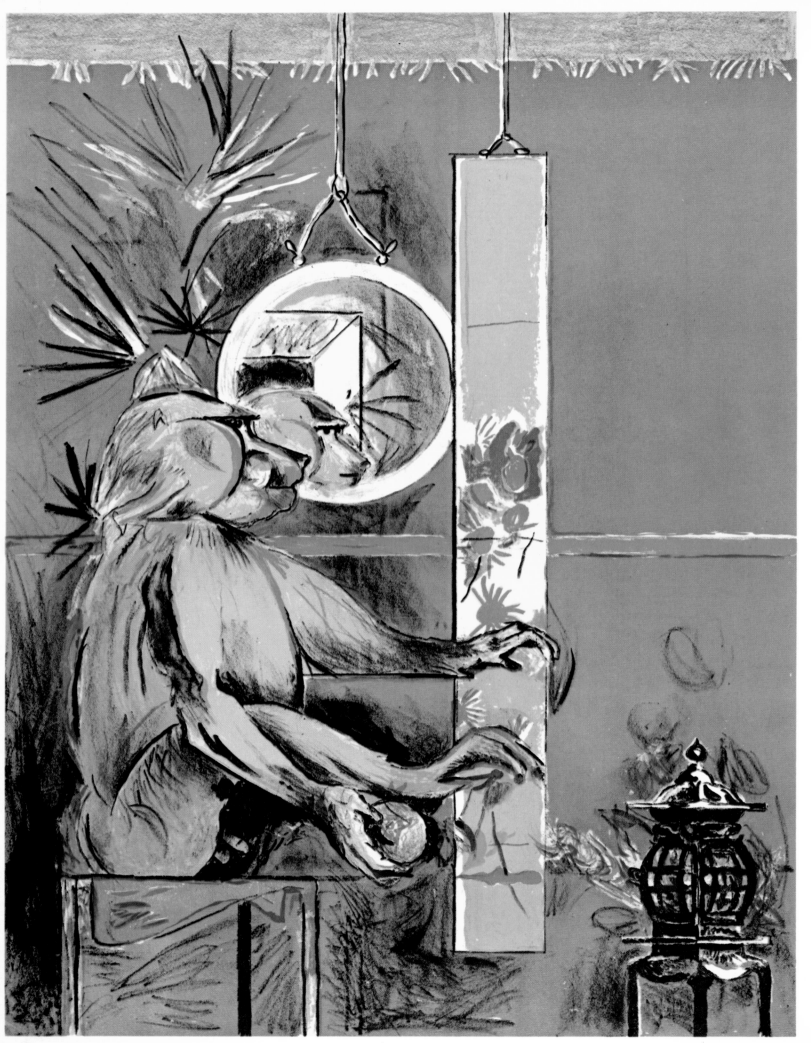

94 CYNOCEPHALUS
Lithograph, 1968
Size: 26″ × 19⅝″;
66 × 50 cm
6 colours
Edition: 70 and 10
artist's proofs
Publisher: Marlborough
Fine Art Ltd, London
Printer: Fernand
Mourlot, Paris

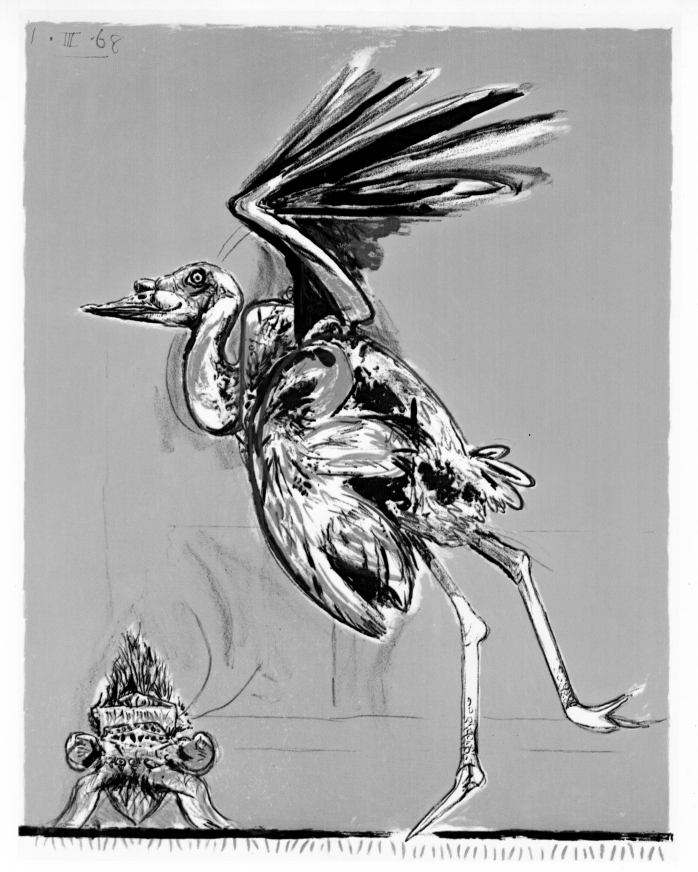

95 BIRD ABOUT TO TAKE FLIGHT
Lithograph, 1968
Size: 25¾″ × 19⅝″; 65.5 × 50 cm
5 colours
Edition: 70 and 10 artist's proofs
Publisher: Marlborough Fine Art Ltd, London
Printer: Fernand Mourlot, Paris

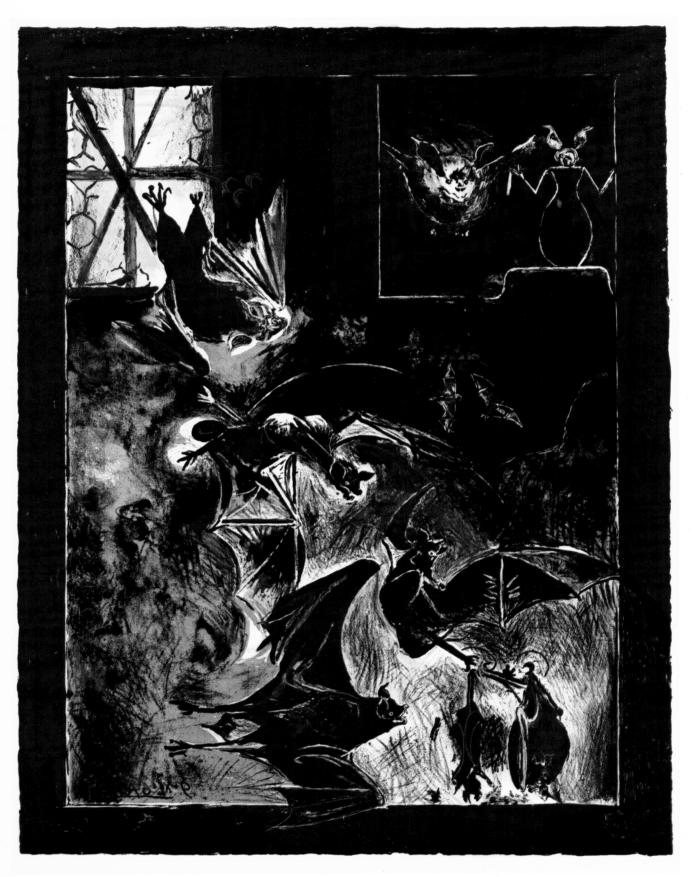

96 CHAUVE SOURIS
(interior)
Lithograph, 1967
Size: $25\frac{1}{4}'' \times 19\frac{1}{4}''$; 64×49 cm
4 colours
Edition: 70 and 10 artist's proofs
Publisher: Marlborough Fine
Art Ltd, London
Printer: Fernand Mourlot, Paris

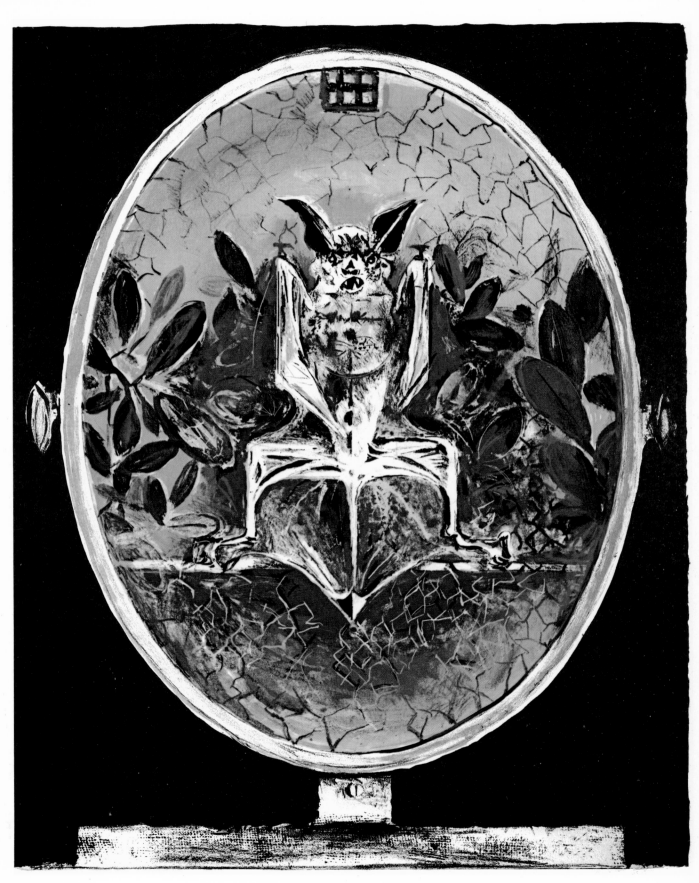

97 CHAUVE-SOURIS IN A
LOOKING-GLASS AGAINST A
WINDOW
Lithograph, 1968
Size: 25⅝″ × 19⅞″; 65 × 50.5 cm
3 colours
Edition: 70 and 10 artist's proofs
Publisher: Marlborough Fine Art
Ltd, London
Printer: Fernand Mourlot, Paris

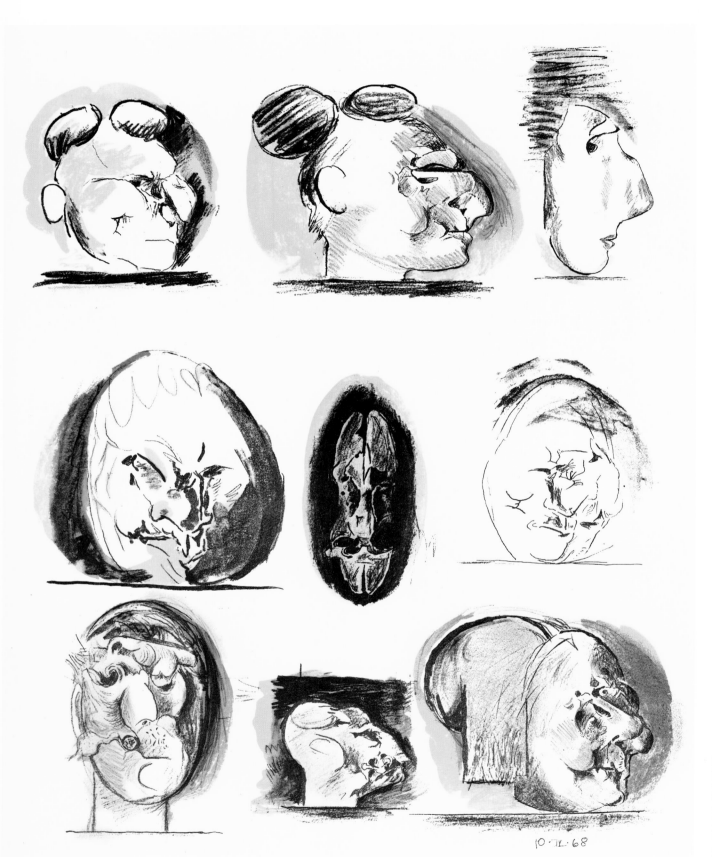

10·IV·68

98 SHEET OF STUDIES
(heads)
Lithograph, 1968
Size: $23\frac{7}{8}'' \times 19\frac{1}{4}''$; 60.75×49 cm
2 colours
Edition: 70 and 10 artist's proofs
Publisher: Marlborough Fine
Art Ltd, London
Printer: Fernand Mourlot, Paris

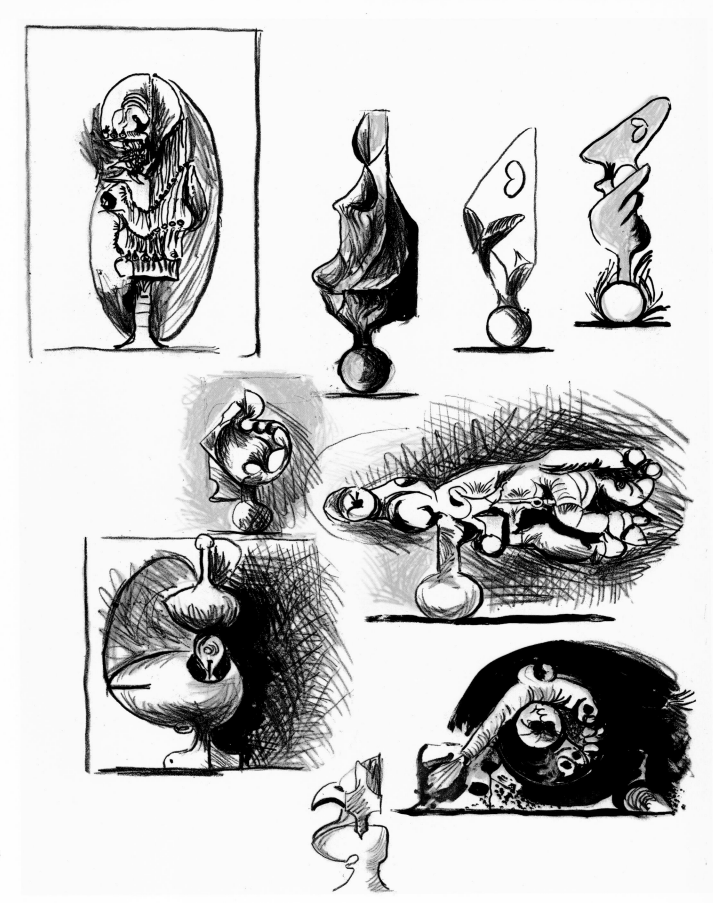

99 SHEET OF STUDIES
(organic forms)
Lithograph, 1968
Size: 26″ × 19½″; 66 × 49.5 cm
2 colours
Edition: 70 and 10 artist's proofs
Publisher: Marlborough Fine
Art Ltd, London
Printer: Fernand Mourlot, Paris

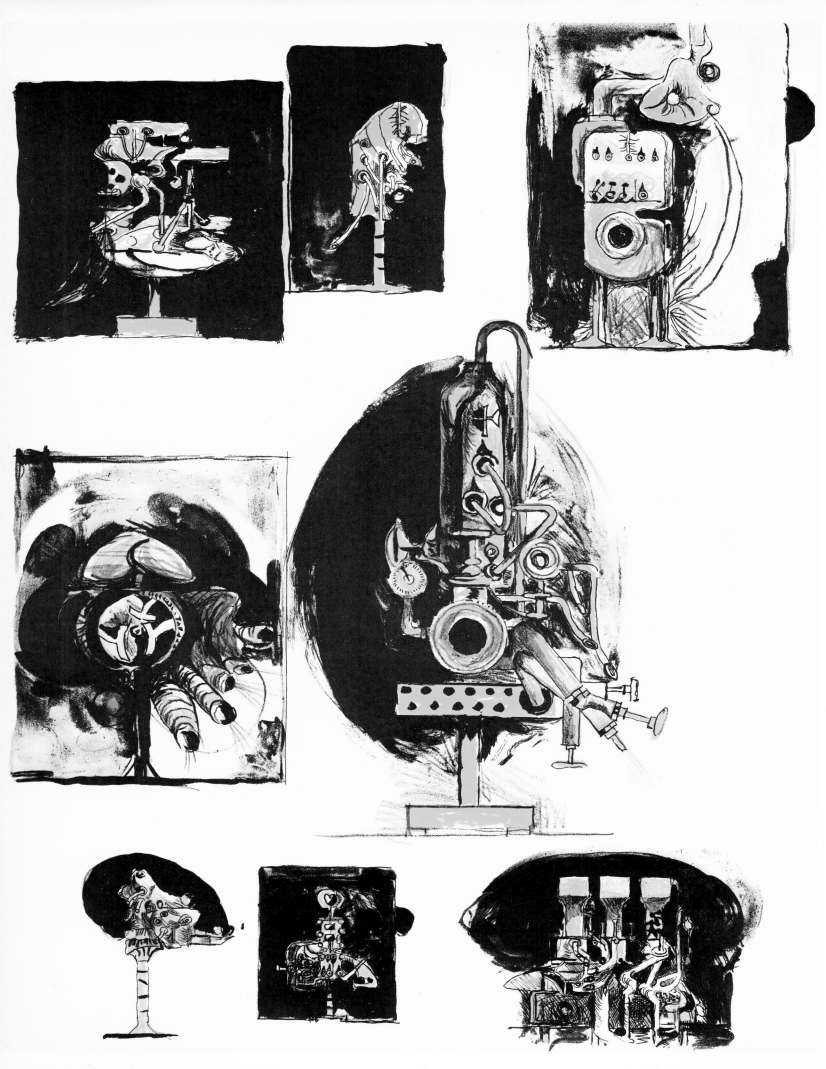

100 SHEET OF
STUDIES
(comparisons:
machines and organic
forms)
Lithograph, 1968
Size: 26″ × 19¾″;
66 × 50.25 cm
2 colours
Edition: 70 and 10
artist's proofs
Publisher:
Marlborough Fine
Art Ltd, London
Printer: Fernand
Mourlot, Paris

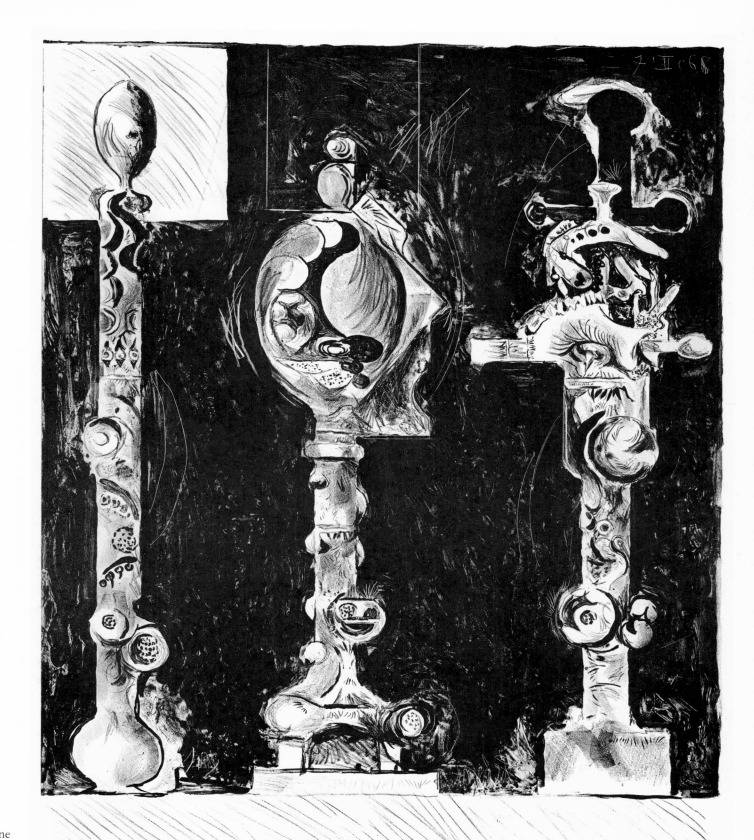

101 THREE ORGANIC
FORMS
Lithograph, 1968
Size: $24\frac{3}{4}'' \times 19\frac{7}{8}''$;
63×50.5 cm
Black
Edition: 70 and 10 artist's
proofs
Publisher: Marlborough Fine
Art Ltd, London
Printer: Fernand Mourlot,
Paris

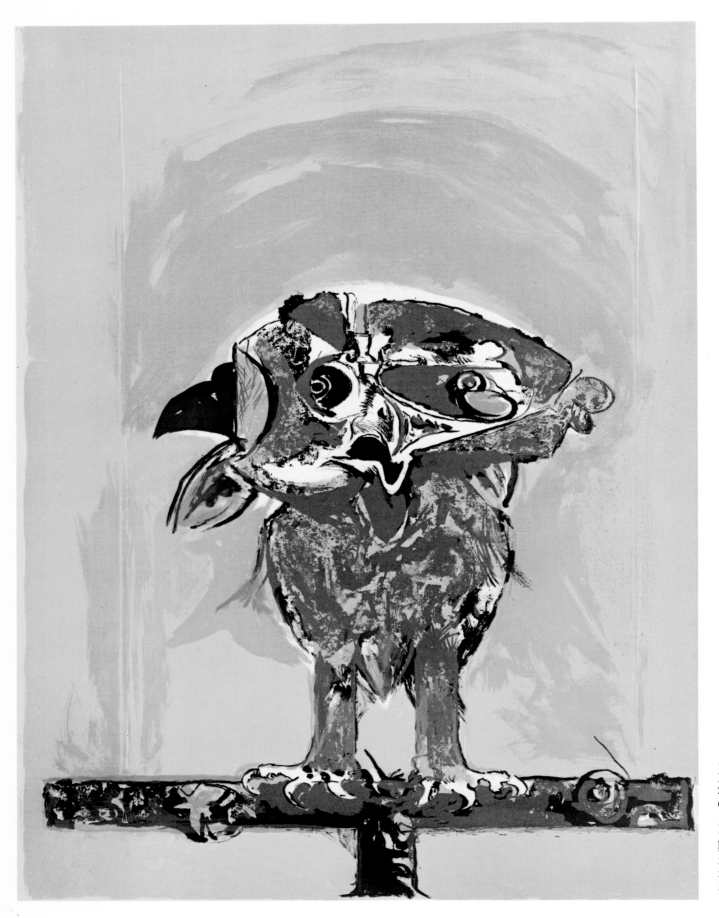

102　OWL (rose ground)
Lithograph, 1968
Size: $26\frac{1}{8}'' \times 19\frac{7}{8}''$;
66.5 × 50 cm
5 colours
Edition: 70 and 10 artist's
proofs
Publisher: Marlborough
Fine Art Ltd, London
Printer: Fernand Mourlot,
Paris

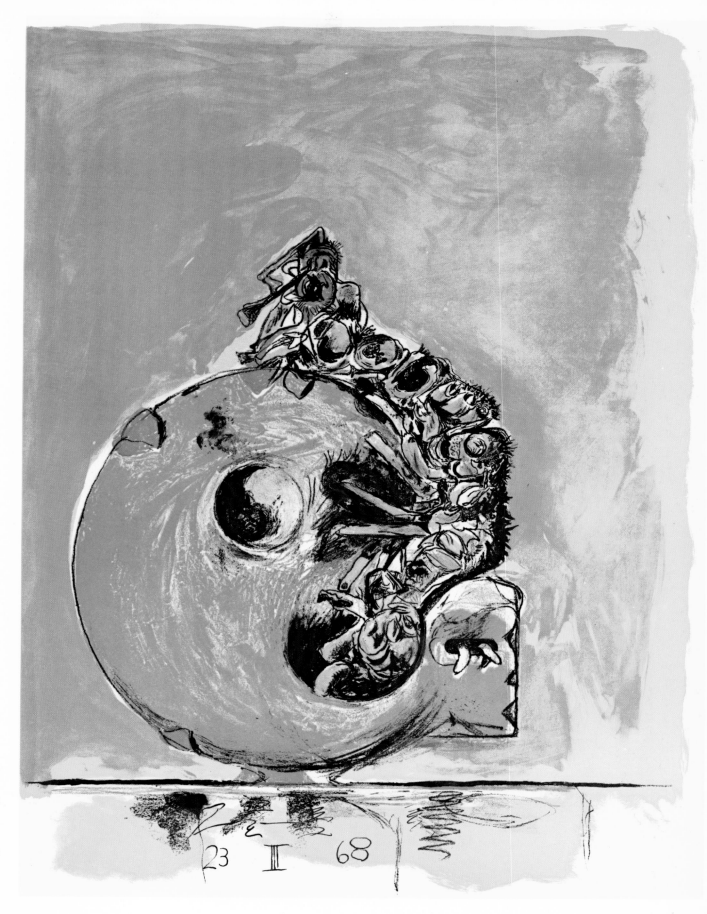

103 EMERGING INSECT
Lithograph, 1968
Size: 26″ × 19½″; 66 × 49.5 cm
6 colours
Edition: 70 and 10 artist's
proofs
Publisher: Marlborough Fine
Art Ltd, London
Printer: Fernand Mourlot,
Paris

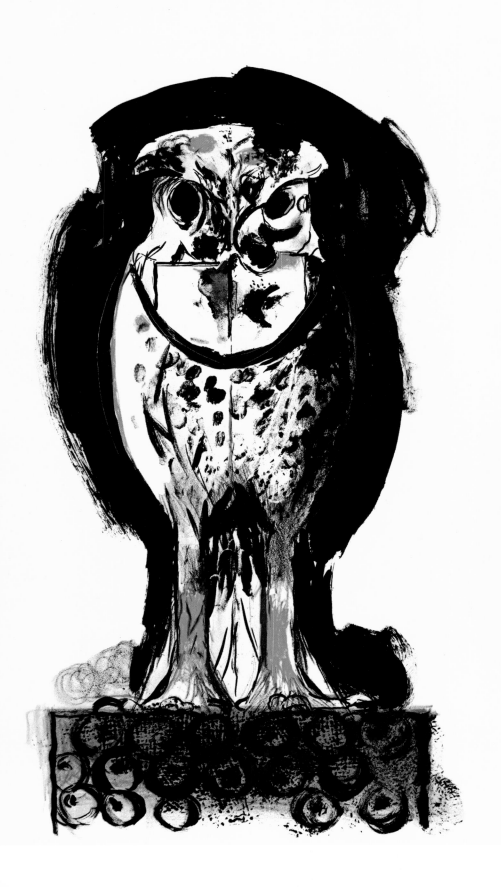

104 BIRD FORM (full face)
Lithograph, 1968
Size: 23″ × 12¾″; 58.5 × 32.5 cm
2 colours
Edition: 70 and 10 artist's proofs
Publisher: Marlborough Fine
Art Ltd, London
Printer: Fernand Mourlot, Paris

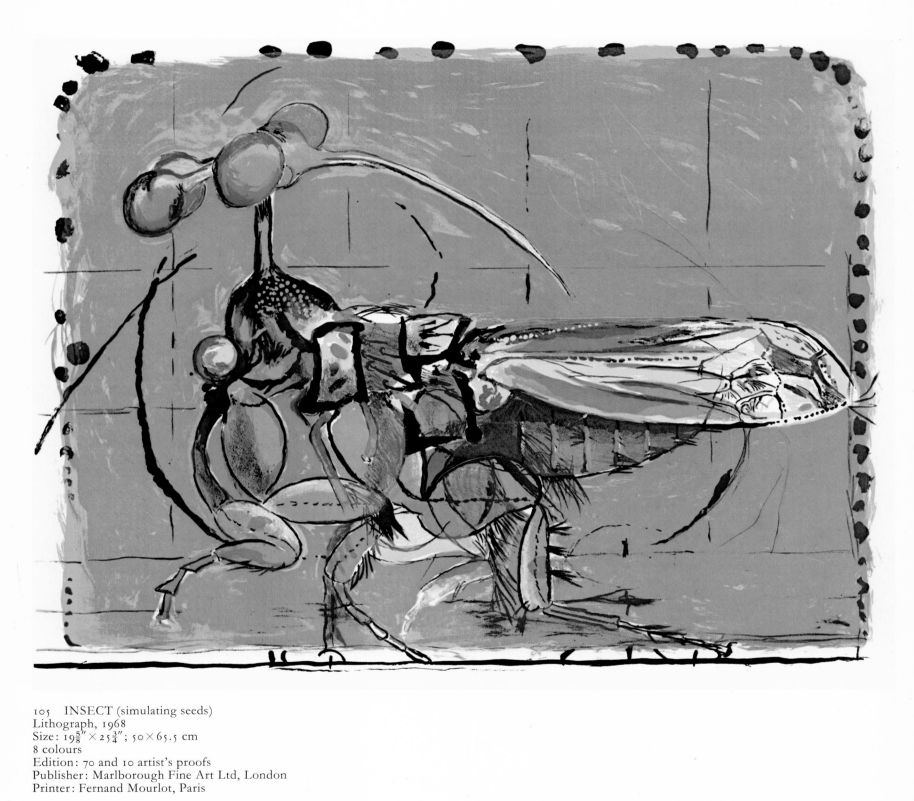

105 INSECT (simulating seeds)
Lithograph, 1968
Size: $19\frac{5}{8}'' \times 25\frac{3}{4}''$; 50×65.5 cm
8 colours
Edition: 70 and 10 artist's proofs
Publisher: Marlborough Fine Art Ltd, London
Printer: Fernand Mourlot, Paris

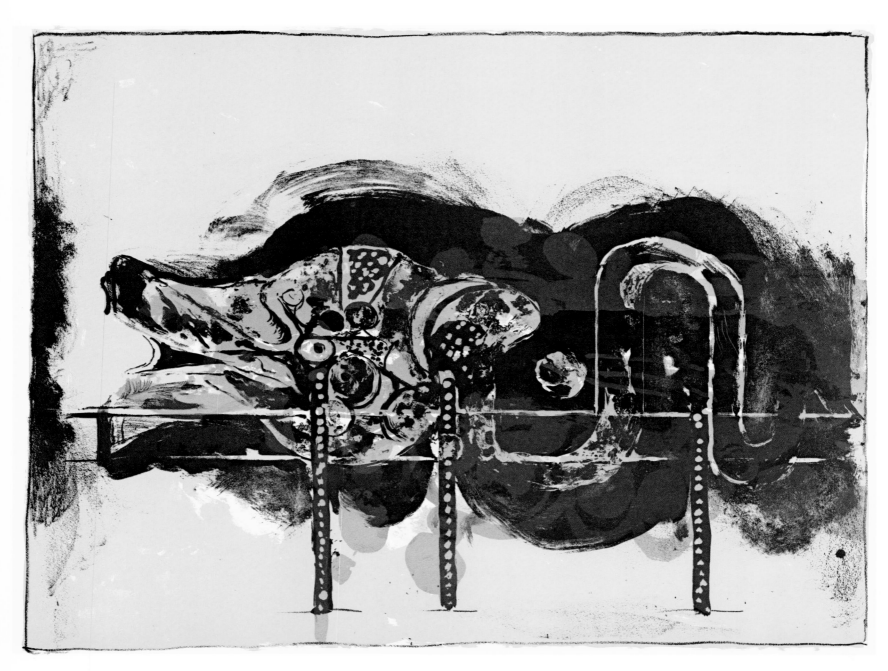

106 SUBMERGED FORM
Lithograph, 1968
Size: $19\frac{5}{8}'' \times 25\frac{3}{8}''$; 50×64.5 cm
3 colours
Edition: 70 and 10 artist's proofs
Printer: Fernand Mourlot, Paris

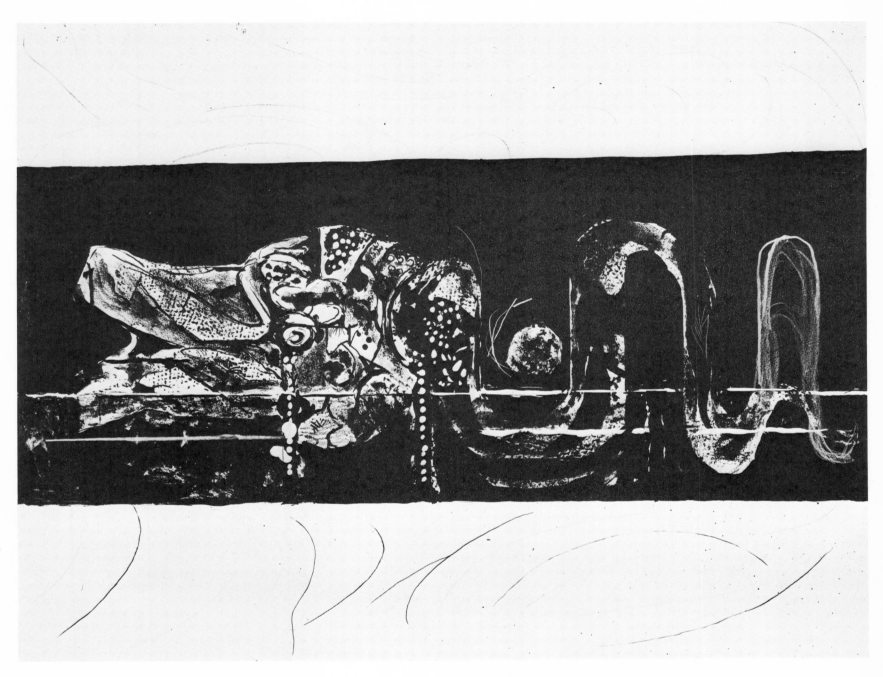

107 SUBMERGED FORM II (shale on black
and white)
Lithograph, 1968
Size: 19⅝″ × 25⅜″; 50 × 64.5 cm
Black
Edition: no edition, one print exists
Printer: Fernand Mourlot, Paris

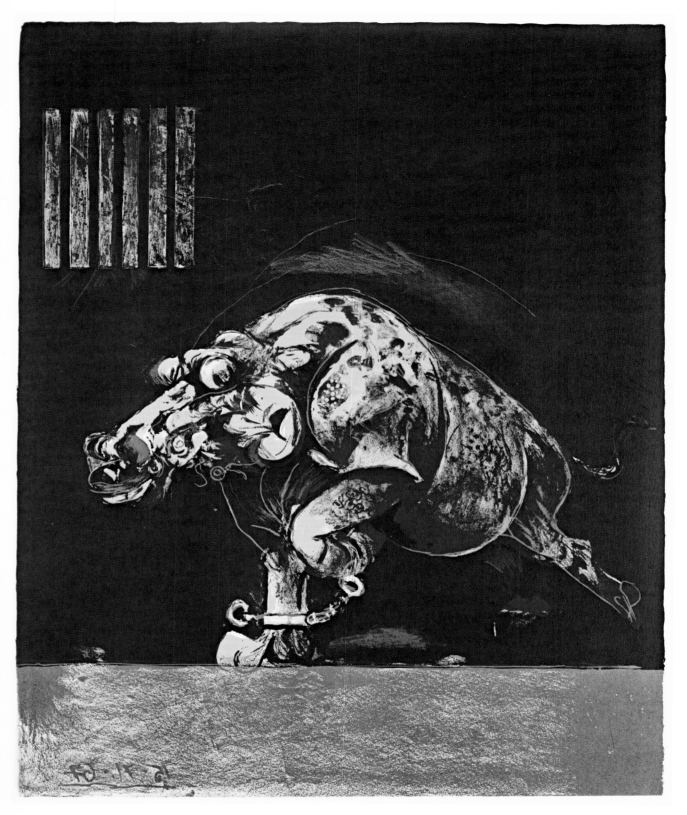

108 CHAINED BEAST
Lithograph, 1967
Size: 26″×20″; 66×51 cm
3 colours
Edition: 70 and 10 artist's proofs
Publisher: Marlborough Fine Art
Ltd, London
Printer: Fernand Mourlot, Paris

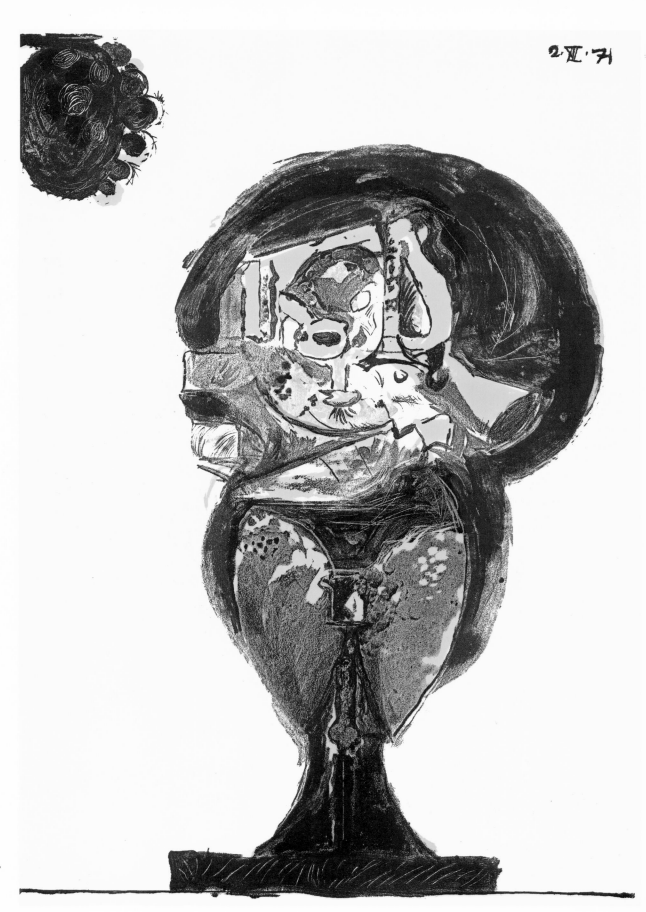

115 STANDING ROCK FORM
Lithograph, 1971
Size: $30\frac{1}{4}'' \times 20\frac{5}{8}''$; 77×52.5 cm
2 colours
Edition: unknown 200
Given by the artist to the Prince Bernhardt
Foundation, Fondation Européenne de la
Culture, Praemium Erasmianum Foundation,
Amsterdam
Publisher: Cercle graphique européen
Printer: unknown

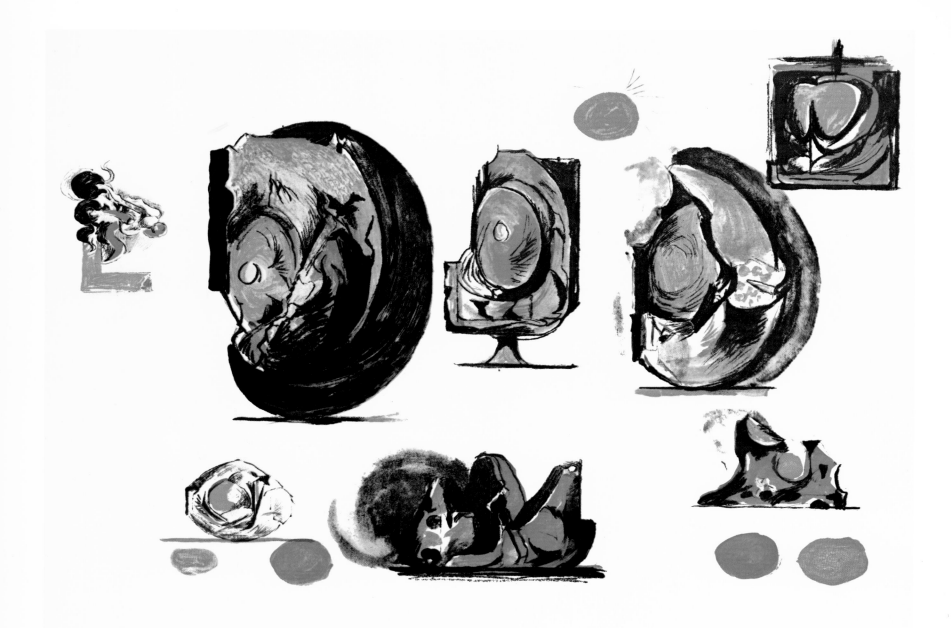

116 SHEET OF STUDIES
Lithograph, 1971
Size: $22\frac{1}{4}'' \times 30\frac{3}{8}''$; 56.5 × 77 cm
3 colours
Edition: unknown 200 and 20 artist's proofs
 numbered
Given by the artist to the Prince Bernhardt
Foundation, Fondation Européenne de la
Culture, Praemium Erasmianum Foundation,
Amsterdam
Publisher: Cercle graphique européen
Printer: unknown

LA FORESTA, IL FIUME,
LA ROCCIA
(THE FOREST, THE RIVER,
THE ROCK)

A portfolio of six lithographs
and a frontispiece with a
preface by Roberto Tassi
Lithographs, 1970–71

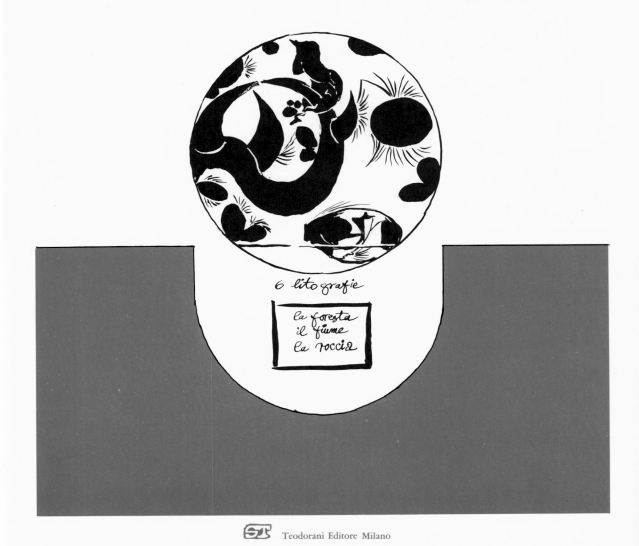

SUTHERLAND

6 litografie

la foresta
il fiume
la roccia

Teodorani Editore Milano

120 FRONTISPIECE TO LA
FORESTA, IL FIUME, LA
ROCCIA
Lithograph
Size: $24\frac{3}{4}'' \times 18\frac{1}{2}''$; 63×47 cm
2 colours
Edition: 75 ex. numbered 1–75
 15 ex. numbered I–XV
 Series A–Z on Japan
 paper
Publisher: Teodorani, Milan
Printer: Teodorani, Milan

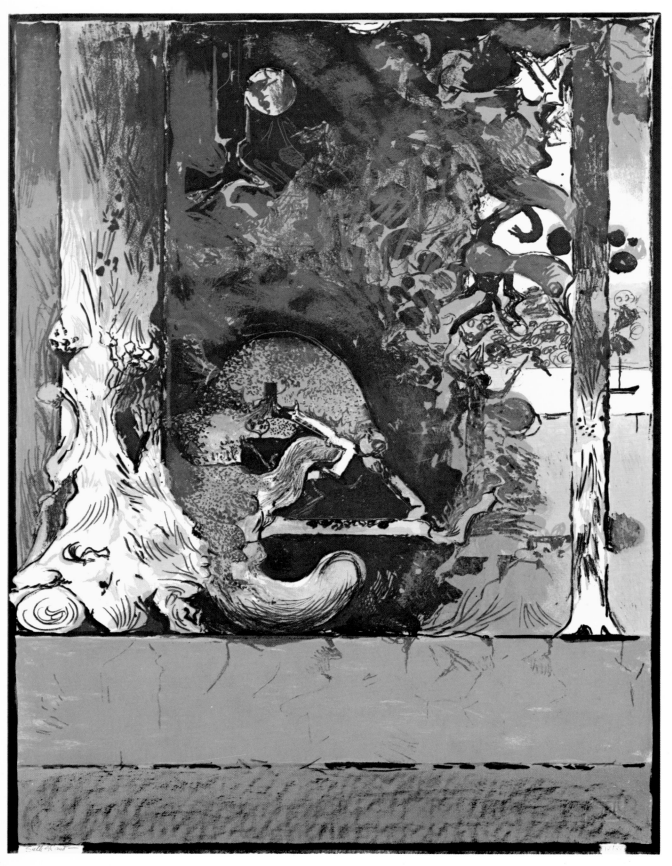

121 LA FORESTA, IL FIUME,
LA ROCCIA
LA FORESTA I (THE FOREST
I)
Lithograph, 1972
Size: $24\frac{3}{4}'' \times 18\frac{1}{2}''$; 63×47 cm
5 colours
Edition: 75 ex. numbered 1–75
 15 ex. numbered I–IV
 Series A–Z on Japan
 paper
Publisher: Teodorani, Milan
Printer: Teodorani, Milan

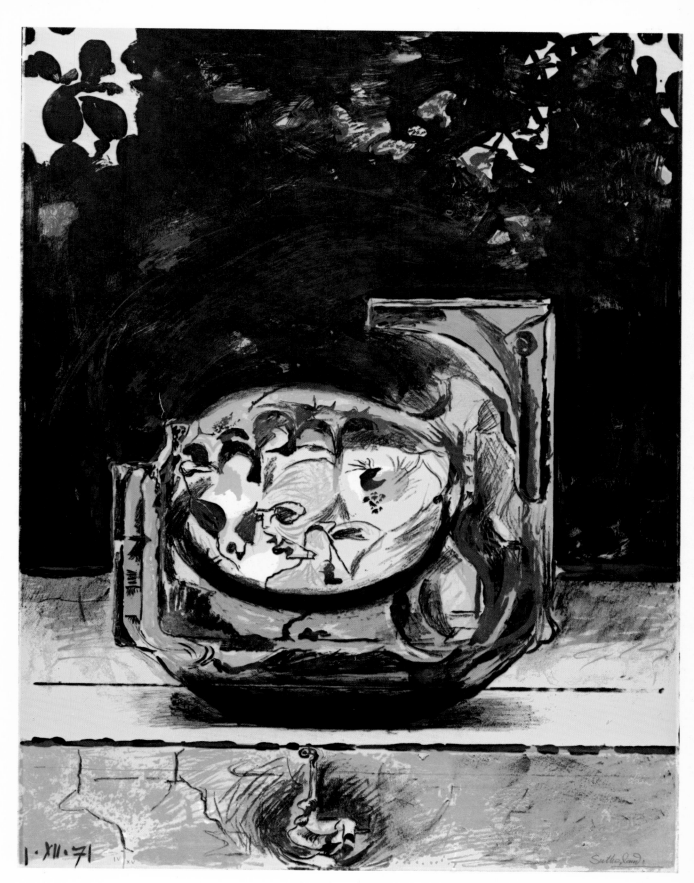

126 LA FORESTA, IL
FIUME, LA ROCCIA
LA ROCCIA I (THE ROCK I)
Lithograph, 1971
Size: 24¾″ × 18½″; 63 × 47 cm
4 colours
Edition: 75 ex. numbered 1–75
 15 ex. numbered I–IV
 Series A–Z on Japan
 paper
Publisher: Teodorani, Milan
Printer: Teodorani, Milan

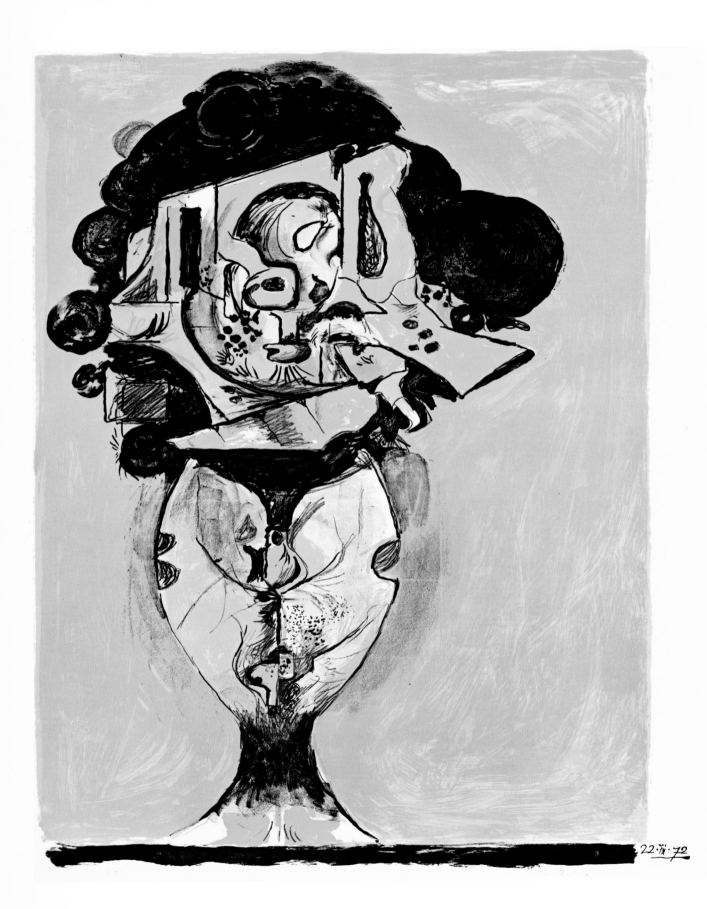

127 LA FORESTA, IL
FIUME, LA ROCCIA
LA ROCCIA II (THE ROCK II)
Lithograph, 1972
Size: $24\frac{3}{4}'' \times 18\frac{1}{2}''$; 63×47 cm
3 colours
Edition: 75 ex. numbered 1–75
 15 ex. numbered I–XV
 Series A–Z on Japan
 paper
Publisher: Teodorani, Milan
Printer: Teodorani, Milan

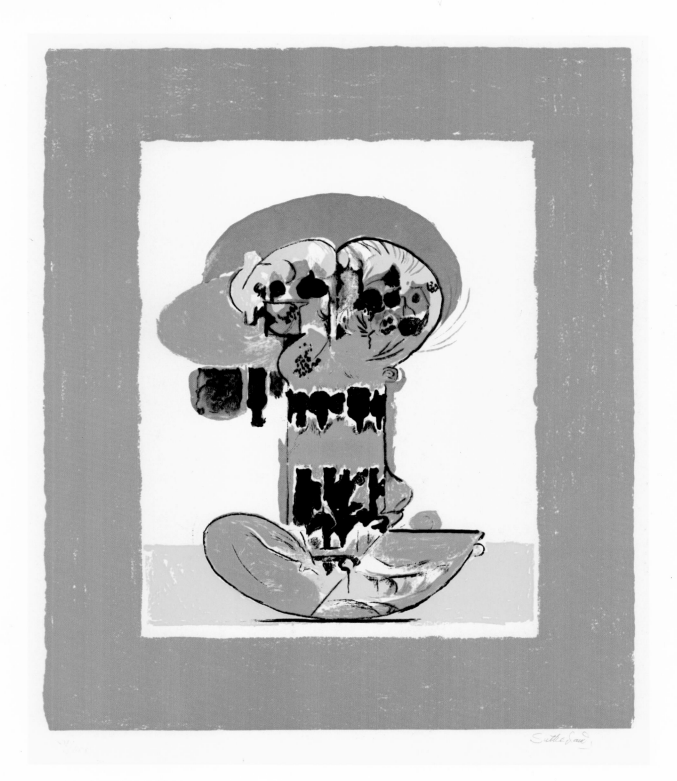

130 BALANCING FORM
Lithograph, 1972
Size: $13\frac{3}{8}'' \times 16\frac{1}{8}''$; 34×41 cm
4 colours
Edition: 90 ex. numbered 1 to 90
Publisher: XXe Siècle, Paris
Printer: Fernand Mourlot, Paris

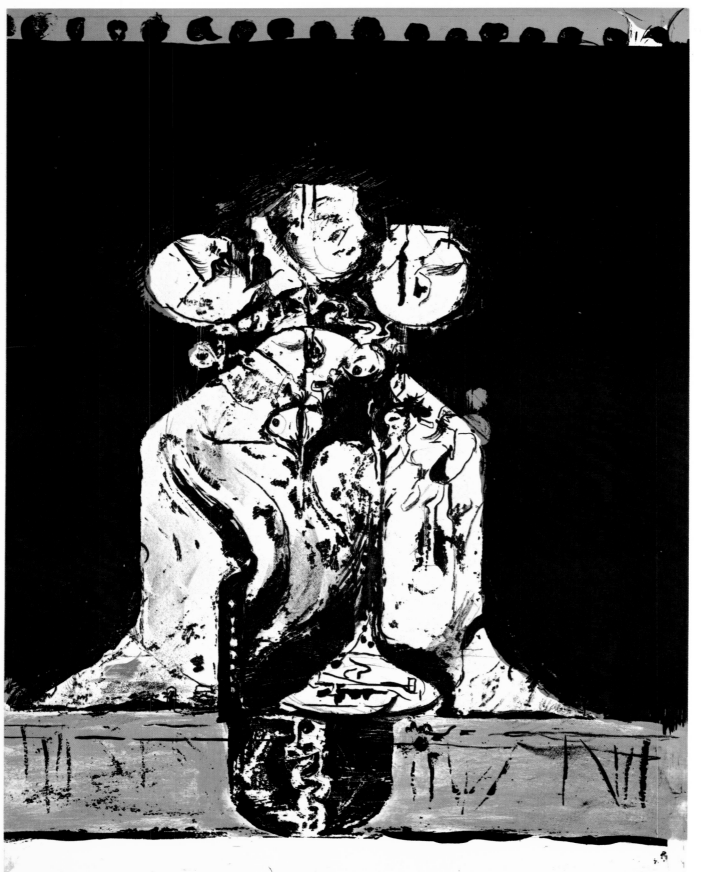

131 THREE-HEADED
ROCK
Lithograph, 1972
Size: $24\frac{3}{4}'' \times 18\frac{1}{2}''$; 63×47 cm
2 colours
Edition: initially made for the
series *La Foresta, Il Fiume, La
Roccia*, not published, a few
prints exist

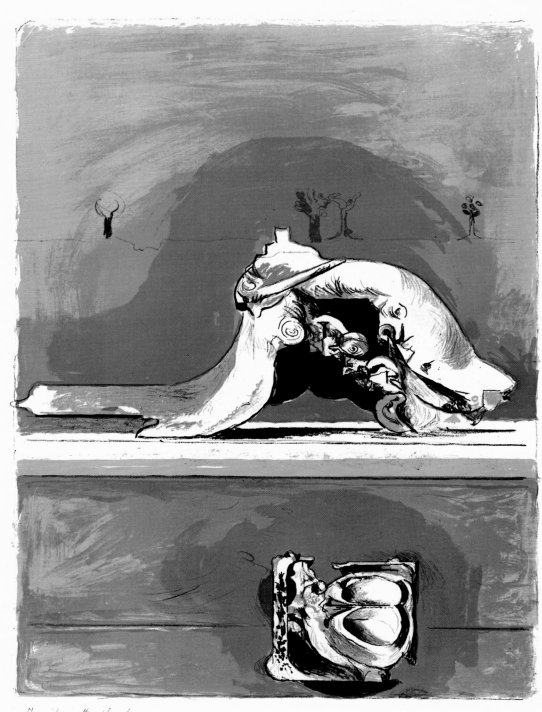

134 UNDULATING FORM
Lithograph, 1972–73
5 colours
Edition: trial prints only

DUE ACQUAFORTI

A portfolio of two etchings
with frontispiece, 1973

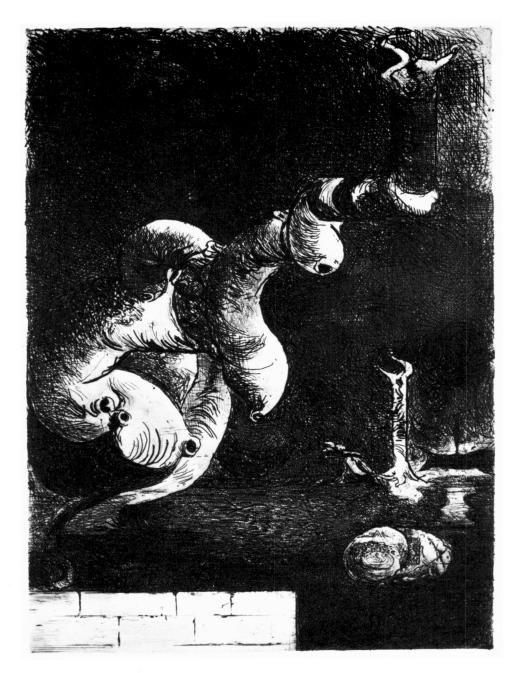

135 PICTON
Etching, 1973
Size: $18\frac{1}{2}'' \times 13\frac{3}{8}''$; 47×34 cm
Black
Edition: 75 ex. numbered 1–75
 15 ex. HC numbered I–XV
 Series A–Z on Japan paper
Publisher: Teodorani, Milan
Printer: Il Cigno, Rome
for *Due Acquaforti*

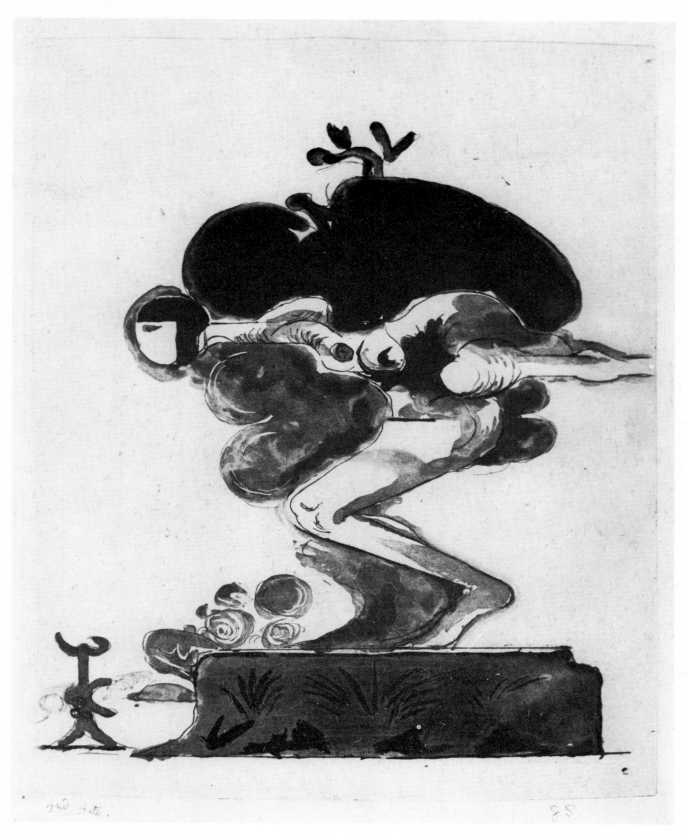

143 THE DIVER
Etching and aquatint, 1973
Size: $15\frac{1}{8}'' \times 12\frac{1}{8}''$; 38.5×31 cm
Black
Edition: 95
Publisher: Valter and Eleonora Rossi, Rome
Printer: Valter and Eleonora Rossi, Rome

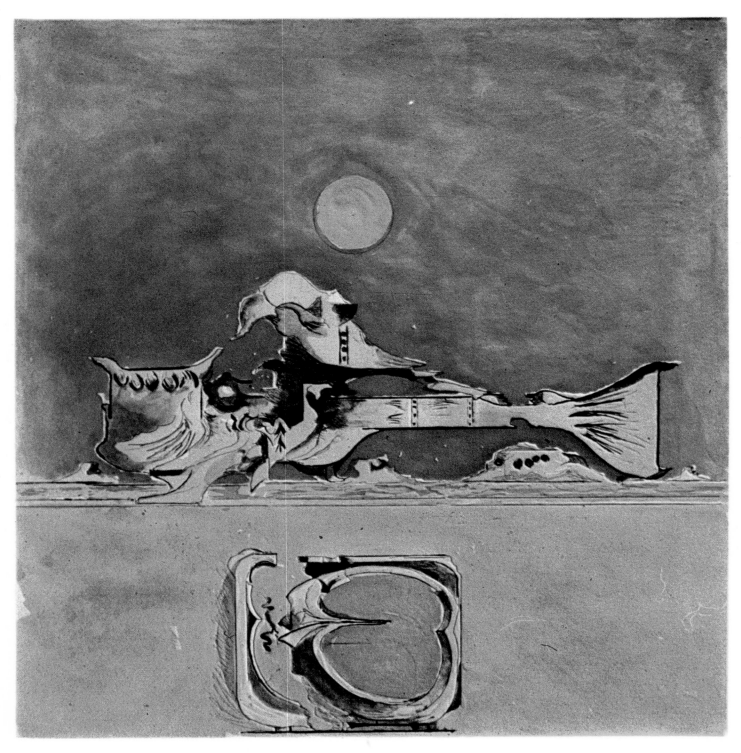

144 FORM IN A DESERT I
Etching and aquatint, 1974
Size: 26⅛″ × 25⅝″; 66.5 × 65 cm
3 colours
Edition: 75
Publisher: Valter and Eleonora Rossi, Rome
Printer: Valter and Eleonora Rossi, Rome

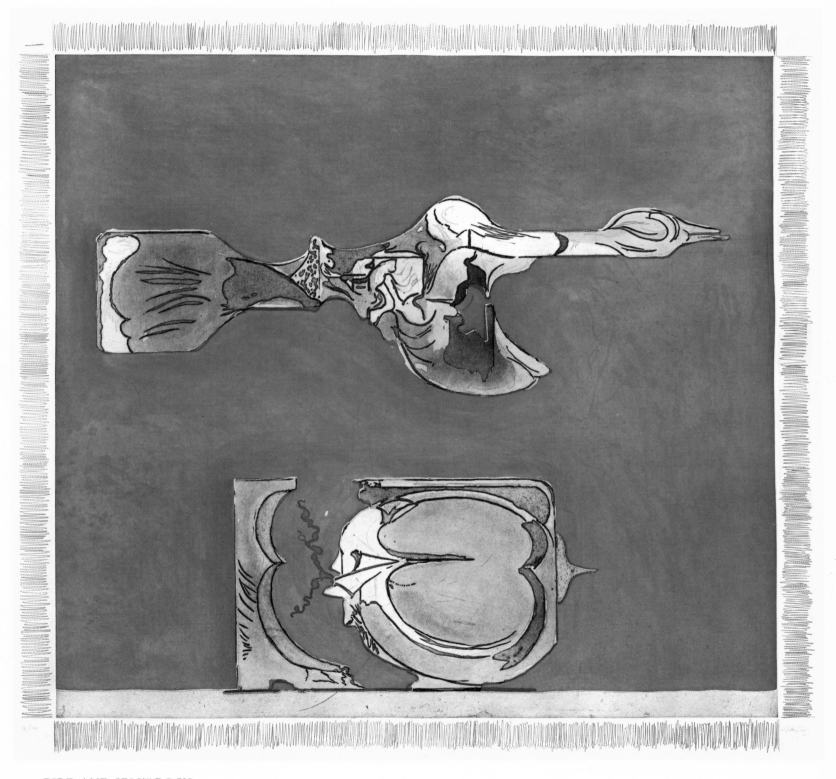

145 BIRD AND SPLIT ROCK
Aquatint, 1974
Size: $42\frac{7}{8}'' \times 45\frac{5}{8}''$; 109×116 cm
3 colours
Edition: 95
Publisher: Valter and Eleonora Rossi, Rome
Printer: Valter and Eleonora Rossi, Rome

146 FRONTISPIECE FOR 3 LITHOGRAPHS
A portfolio of three lithographs with frontispiece,
1973–74
Size: $11\frac{1}{4}''$; 28.6 cm
Black
Edition: 75 ex. numbered 1–75
 15 ex. HC numbered I–XV
 Series A–Z on Japan paper
Publisher: Teodorani, Milan
Printer: Fernand Mourlot, Paris

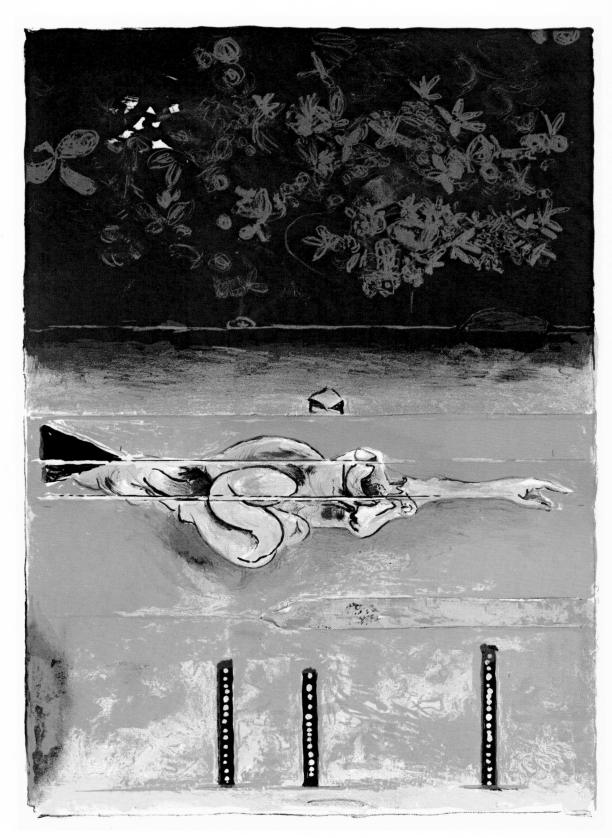

147 For 3 LITHOGRAPHS
THE SWIMMER
Lithograph, 1973–74
Size: $26\frac{1}{2}'' \times 18\frac{3}{4}''$; 67.5 × 47.5 cm
5 colours
Edition: 75 ex. numbered 1–75
　　　　15 ex. HC numbered I–XV
　　　　Series A–Z on Japan paper
Publisher: Teodorani, Milan
Printer: Fernand Mourlot, Paris

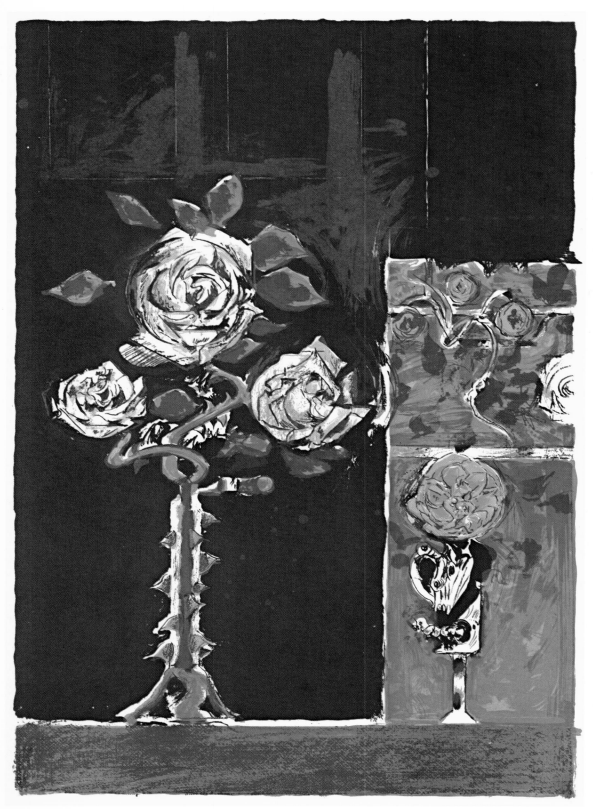

148 For 3 LITHOGRAPHS
ROSES
Lithograph, 1973–74
Size: $26\frac{1}{8}'' \times 18\frac{1}{2}''$; 66.5 × 47 cm
6 colours
Edition: 75 ex. numbered 1–75
 15 ex. HC numbered I–XV
 Series A–Z on Japan paper
Publisher: Teodorani, Milan
Printer: Fernand Mourlot, Paris

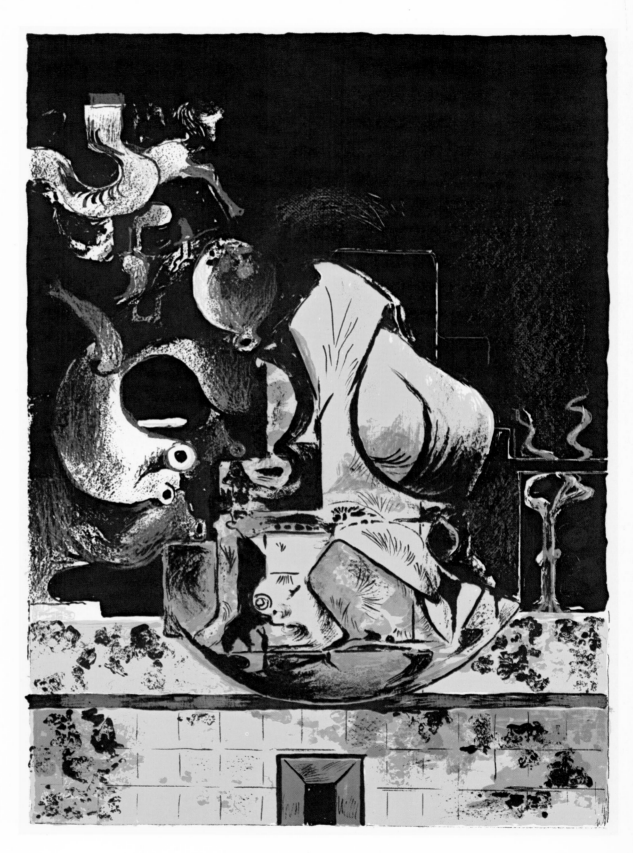

149 For 3 LITHOGRAPHS
THE ROCK
Lithograph, 1973–74
Size: $26\frac{1}{2}'' \times 18\frac{7}{8}''$; 67.5 × 48 cm
5 colours
Edition: 75 ex. numbered 1–75
 15 ex. HC numbered I–XV
 Series A–Z on Japan paper
Publisher: Teodorani, Milan
Printer: Fernand Mourlot, Paris

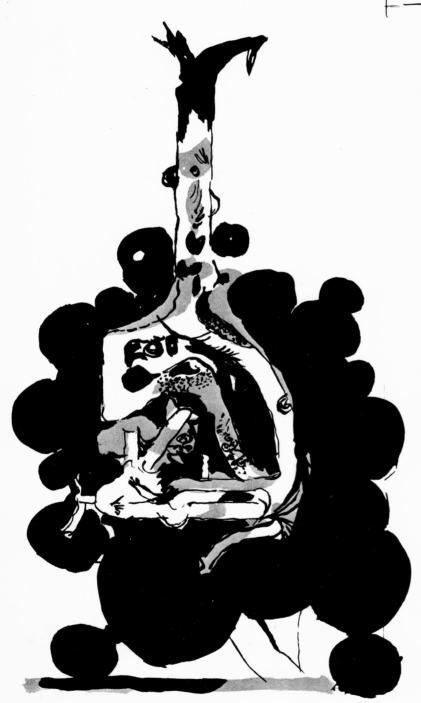

150 ILLUSTRATION FOR T.S. ELIOT
Silk-screen process
2 colours
Edition: not published, 20 artist's proofs
only
(Designed but not printed by Graham
Sutherland)

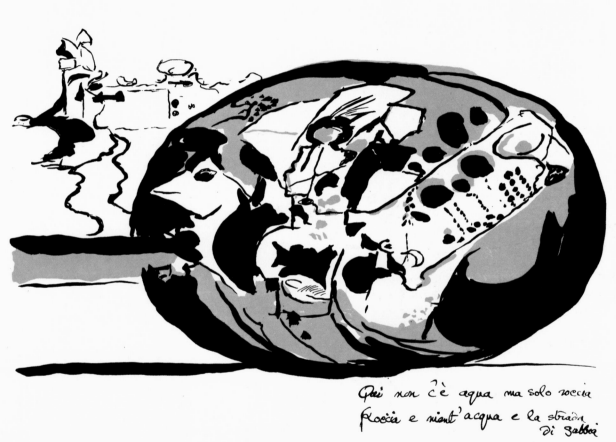

151 ILLUSTRATION FOR T.S. ELIOT
Silk-screen process
2 colours
Edition: not published, 20 artist's proofs only
(Designed but not printed by Graham
Sutherland)

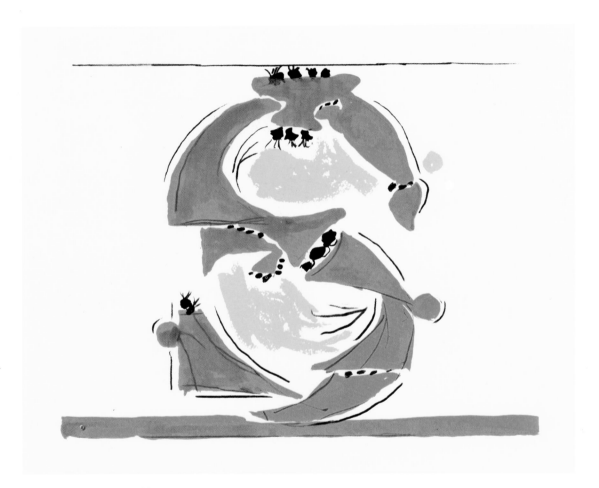

152 LETTERS
Photolitho from a drawing of the artist
1973
Publisher: Bolaffi Arte, Turin
(Designed but not printed by Graham Sutherland)

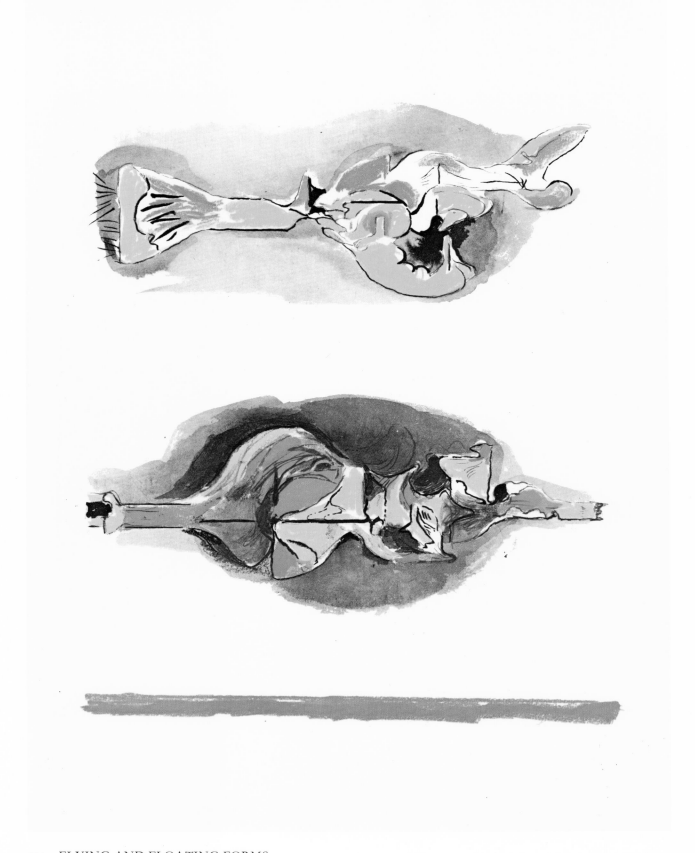

153 FLYING AND FLOATING FORMS
Collotype
(Designed but not printed by Graham Sutherland)

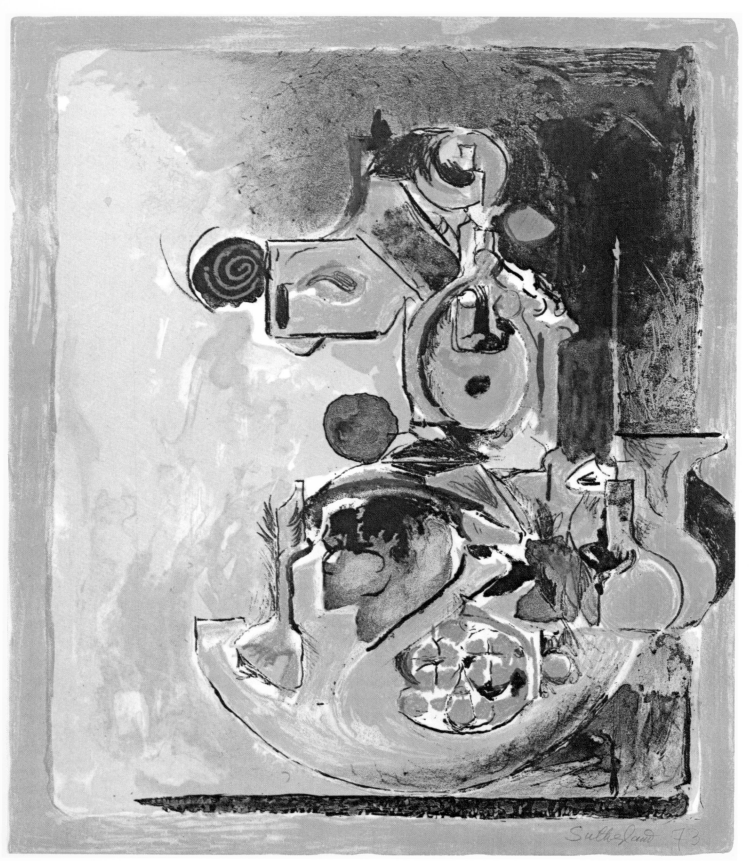

154 COMPLEX OF
ROCKS
Lithograph, 1973
Size: 12″ × 10″;
30.7 × 25.5 cm
4 colours
Edition: 50 ex. numbered
1–50
Publisher: Fratelli Fabbri,
Milan for the Italian
Édition de Tête of *Graham
Sutherland* by Francesco
Arcangeli
Printer: Valter and
Eleonora Rossi, Rome

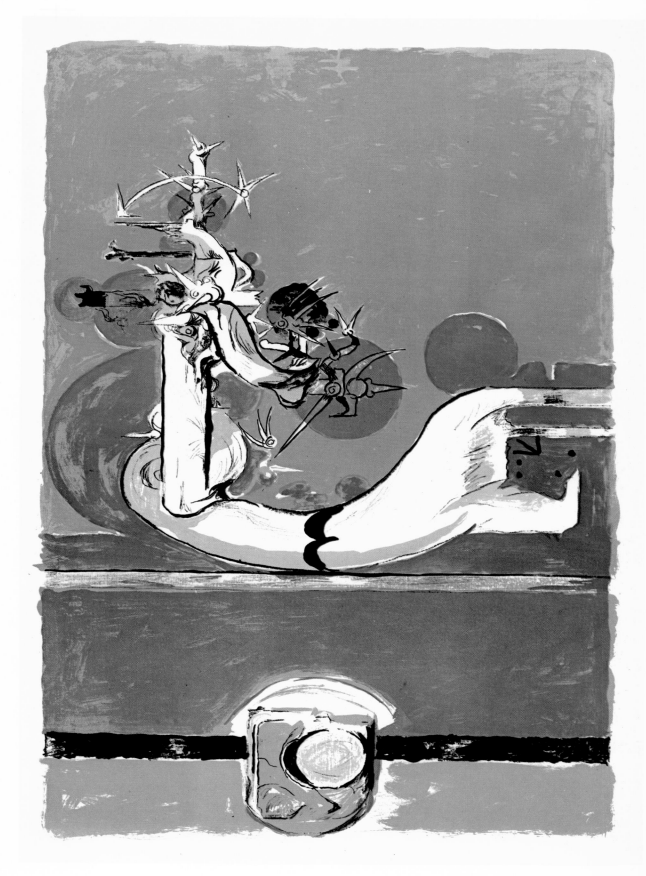

155 POISED FORM
Lithograph, 1972–73
4 colours
Edition: trial proofs only

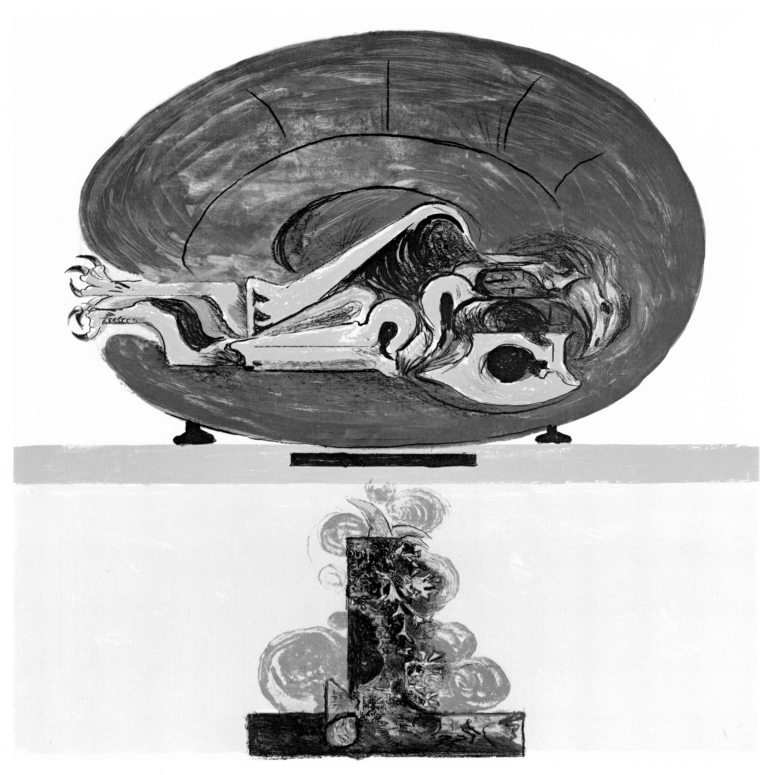

156 SLEEPING BIRD I
Lithograph, 1975
Size: $23\frac{5}{8}'' \times 20\frac{1}{2}''$; 60 × 52 cm
5 colours
Edition: 50 ex. numbered 1–50
 15 ex. HC numbered I–XV
 Series A–Z on Japan paper
Publisher: given to La Jeune Chambre
 Économique de Menton in aid of
 Sahel
Printer: Teodorani, Milan

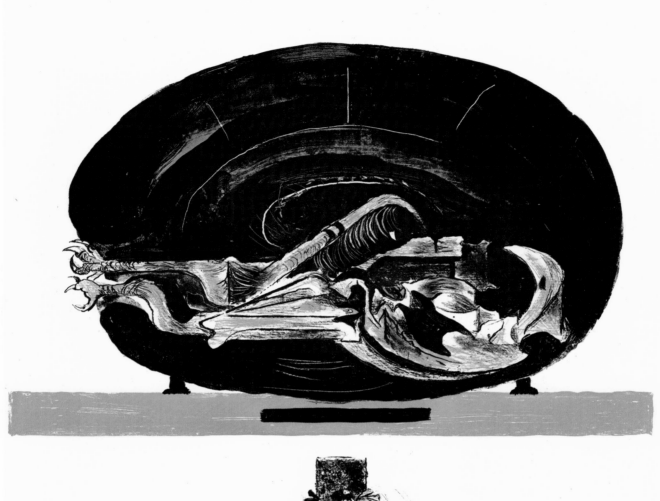

157 SLEEPING BIRD II
Lithograph, 1975
Size: 23⅝″ × 20½″; 60 × 52 cm
3 colours
Edition: not published
 15 artist's proofs only
Printer: Teodorani, Milan

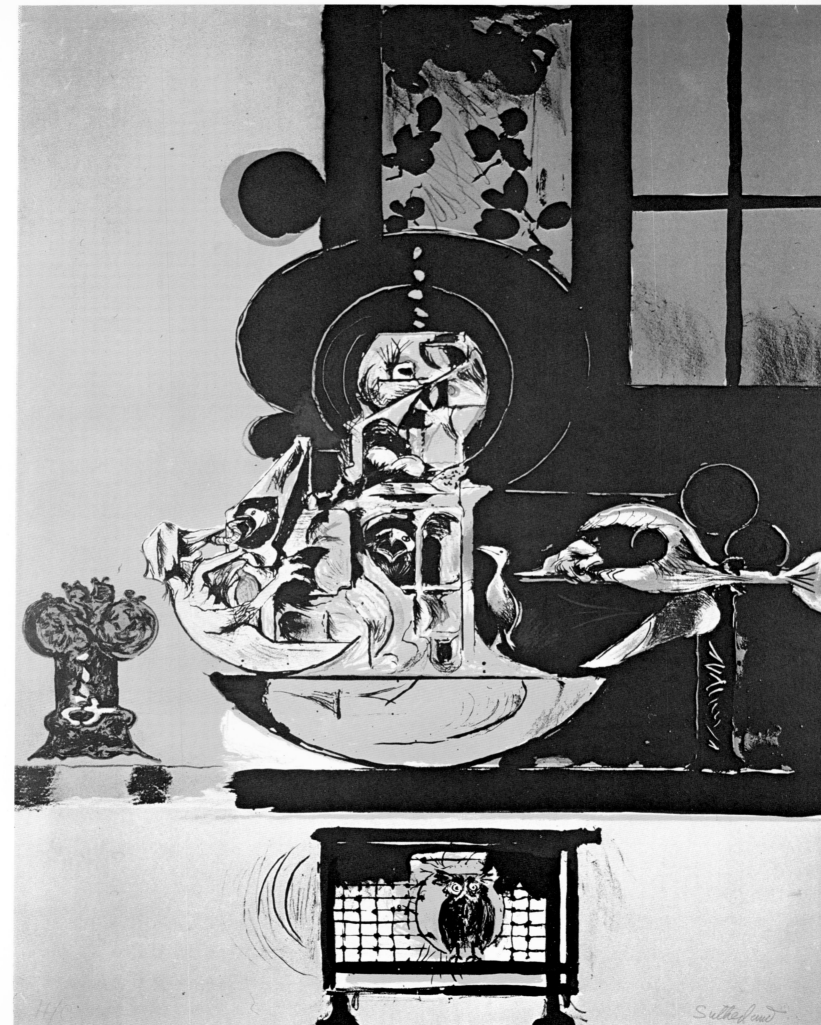

158 TOWER OF
BIRDS
Lithograph, 1975
Size: 25⅝″ × 19¾″;
65 × 50 cm
6 colours
Edition: 175 ex.
numbered.
50 ex.
numbered
on Japan
paper
Publisher:
Transworld Art
Corporation, New
York for the
Bicentenary of the
American
Declaration of
Independence
Printer: Fernand
Mourlot, Paris

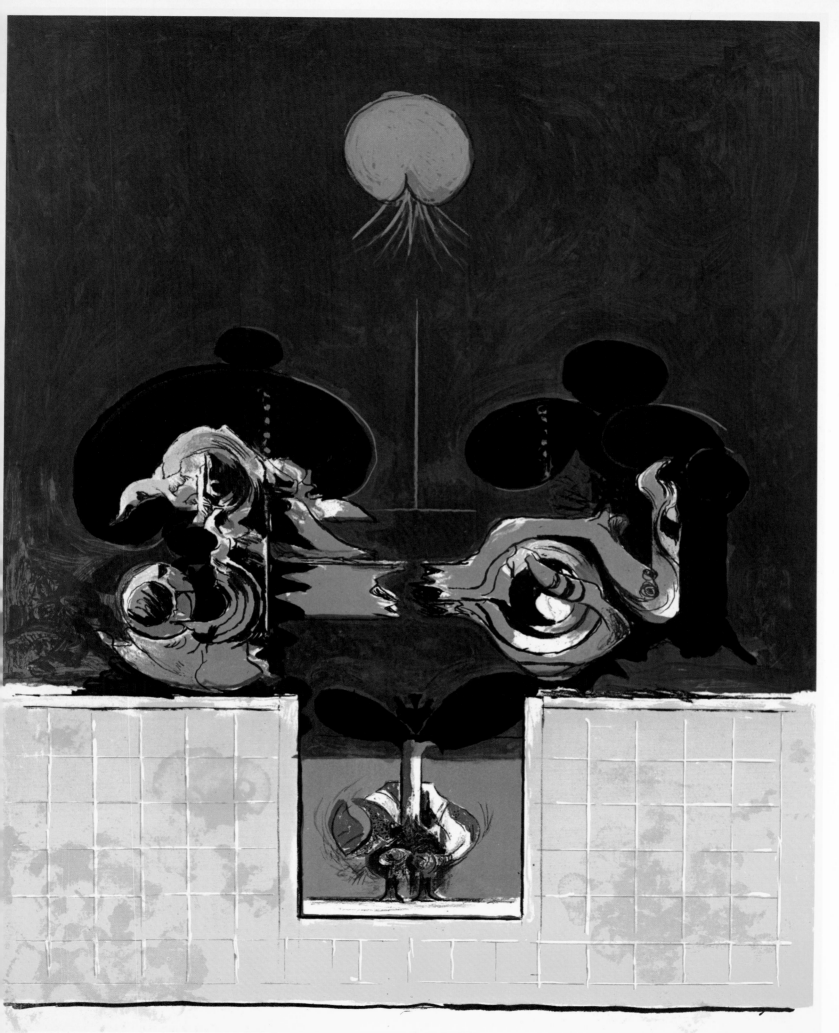

159 THE
BREACH
Lithograph, 1975
Size: 25⅝" × 19¾";
65 × 50 cm
6 colours
Edition: 75 ex.
numbered 1–75
15 artist's proofs
Publisher: Spirale,
Milan
Printer: Fernand
Mourlot, Paris

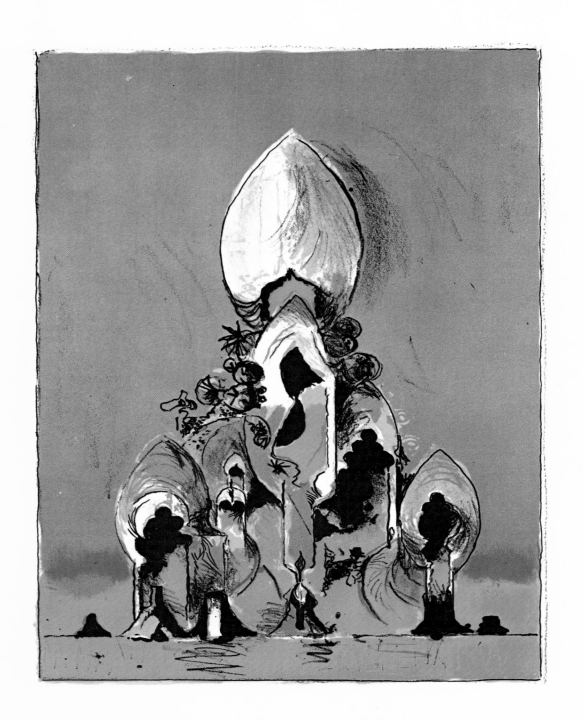

160 THE
CATHEDRAL I
Lithograph, 1974
Size: 12¼″ × 9¼″;
31 × 23.5 cm
5 colours
Edition: 50 ex.
numbered 1–50
620 ex. book-plates
(hors-texte) for
*Hommage à San
Lazzaro*, 200 suite
Publisher: XXe
Siècle, Paris
Printer: Fernand
Mourlot, Paris

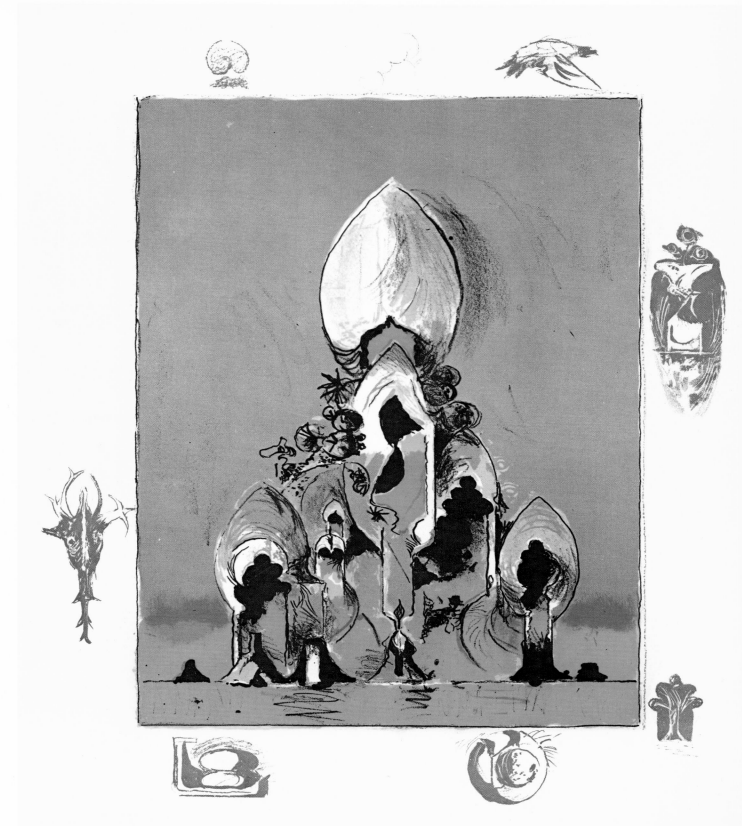

161 THE
CATHEDRAL II
Lithograph, 1975
Size: 16⅜″ × 13½″;
41.5 × 34.5 cm
with designs in border
5 colours
Edition: some artist's
proofs
Publisher: not yet
published
Printer: Fernand Mourlot,
Paris

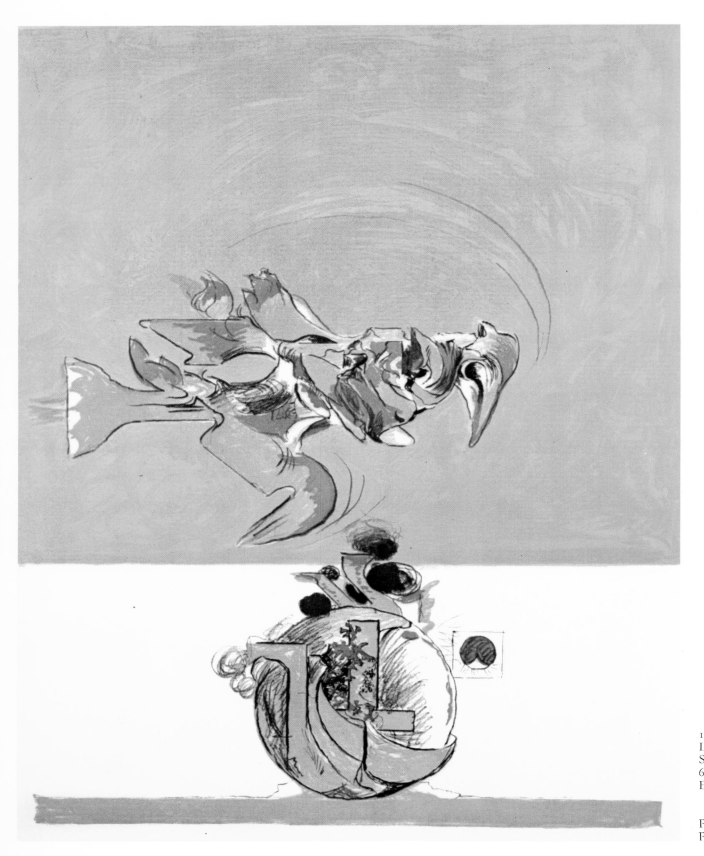

162 FIREBIRD I
Lithograph, 1975
Size: $25\frac{5}{8}'' \times 19\frac{3}{4}''$; 65×50 cm
6 colours
Edition: 75 ex. numbered 1–75
 15 ex. HC numbered I–XV
 Series A–Z on Japan paper
Publisher: Teodorani, Milan
Printer: Teodorani, Milan

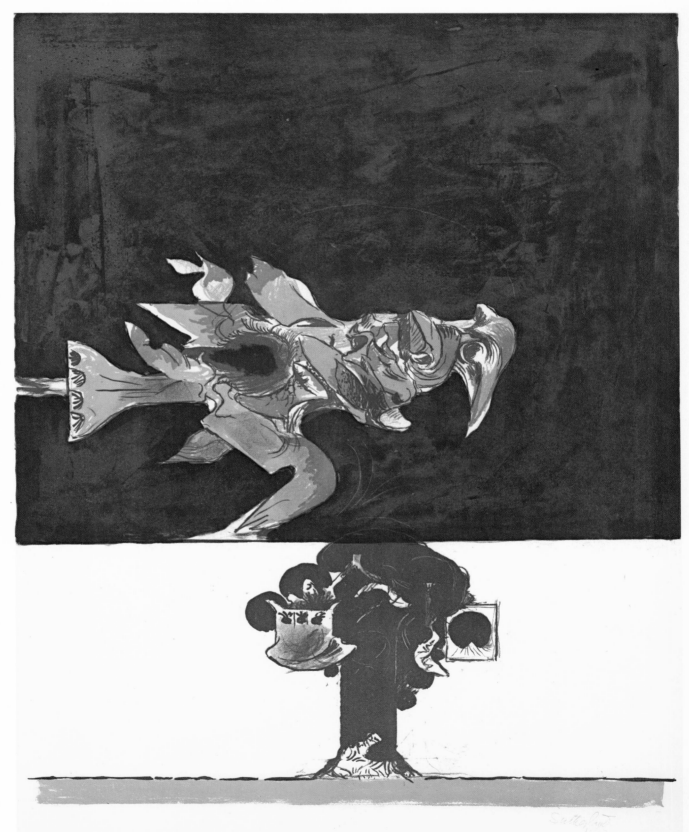

163 FIREBIRD II
Lithograph, 1975
Size: $25\frac{5}{8}'' \times 19\frac{3}{4}''$; 65×50 cm
6 colours
Edition: 75 ex. numbered 1–75
15 ex. HC numbered I–XV
Series A–Z on Japan paper
Publisher: Teodorani, Milan
Printer: Teodorani, Milan

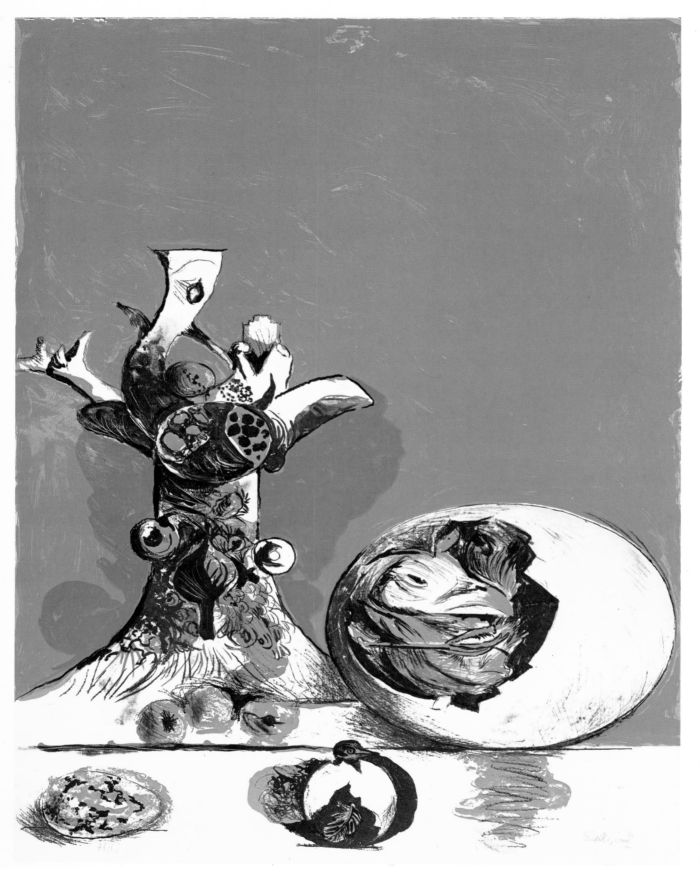

164 THE EGG
Lithograph, 1975
Size: $25\frac{5}{8}'' \times 19\frac{3}{4}''$; 65×50 cm
6 colours
Edition: 75 ex. numbered 1–75
 15 ex. HC numbered I–XV
 Series A–Z on Japan paper
Publisher: Teodorani, Milan
Printer: Teodorani, Milan

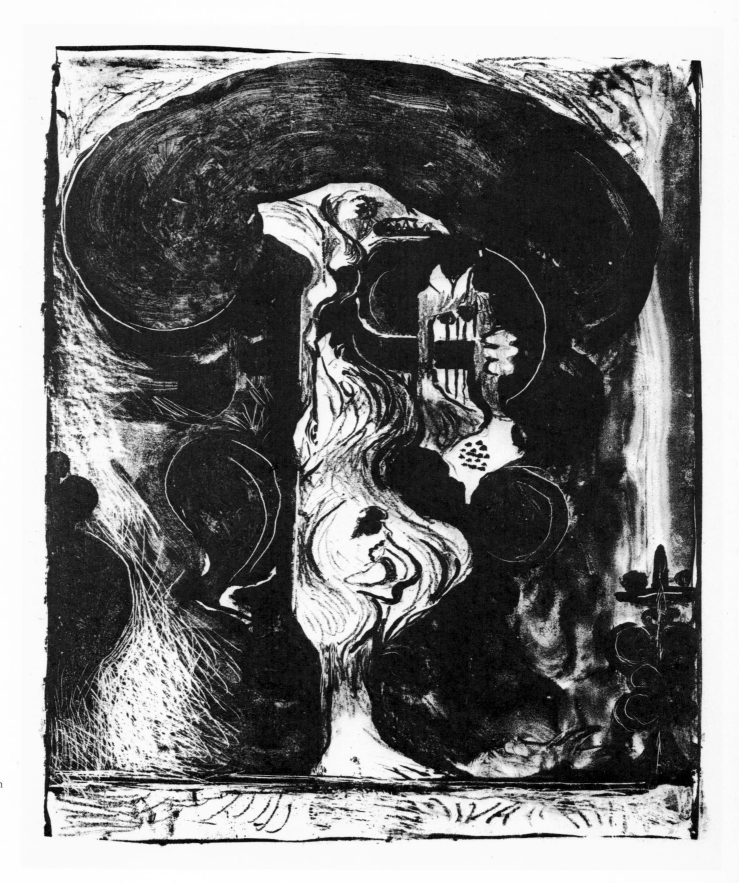

165 LA MUSIQUE
Lithograph, 1976
Size: 11″×10″; 28×25.5 cm
Black
Edition: 50 ex. for the English
Édition de Tête of *Graham
Sutherland* by Francesco
Arcangeli
Publisher: Fratelli Fabbri,
Milan
Printer: Teodorani, Milan

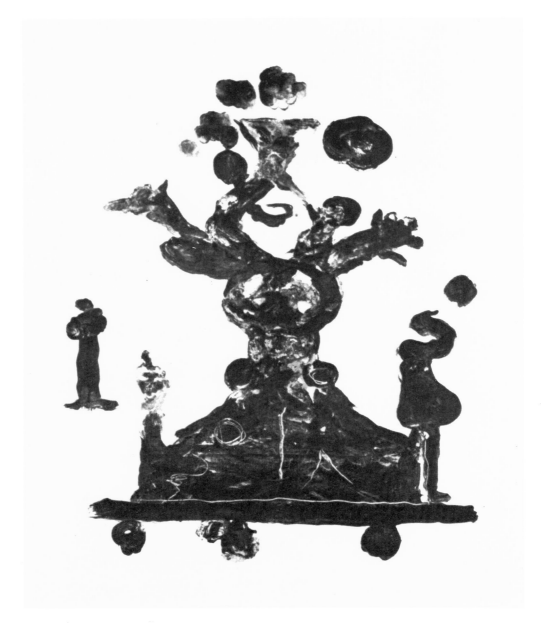

166 THE OAK TREE II
Lithograph, 1975
Size: 12″ × 8″; 30.5 × 25.5 cm
Black
Edition: artist's proofs only
Essay for the frontispiece of the Édition de Tête of *Graham Sutherland*, published by
Fratelli Fabbri
Printer: Teodorani, Milan

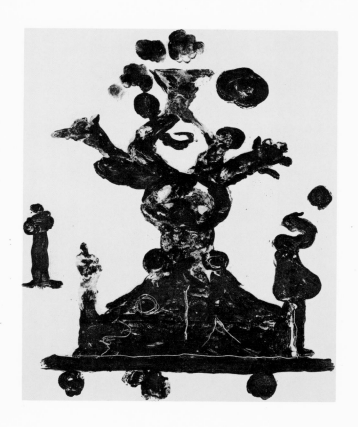

167 THE OAK TREE I
Lithograph, 1975
Size: 12″ × 8″; 30.5 × 25.5 cm
2 colours
Edition: artist's proofs only
Essay for the frontispiece of the Édition de Tête of *Graham Sutherland*, published by
Fratelli Fabbri
Printer: Teodorani, Milan

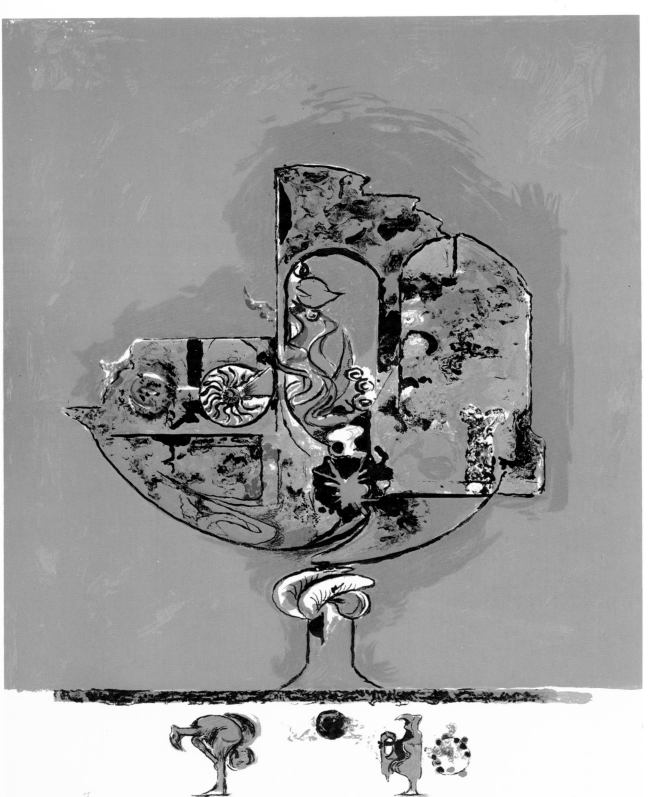

168 FLAMES IN A ROCK FORM I
Lithograph, 1975–76
Size: $25\frac{5}{8}'' \times 19\frac{3}{4}''$; 65 × 50 cm
7 colours
Edition: 75 ex. and 15 prints marked
I–XV HC
Publisher: Ediciones Poligrafa S. A.,
Barcelona
Printer: Fernand Mourlot, Paris

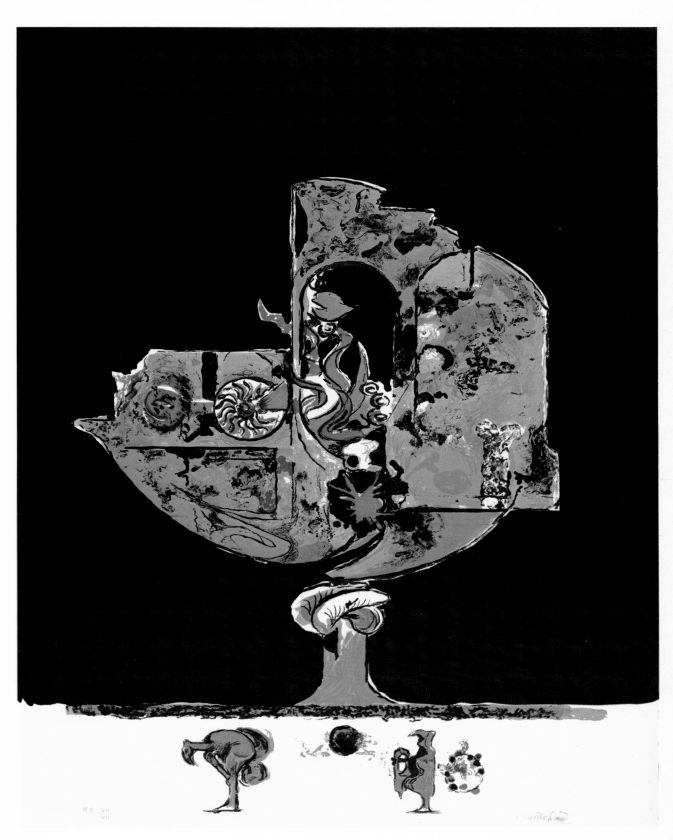

169 FLAMES IN A ROCK FORM II
Lithograph, 1975–76
Size: 25⅝″ × 19¾″; 65 × 50 cm
7 colours
Edition: 15 ex. and 7 prints marked
I–VII HC
Publisher: Ediciones Poligrafa S. A.,
Barcelona
Printer: Fernand Mourlot, Paris

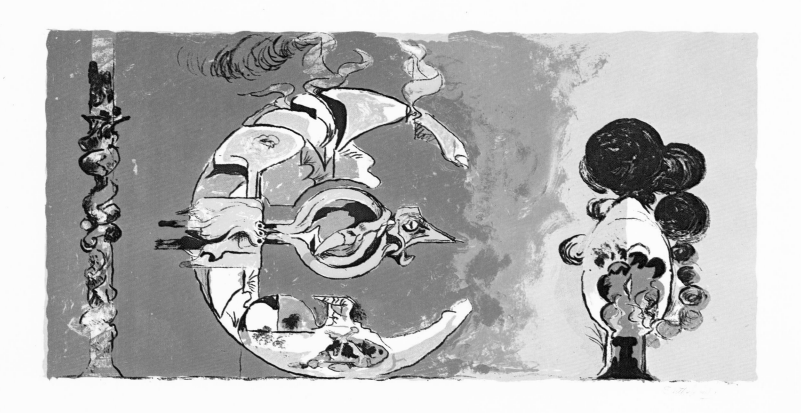

170 FOSSIL WITH ROCKS AND FLAMES
(1st state)
Lithograph, 1975
Size: $10\frac{3}{4}'' \times 21\frac{1}{2}''$; 27.5 × 54.5 cm
6 colours
Edition: 99 ex. for the Édition de Tête of *Graham
 Sutherland, The Graphic Work* and 15
 prints marked I–XV HC
Publisher: Ediciones Poligrafa S. A., Barcelona
Printer: Fernand Mourlot, Paris

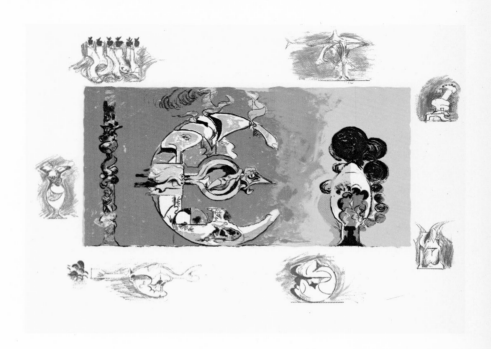

171–78　FOSSIL WITH ROCKS AND
FLAMES
Lithograph, 1975, with handmade drawings by
the artist
Edition: 30 ex. each one with different drawings
Publisher: Ediciones Poligrafa S. A., Barcelona
Printer: Fernand Mourlot, Paris

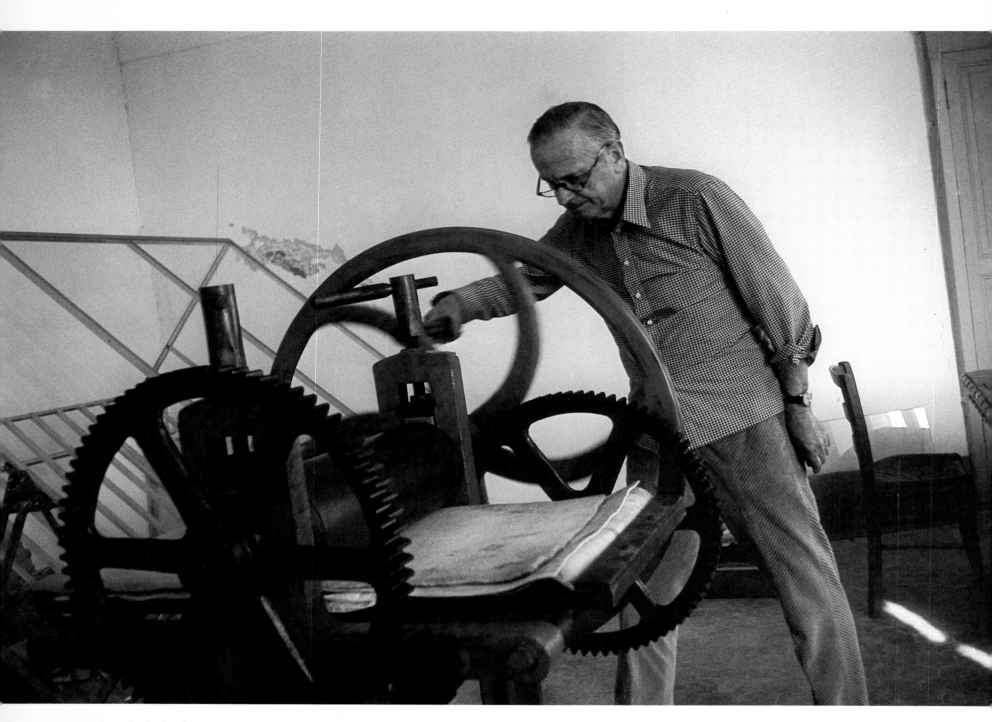

Graham Sutherland preparing his printing press

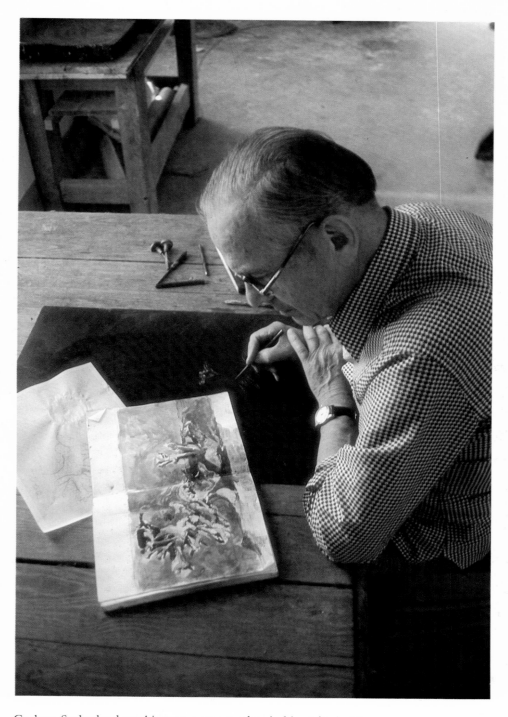

Graham Sutherland working on a copper plate in his *atelier* in Menton

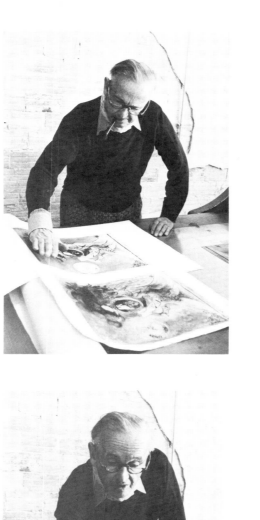
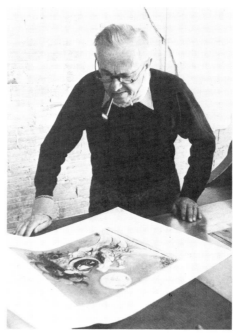
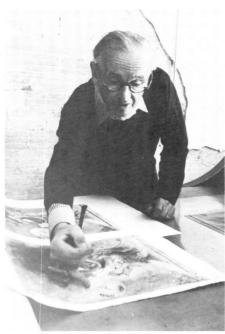
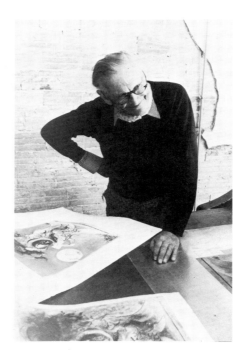

Graham Sutherland working on the *Bees* series

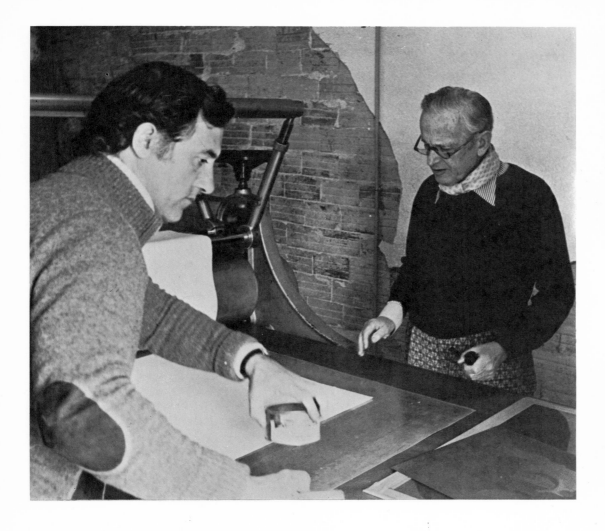

THE BEES
The edition of aquatints is limited to 100 copies
composed of:

Édition de Tête

14 copies numbered from I to XIV in Roman
numerals of which the Édition de Tête contains an
original work, signed and dated by the artist, and
14 aquatints signed and numbered by the artist.

Standard Edition

66 copies numbered from 1 to 66 in Arabic numerals
containing 12 aquatints signed and numbered by the
artist.

Hors Commerce

20 copies numbered HC1 to HC20 in Arabic numerals
as artist's proofs containing the 14 aquatints signed
and numbered by the artist.

All the aquatints were printed in the 2RC Studio in
Rome under the supervision of Eleonora and
Valter Rossi, who were also responsible for the design
and the binding of the portfolios.

The portfolios for the Édition de Tête are bound
in parchment, the portfolios for the Standard Edition
in Roma paper.
Each copy of the aquatints is embossed with a dry
stamp with the mark of the artist and the printer 2RC.

The aquatints were conceived and produced during
October 1976–May 1977.

Publisher: Marlborough Fine Art Ltd, London and
2RC Editrice, Rome.
Printer: Valter and Eleonora Rossi, Rome.

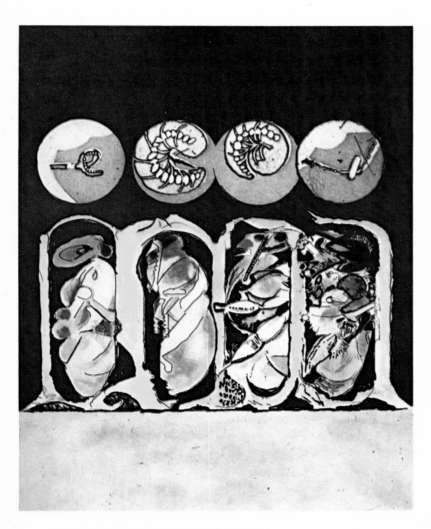

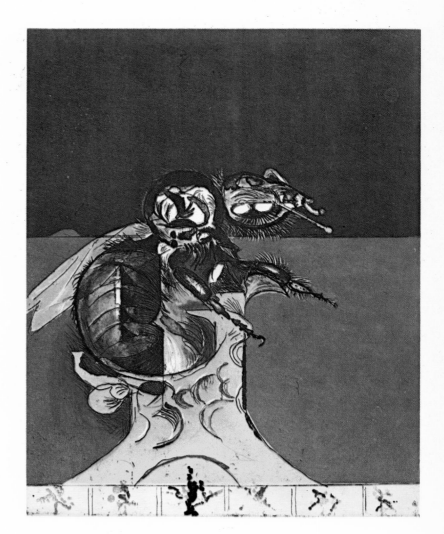

179 METAMORPHOSIS: EGG, LARVAE,
PUPAE
Bon à tirer 15 April 1977
Size: $22\frac{3}{4}'' \times 18''$; 56.5×45.6 cm
6 colours

180 HATCHING I
Bon à tirer 14 April 1977
3 colours

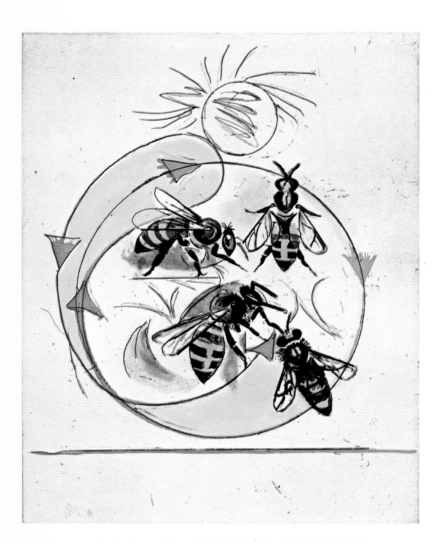

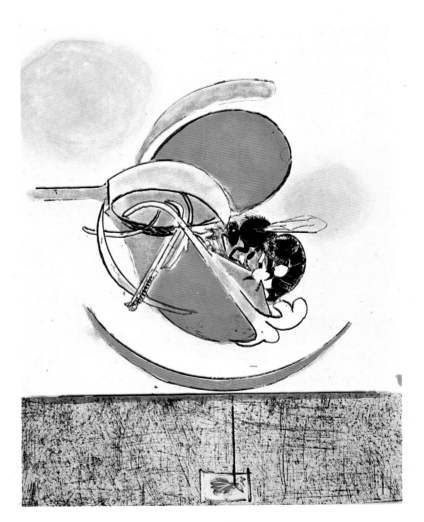

185 ROUND DANCE: ORIENTATION TO SOURCES OF
NECTAR AND POLLEN
Etching for the Édition de Tête
Bon à tirer 15 April 1977
5 colours

186 BEE AND FLOWER
Bon à tirer 26 February 1977
3 colours

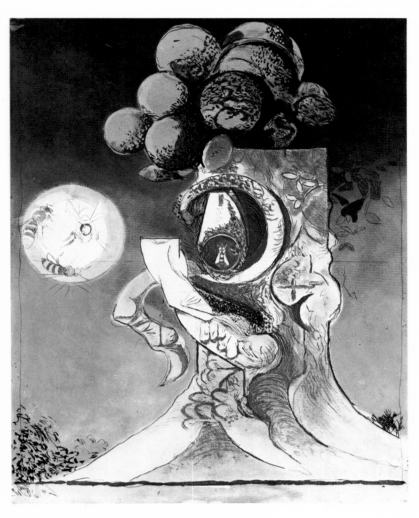

187 WILD NEST
Bon à tirer 25 February 1977
3 colours

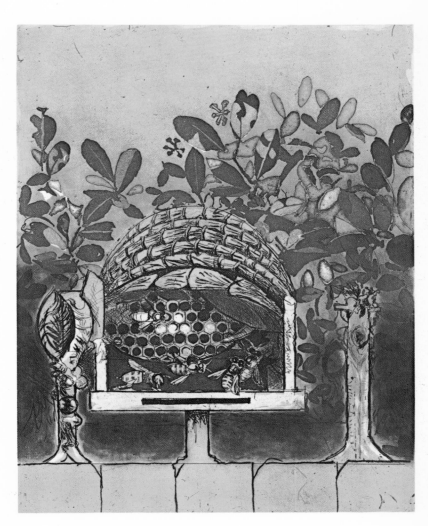

188 PRIMITIVE HIVE I (SKEP)
Bon à tirer 14 February 1977
3 colours

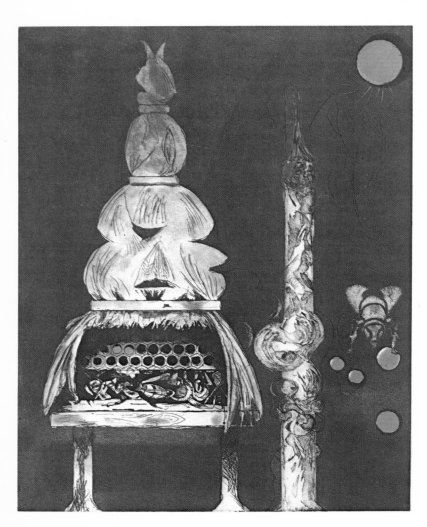

189 PRIMITIVE HIVE II
Etching for the Édition de Tête
Bon à tirer 15 April 1977
3 colours

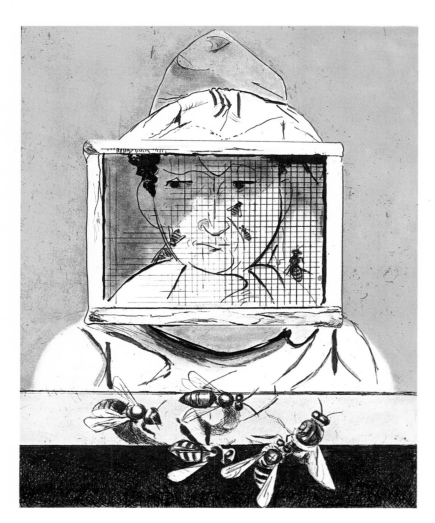

190 BEE KEEPER
Bon à tirer 27 February 1977
3 colours

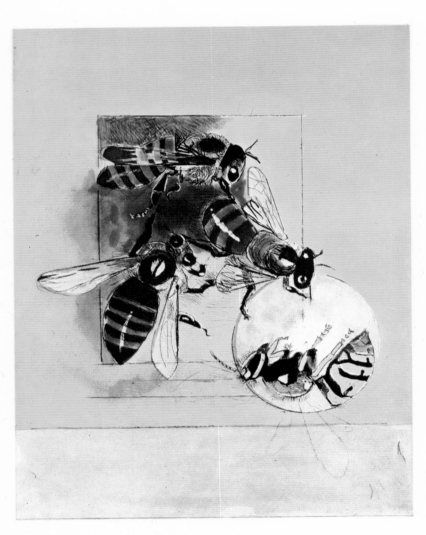

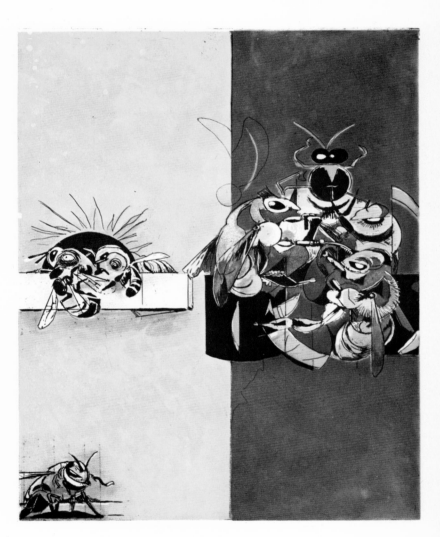

191 EXPULSION AND KILLING OF AN
ENEMY
Bon à tirer 10 December 1976
2 colours

192 FIGHT BETWEEN WORKERS AND
DRONES
Bon à tirer 2 March 1977
4 colours

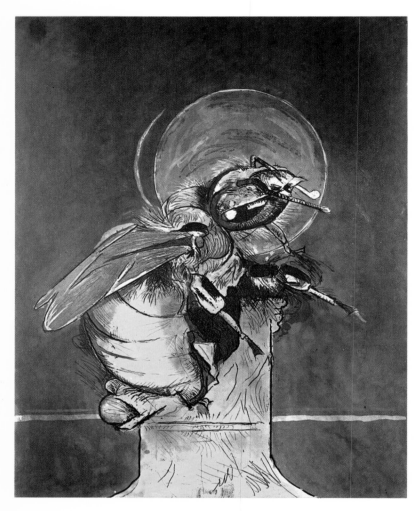

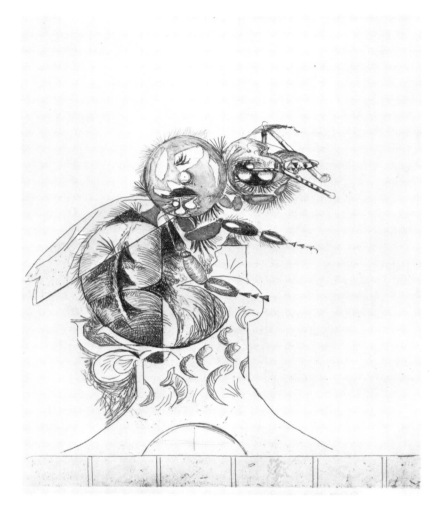

193 HATCHING II
Etching and aquatint, 1977
Size: 22¾″ × 18″; 56.5 × 45.6 cm
3 colours
Edition: 50 ex. numbered 1–50

194 HATCHING III
Etching, 1977
Size: 22¾″ × 18″; 56.5 × 45.6 cm
Black
Edition: 50 ex. numbered 1–50

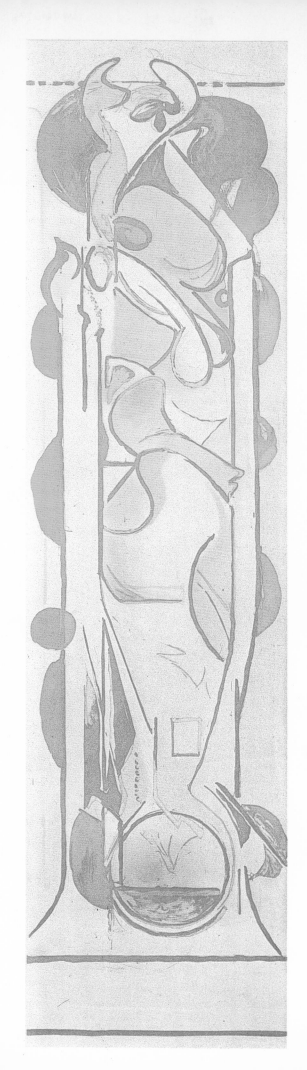

195 PUPAE I
Etching and aquatint, 1977
Size: 57″ × 15⅝″; 145 × 39 cm
Black
Yellow
Green
Edition: 75 ex., 25 for each colour, 1–25 black,
 26–50 green and 51–75 yellow
 15 artist's proofs, 5 for each colour
Publisher: Valter and Eleonora Rossi, Rome
Printer: Valter and Eleonora Rossi, Rome

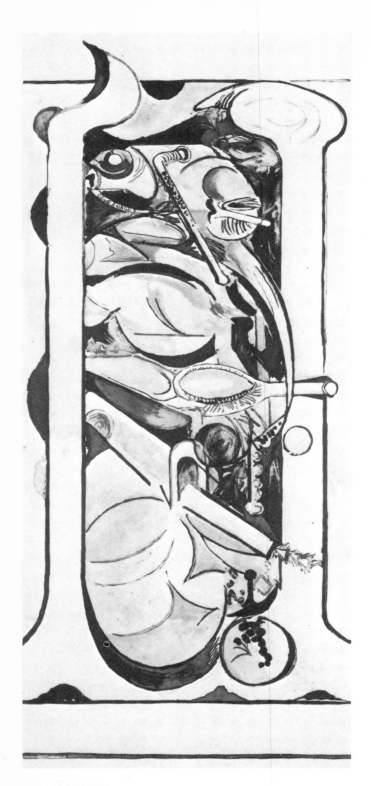

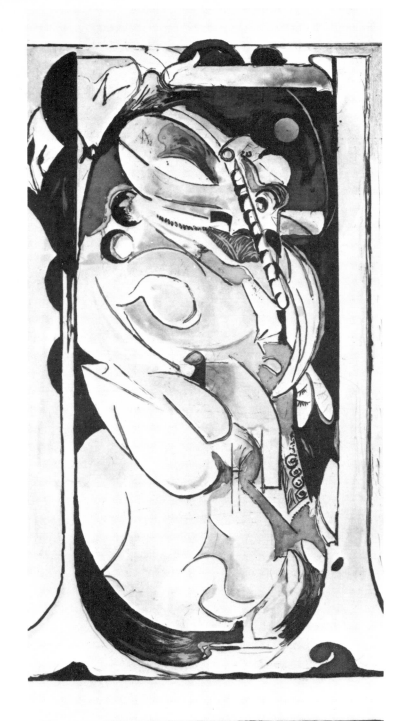

196 PUPAE II
Etching and aquatint, 1977
Size: 57″ × 24¾″; 145 × 63 cm
Black
Yellow
Green
Edition: 75 copies, 25 for each colour, 1–25 black,
 26–50 green and 51–75 yellow
 15 artist's proofs, 5 for each colour
Publisher: Valter and Eleonora Rossi, Rome
Printer: Valter and Eleonora Rossi, Rome

197 PUPAE III
Etching and aquatint, 1977
Size 57″ × 26″; 145 × 66 cm
Black
Yellow
Green
Edition: 75 copies, 25 for each colour, 1–25 black,
 26–50 green and 51–75 yellow
 15 artist's proofs, 5 for each colour
Publisher: Valter and Eleonora Rossi, Rome
Printer: Valter and Eleonora Rossi, Rome

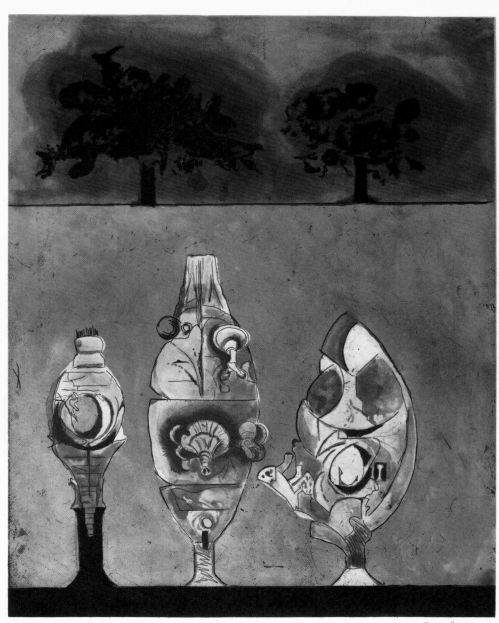

198 THREE STANDING FORMS;
Green ground
Etching and aquatint, 1978
Size: 28½″ × 20″; 77.5 × 50.8 cm
2 colours
Edition: 75 copies numbered 1–75
 10 copies HC marked I–X HC
 10 copies AP marked I–X AP
Publisher: Ediciones Polígrafa, S.A., Barcelona
Printer: Valter and Eleonora Rossi, Rome

Biography

1903 August 24. Graham Sutherland born in London. His father is a lawyer.

1903 The family lives at Merton Park, Surrey; then at Rustington in Sussex.

1912 The family moves to Sutton in Surrey.

1913 Spends his first holiday in Dorset and visits Swanage.

1914–18 Attends Epsom College.

1919–20 Serves as Privileged Apprentice, Locomotive Works, Midland Railway, Derby.

1921–26 Studies at University of London, Goldsmith's College School of Art.
Draws from nature in Kent and Sussex.
Studies engraving techniques under Stanley Anderson and Malcolm Osborne.
Friendship with F. L. Griggs.

1923 First etchings issued in small editions. *Barn Interior I* exhibited at the Royal Academy, where he exhibits annually until 1929.

1924 Works with Clive Gardiner on decorations for a pavilion at the Wembley International Exhibition.

1925 Finalist in engraving section for Prix de Rome (unsuccessful). Elected an Associate of the Royal Society of Painter-Etchers and Engravers. First one-man exhibition at the Twenty-one Gallery, London (drawings and engravings).

1926 Lives at Blackheath. Converted to Roman Catholic Church.

1927 Teaches at an art school in Kingston.
December 29: marries Kathleen Frances Barry; they move to Farningham in Kent.

1928 Second one-man exhibition at the Twenty-one Gallery (September).
Visits Dorset (summer).
Teaches engraving at the Chelsea School of Art (till 1932).

1929 Visits Dorset (June–July).

1930 Visits Dorset (spring) and Devonshire (summer).
Abandons engraving following the collapse of the market.

1931 Takes up painting. Visits Dorset (summer).
Moves to Eynsford in Kent.

1932–39 Concentrates on painting, but earns a living by teaching and by designing posters for Shell-Mex, the London Passenger Transport Board, the Post Office, etc. Also designs for china and fabrics.

1932 Visits Dorset (spring).
Appointed to teach Composition and Book Illustration at the Chelsea School of Art (till 1939).

1933 Visits Cornwall and Dorset (summer).
Expelled from the Royal Society of Painter-Etchers and Engravers.
Moves to Sutton-at-Hone in Kent.

1934 First visit to Pembrokeshire in Wales in summer leads to first creative paintings.

1935–39 Annual painting trips to Wales in vacations from teaching: these provide the subject-matter of all Sutherland's work. He visits St David's, Solva, Dale, Haverfordwest, Sandy Haven, and Crickhowell.
The English landscape period begins (1935–45).

1936 Rents a house at Trottiscliffe in Kent (spring).
Publishes 'A Trend in English Draughtsmanship' in *Signature* (July).

1937 Publishes 'An English Stone Landmark' (Brimham Rocks) in *The Painters Object*.

1938 First one-man exhibition of paintings at Rosenberg and Helft Gallery, London (September).

1939 Loses his teaching job at the Chelsea School of Art on the outbreak of war. Invited by Sir Kenneth Clark to move to Upton House, Tetbury, Gloucestershire, where he continues to paint. Does illustrations for *Henry VI, Part I* by Shakespeare (Limited Editions Club, New York, 1940).
Visits Wales at Christmas-time.

1940 Second exhibition of paintings at the Leicester Galleries, London (May). Appointed an Official War Artist (August). First commissions take him to airfields in Wiltshire, then to bomb-damaged Swansea.
Returns to Trottiscliffe (autumn).
Designs décor and costumes for *The Wanderer*, a ballet by Frederick Ashton, presented by the Sadler's Wells Company at the New Theatre, London, in January 1941.

1940–45 Employed as War Artist and has little time for painting on his own. Sent to armaments factories and bomb-damaged areas in London and the Midlands; to Wales (1941, 1942, 1943, 1944): to Cornwall (1942); to Derbyshire (1943); and to France (1944). Sutherland adopts a more factual idiom.

1942 'A Welsh Sketchbook' published in *Horizon* (April).

1943 Publication of *Graham Sutherland* by Edward Sackville-West (Penguin Modern Painters).

1944 Canon Walter Hussey commissions a *Crucifixion* for St Matthew's Church, Northampton (September).
A transitional phase begins in Sutherland's painting.
First visit to Paris, on return journey from Trappes and St Leu (autumn).

1945 Ceases to be a War Artist.
Buys The White House at Trottiscliffe.
At work on the *Crucifixion*. Series of *Thorn Trees* and *Thorn Heads* (1945–46).
Visits Wales (summer).

1946 First one-man exhibition in New York at the Buchholz Gallery run by Curt Valentin (February).
Short visit to Paris (summer).
Completes the *Crucifixion* (November).

1947 First visit to the south of France. Works at Villefranche (April–May, October–December).
Sees Picasso Museum at Antibes.
Meridional subjects: *Vine Pergolas, Palm Palisades, Cactus, Banana, Cigale*.
Meets Picasso and Matisse (November).

216

1948 Spends summer and autumn at Villefranche.
One-man exhibitions at the Hanover Gallery, London (June); also Buchholz Gallery, New York (November).
A new phase in his painting begins. He interests himself in Man, Nature and Machinery.

1949 Works at St Jean-Cap Ferrat (February–June, November–January 1950); paints the portrait of Somerset Maugham.
Designs a tapestry *Birds and Foliage* for the Edinburgh Tapestry Company. Appointed a Trustee of the Tate Gallery.
Phase of sculptural 'monuments and presences' begins (till 1957).

1950 The Arts Council commissions *The Origins of the Land* for the Festival of Britain (1951).
Works at Villefranche (August). First visit to Venice (September).

1951 Works at St Jean-Cap Ferrat (January), then in England on *The Origins of the Land* (February–March).
One-man exhibition at the Hanover Gallery, London (June).
Begins portrait of Lord Beaverbrook (May).
BBC broadcasts *Thoughts on Painting* (August).

1952 Winter at Villefranche. First sculpture experiments.
Visits Jersey (March) and Paris (June).
Visits Venice on the occasion of an exhibition of his works in the British Pavilion at the Biennale (June). Awarded the Acquisition Prize of the Museu de Arte Moderna, São Paulo.
An enlarged version of this retrospective exhibition is subsequently shown at the Musée d'Art Moderne, Paris (November).
Works at St Jean-Cap Ferrat (June–July).
Visits Paris (November).
Commissioned to design a large tapestry – *Christ in Glory in the Tetramorph* – for the new Coventry Cathedral.
BBC TV begins a film of Sutherland at work.

1953 Works at Pont St Jean (January–March).
Retrospective exhibitions at the Stedelijk Museum, Amsterdam (January), then at the Kunsthaus, Zürich (March).
One-man exhibition at the Curt Valentin Gallery, New York (March).
Retrospective exhibition at the Tate Gallery, London (May).
Begins portrait of Hon. E. Sackville-West (November).
His brushwork becomes finer.
Works on lithographs with Mourlot in Paris (October–November).

1954 Works at Roquebrune (January–April) and St Jean-Cap Ferrat (April–May).
Obliged to resign as a Trustee of the Tate Gallery (January).
Visits Venice (July–August).
Paints portrait of Sir Winston Churchill (August–November).
Retrospective exhibition at Akademie der bildenden Künste, Vienna, which goes on to Innsbruck, Berlin, Cologne, Stuttgart, Mannheim and Hamburg (1954–55).

1955 Works at Cap d'Ail (February–March) and St Jean-Cap Ferrat (June).
Buys a house at Menton (May; moves there in November).
Works in Venice (August).
Exhibits at the 3rd Biennale of the Museu de Arte Moderna in São Paulo (November).
Paints portrait of Paul Sacher in Basle (November).

1955–61 Predominantly occupied in painting portraits and supervising the design and execution of the Coventry tapestry.

1956 Works in Menton (January–April) and in Venice (June).
BBC TV shows a documentary film of Sutherland at work.
Visits Venice (September); in Menton (September–October).

1957 Commissioned by H.M. The Queen and Prince Philip to paint a composition symbolizing *The Common Interest of Portugal and England* for presentation to the President of Portugal on the occasion of their State visit.
Works in Venice (May–July): first Venetian subjects *The Church of the Salute* and *St Mark's Night*.
In Menton (July).
Completes design for the Coventry tapestry (September).
Exhibits at the Fourth International Art Exhibition in Japan (Tokyo, Osaka, Nagoya, Fukuoka) and receives the Prize of Foreign Minister.

1958 Works in Menton (March–May) and in Venice (May–June).
Weaving of Coventry tapestry begins at Felletin.
Goes to Donaueschingen to start portrait of Prince Fürstenberg (July).

1959 One-man exhibition in Frankfurt a.M. (January).
Designs ceramic table-tops.
Works in Menton (April–May, July–August, October–December).
In Venice (June).
One-man exhibition at the Paul Rosenberg Gallery, New York (November).

1960 Awarded the Order of Merit (April).
Works in Menton (April–May, July–August) and in Venice (June).
Commissioned to paint a *Noli Me Tangere* for the Chapel of St Mary Magdalen in Chichester Cathedral; also a *Crucifixion* for St Aidan's Church, Acton.

1961 Works in Menton (February–March, April–May) and in Venice (June–July).
Visits Felletin to work on Coventry tapestry.

1962 Receives honorary degrees (D. Litt.) from Oxford and Leicester Universities.
Visit to Felletin. The tapestry is flown to England and the consecration of Coventry Cathedral takes place on 25 May.

1963 Exhibition 'Graham Sutherland – Drawings of Wales', arranged by the Welsh Committee of the Arts Council.

1964 Visits New York.

1965 Finishes portrait of Dr Adenauer.
In Venice he discovers a studio on a dockyard and creates there the great *Interior*.
Retrospective exhibition at the Galleria Civica d'Arte Moderna, Turin.

1966 Retrospective exhibition at the Kunsthalle, Basle.
Studies for a lithograph cycle of 24 themes to be printed by Fernand Mourlot, Paris and edited by Marlborough Fine Art Ltd, London and entitled *Natural History* or *Correspondences*.

217

Exhibition of gouaches, water-colours, drawings and sculptures at Marlborough Fine Art Ltd, London.
Returns to his Venice studio and works at further versions of *Interior* of 1965.

1967 Begins lithographs for *Natural History*, later called *A Bestiary*.
Retrospective exhibition at the Haus der Kunst, Munich, subsequently shown at The Hague, Berlin and Cologne.
Pier Paolo Ruggerini initiates for Italian television the film *Graham Sutherland: lo specchio et il miraggio*, text by Douglas Cooper and Franco Russoli.
Visits Wales in connection with this film.

1968 Works in Wales (Pembrokeshire), Venice and Menton.
Publication of the series of 26 lithographs entitled *A Bestiary*.
Exhibition at the Marlborough Fine Art Gallery, London.
Begins (from 1968 onwards) visiting Milford Haven several times a year in connection with his work.

1968–69 Visits Wales in connection with the television film on his work directed by Pier Paolo Ruggerini.

1969 Presentation to the town of Menton, where he is a citizen of honour, of *A Bestiary*.

1970 Works on 12 water-colours for the Olivetti 1971 diary published with poems by Raffaele Carriari and photographs by Giorgio Soavi.
Exhibition of graphic work in Nuremberg.

1972 Queen Elizabeth orders a painting as a gift from England to President Pompidou of France.
Elected honorary member of the National Institute of Arts and Letters and the American Academy of Arts and Letters in New York.
Guest of honour of the IX Biennale internationale d'art, Menton, awarded first prize by the French President.
Exhibitions in Turin and Milan.

1973 Publication of *Graham Sutherland* by Francesco Arcangeli (Fratelli Fabbri, Milan).
Named Commandeur des Arts et des Lettres in France and Honorary Fellow of the Accademia di S. Luca in Rome.

1974 Publication of *Graham Sutherland Sketchbook*, a limited facsimile edition reproducing a selection of working drawings from his recent Welsh sketchbooks.
Appointed Honorary President of the Biennale internationale d'art, Menton. Awarded the Shakespeare Prize, Hamburg.

1975 Exhibition at the Lefevre Gallery, London.

1976 Exhibitions in Turin, Bologna, Florence and Acqui Terme.
Inauguration of the Graham Sutherland Foundation (Picton).

1977 Exhibition of the *Bees*, a series of aquatints, at the Marlborough Fine Art Gallery, London.
Exhibition, a retrospective selection of portraits at the National Portrait Gallery, London.
Film for BBC TV by John Ormond of Graham Sutherland in Wales.

Sources for further reference

Books

Arcangeli, Francesco, *Graham Sutherland*, Milan 1973

Busse, Jacques, 'Graham Vivian Sutherland,' in E. Bénézit, *Dictionaire . . . des Peintres, Sculpteurs, Dessinateurs et Graveurs*, Paris, 1955

Carrieri, R. and Soavi, G., *Graham Sutherland, dodici acquarelli*, Ivrea, 1971

Cooper, Douglas, *The Work of Graham Sutherland*, London, 1961

Cooper, D., Russoli, F. and Viale, V., *Sutherland*, Turin, 1965

Coulonges, H. and Rèvai, A., *Sutherland: Chefs d'oeuvres de l' Art*, Paris, 1968

Gascoyne, David, *Poems, 1937–42*, London, 1943, with drawings by Sutherland, including coloured dustwrapper

Janus, *Graham Sutherland,* Turin, 1973

Man, Felix H., *Graham Sutherland. Das Graphische Werk 1922–1970*, Munich, 1970

Marlborough Fine Art Ltd, *Graham Sutherland Sketchbook*. An anthology selected from four sketchbooks used between 1968 and 1972, facsimile edition, London, 1974

Melville, Robert, *Graham Sutherland*, London, 1950

Rèvai, Andrew, *Sutherland, Christ in Glory in the Tetramorph*, with text based on conversations with the artist and introduction by Eric Newton, London, 1964

Sackville-West, Edward, *Graham Sutherland*, London, 1943

Soavi, Giorgio, *Storia con Sutherland*, Milan, 1968

Soavi, Giorgio, *Protagonisti (Giacometti, Sutherland, de Chirico)*, Milan, 1969

Soavi, Giorgio, and Janus, *I luoghi di Graham Sutherland*, Turin, 1973

Catalogues

Twenty-one Gallery, *Catalogue of Etchings by Graham Sutherland*, London, 1928

Rosenberg and Helft Galleries, *Recent Works of Graham Sutherland*, London, 1938

Buchholz Gallery (Curt Valentin), *Graham Sutherland*, New York, 1946

Lefevre Galleries, *Preliminary Paintings for the Northampton Crucifixion by Graham Sutherland*, London, 1947

Hanover Gallery, *Paintings by Graham Sutherland*, London, 1948

Buchholz Gallery (Curt Valentin), *Graham Sutherland*, with introduction by R. Mortimer, New York, 1948

Institute of Contemporary Arts, *Graham Sutherland: A Retrospective Selection, 1938–51*, London, 1951

Hanover Gallery, *Recent Paintings – Graham Sutherland*, London, 1951

Biennale di Venezia, *Works by Sutherland*, Venice, 1952

Musée National d'Art Moderne, *Exposition Graham Sutherland*, with preface by H. Read, Paris, 1952

Curt Valentin Gallery, *Graham Sutherland*, with preface by H. Read, New York, 1953

Institute of Contemporary Art, Fiftieth birthday retrospective, Boston, 1953

Arts Council of Great Britain, *An Exhibition of Paintings and Drawings by Graham Sutherland*, London, 1953

Stedelijk Museum, *Graham Sutherland*, Amsterdam, 1953

Kunsthaus, *Graham Sutherland*, Zurich, 1953

Akademie der Bildenden Künste, *Graham Sutherland*, with preface by K. Clark, H. Read, and the artist, Vienna, 1954

Museu de Arte Moderna, *Obras de Sutherland*, with preface by H. Read, São Paulo, 1955

Frankfurter Kunstkabinett, *Graham Sutherland: Ölgemälde, Gouaches, Graphiken*, Frankfurt a/Main, 1957

Hoffman Galerie, *Graham Sutherland: Gemälde, Aquarelle, Graphiken*, Hamburg, 1957

Jeffress Gallery, *Graham Sutherland: A Collection 1939–58*, London, 1959

Paul Rosenberg & Co., *Recent Paintings by Graham Sutherland*, New York, 1959

Galleria Galatea, *Graham Sutherland*, Turin, 1961

Marlborough Fine Art Ltd, *Graham Sutherland – Recent Paintings*, London, 1962

Paul Rosenberg & Co., *Recent Paintings by Graham Sutherland*, with preface by D. Cooper, New York, 1964

Galleria Civica d'Arte Moderna, Sutherland retrospective, Turin, 1965

Kunsthalle, Sutherland retrospective, presentation by D. Cooper. Basle, 1966

Haus der Kunst (Munich); Gemeentemuseum (The Hague); Haus am Waldsee (Berlin); Wallraf-Richartz Museum (Cologne), *Graham Sutherland*, with foreword by D. Cooper, 1967

Marlborough Fine Art Ltd, *Graham Sutherland: A Bestiary and Correspondences*, London, 1968

Palais de l'Europe, Menton, *The Bestiary*, 1969

Albrecht Dürer Gesellschaft Kunsthalle, *Graham Sutherland: Graphiken*, Nuremberg, 1970

Galleria Il Fauno, *Graham Sutherland*, with preface by Janus, Turin, 1969

Marlborough Fine Art Ltd, *Moore – Picasso – Sutherland: Drawings, Watercolours, Gouaches*, with preface by Robert Melville, London, 1970

Galleria Il Fauno, *Graham Sutherland*, with preface by Janus, Turin, 1972

Galleria Narciso, Selected works, with preface by M. Pinottini, Turin, 1972

Galleria d'Arte Sant'Ambrogio, Selected works, with preface by M. Pinottini, Milan, 1972

Galleria Bergamini, *La Foresta, il Fiume et la Roccia*, with preface by Roberto Tassi, Milan, 1972

IXe Biennale de Menton, *Graham Sutherland, l'hôte d'honneur*, Menton, 1972

Marlborough Galerie A.G., *Graham Sutherland: Neue Werke*, with preface by D. Cooper, Zurich, 1972

Marlborough Fine Art Ltd, *Graham Sutherland: Recent Work*, with preface by D. Cooper, London, 1973

Galleria Bergamini, *Sutherland: Opere recenti*, with preface by F. Russoli, Milan, 1973

The Picton Castle Trust and the National Museum of Wales, *Sutherland in Wales*, a catalogue of the collection at the Graham Sutherland Gallery, Picton Castle, Haverfordwest, Dyfed, London, 1976

Marlborough Fine Art Ltd, London, in co-operation with 2 RC Editrice, Rome, 'Bees', 1977

Galleria 2 RC, '*Api*', Rome, Sept. 1977

Galleria 2 RC, '*Api*', Milan, Nov. 1977

Galleria Bergamini, *Api' e altre opere recenti*, Milan, Nov. 1977

Films

1945 *Out of Chaos*, produced by Two Cities, London

1956 *Graham Sutherland*, written and directed by John Read, BBC, London

1968 *Graham Sutherland*, directed by Margaret McCall, BBC, London

1969 *Graham Sutherland*, written and directed by Pier Paolo Ruggerini, RAI, Rome

1977 *Sutherland in Wales*, directed by John Ormond, BBC, Wales, also shown BBC, London

1977 *Graham Sutherland*, directed by Adriano Viale, privately made

Catalogue

Unnumbered catalogue entries refer to works that are not illustrated.

36 A–Z
Lithograph, 1936
Size: $10\frac{1}{4}'' \times 7\frac{1}{2}''$; 26 × 19 cm
Black, red
Publisher: Curwen Press, London
Printer: Curwen Press, London
Cover for Newsletter No. 12, The Curwen Press,
June 1936

11 ADAM AND EVE (THE EXPULSION
FROM EDEN)
Etching, 1924
Size: $8'' \times 6\frac{1}{8}''$; 20.3 × 15.7 cm
Black
Edition: 12
Publisher: Twenty-one Gallery, London
Printer: the artist
Test piece for the Prix de Rome Final

93 ANTS
Lithograph, 1968
Size: $25\frac{1}{4}'' \times 19\frac{5}{8}''$; 64 × 49.75 cm
2 colours
Edition: 70 and 10 artist's proofs
Publisher: Marlborough Fine Art Ltd, London
Printer: Fernand Mourlot, Paris

89 ARMADILLO
Lithograph, 1968
Size: $25\frac{1}{2}'' \times 19\frac{7}{8}''$; 65 × 50.5 cm
5 colours
Edition: 70 and 10 artist's proofs
Publisher: Marlborough Fine Art Ltd, London
Printer: Fernand Mourlot, Paris

54 ARTICULATED FORMS (pink back-
ground). Forms on a terrace
Lithograph, 1950
Size: $11\frac{7}{8}'' \times 23''$; 30 × 52.25 cm
5 colours
Edition: 60, signed and numbered by the artist,
and 6 artist's proofs
Publisher: Redfern Gallery, London
Printer: Curwen Press, London

1b ARUNDEL
Drypoint, 1922
Size: $1\frac{5}{8}'' \times 3\frac{3}{4}''$; 4.25 × 9.4 cm
Black
Edition: no edition printed
Printer: the artist

130 BALANCING FORM
Lithograph, 1972
Size: $13\frac{3}{8}'' \times 16\frac{1}{8}''$; 34 × 41 cm
4 colours
Edition: 90 ex. numbered 1 to 90
Publisher: XXe Siècle, Paris
Printer: Fernand Mourlot, Paris

BARN INTERIOR I
Etching, 1923
Size: $6\frac{3}{4}'' \times 5\frac{3}{4}''$; 17 × 14.5 cm
Black
Edition: 20
Publisher: Twenty-one Gallery, London
Printer: the artist

4 BARN INTERIOR II
Drypoint, 1923

Size: $6'' \times 7\frac{7}{8}''$; 15.3 × 20.1 cm
Black
Edition: 10 State I
 15 State II
Publisher: Twenty-one Gallery, London
Printer: the artist

16 BARROW HEDGES FARM
Etching, 1924
Size: $3\frac{1}{8}'' \times 4\frac{1}{8}''$; 8 × 10.5 cm
Black
Edition: 46, some artist's proofs not included
Publisher: Twenty-one Gallery, London
Printer: the artist

186 BEE AND FLOWER
Bon à tirer 26 February 1977
3 colours

190 BEE KEEPER
Bon à tirer 27 February 1977
3 colours

70 BEES
Lithograph, 1963
Size: $25\frac{5}{8}'' \times 19\frac{7}{8}''$; 65 × 50.5 cm
6 colours
Edition: Ed. A: 35 ex. on Japan paper
 numbered I–XXXV
 Ed. B: 65 ex. on Arches 1–63, in
 addition 13 prints marked HC as artist's
 proofs
Publisher: Galerie Wolfgang Ketterer, Munich,
 published in *Europäische Graphik I*,
 edited by Felix H. Man
Printer: Emil Matthieu, Zurich

BEETLE WITH ELECTRIC LAMP
Photolitho, 1969
Size: $25\frac{1}{2}'' \times 19\frac{5}{8}''$; 65 × 50 cm
4 colours
Edition: 300 ex. numbered and 25 artist's proofs
Publisher: Biennale international d'art de Menton
Printer: Ateliers des Impressions Artistiques, Nice

82 BEETLES I
Lithograph, 1967
Size: $19\frac{7}{8}'' \times 26\frac{1}{8}''$; 50.0 × 66.5 cm
5 colours
Edition: 70 and 10 artist's proofs
Publisher: Marlborough Fine Art Ltd, London
Printer: Fernand Mourlot, Paris

83 BEETLES II (with electric lamp)
Lithograph, 1968
Size: $25\frac{1}{2}'' \times 19\frac{7}{8}''$; 65 × 50.5 cm
4 colours
Edition: 70 and 10 artist's proofs
Publisher: Marlborough Fine Art Ltd, London
Printer: Fernand Mourlot, Paris

BESTIARY, *see* FRONTISPIECE TO A
BESTIARY

59 BIRD
Lithograph, 1953
Size: $17'' \times 17\frac{3}{8}''$; 43 × 44 cm
3 colours
Edition: 60 signed and numbered by the artist,
 and 6 artist's proofs

Publisher: Curt Valentin, New York
Printer: Fernand Mourlot, Paris

117 BIRD
Silk-screen, 1971
5 colours
Edition: unknown
Made for the Amis des Musées de Menton
(Designed but not printed by Graham
Sutherland)

95 BIRD ABOUT TO TAKE FLIGHT
Lithograph, 1968
Size: $25\frac{3}{4}'' \times 19\frac{5}{8}''$; 65.5 × 50 cm
5 colours
Edition: 70 and 10 artist's proofs
Publisher: Marlborough Fine Art Ltd, London
Printer: Fernand Mourlot, Paris

92 BIRD AND MOUSE
Lithograph, 1968
Size: $26'' \times 20''$; 66 × 51 cm
5 colours
Edition: 70 and 10 artist's proofs
Printer: Fernand Mourlot, Paris

145 BIRD AND SPLIT ROCK
Aquatint, 1974
Size: $42\frac{7}{8}'' \times 45\frac{5}{8}''$; 109 × 116 cm
3 colours
Edition: 95
Publisher: Valter and Eleonora Rossi, Rome
Printer: Valter and Eleonora Rossi, Rome

104 BIRD FORM (full face)
Lithograph, 1968
Size: $23'' \times 12\frac{3}{4}''$; 58.5 × 32.5 cm
2 colours
Edition: 70 and 10 artist's proofs
Publisher: Marlborough Fine Art Ltd, London
Printer: Fernand Mourlot, Paris

8 THE BLACK RABBIT
Etching, 1923
Size: $7\frac{5}{8}'' \times 8\frac{3}{4}''$; 19.2 × 21.3 cm
Black
Edition: 10 State I (reproduced)
 26 State II
 artist's proofs included
Publisher: Twenty-one Gallery, London
Printer: the artist

159 THE BREACH
Lithograph, 1975
Size: $25\frac{5}{8}'' \times 19\frac{3}{4}''$; 65 × 50 cm
6 colours
Edition: 75 ex. numbered 1–75
 15 artist's proofs
Publisher: Spirale, Milan
Printer: Fernand Mourlot, Paris

17 CAIN AND ABEL
Etching, 1924
Size: $7'' \times 7\frac{1}{2}''$; 17.9 × 19.2 cm
Black
Edition: 12
Publisher: Twenty-one Gallery, London
Printer: the artist

160　THE CATHEDRAL I
Lithograph, 1974
Size: $12\frac{1}{4}'' \times 9\frac{1}{4}''$; 31×23.5 cm
5 colours
Edition: 50 ex. numbered 1–50
　　620 ex. book-plates (hors-texte) for
　　Hommage à San Lazzaro 200 suite
Publisher: XXe Siècle, Paris
Printer: Fernand Mourlot, Paris

161　THE CATHEDRAL II
Lithograph, 1975
Size: $16\frac{3}{8}'' \times 13\frac{1}{2}''$; 41.5×34.5 cm
with designs in border
5 colours
Edition: some artist's proofs
Publisher: not yet published
Printer: Fernand Mourlot, Paris

108　CHAINED BEAST
Lithograph, 1967
Size: $26'' \times 20''$; 66×51 cm
3 colours
Edition: 70 and 10 artist's proofs
Publisher: Marlborough Fine Art Ltd, London
Printer: Fernand Mourlot, Paris

96　CHAUVE SOURIS (interior)
Lithograph, 1967
Size: $25\frac{1}{4}'' \times 19\frac{1}{4}''$; 64×49 cm
4 colours
Edition: 70 and 10 artist's proofs
Publisher: Marlborough Fine Art Ltd, London
Printer: Fernand Mourlot, Paris

97　CHAUVE-SOURIS IN A LOOKING-
GLASS AGAINST A WINDOW
Lithograph, 1968
Size: $25\frac{5}{8}'' \times 19\frac{7}{8}''$; 65×50.5 cm
3 colours
Edition: 70 and 10 artist's proofs
Publisher: Marlborough Fine Art Ltd, London
Printer: Fernand Mourlot, Paris

33　CLEGYR-BOIA I (Landscape in Wales)
Etching and aquatint, 1936
Size: $7\frac{7}{8}'' \times 5\frac{7}{8}''$; 20×14.9 cm
Black
Edition: *c.* 1000 and a few artist's proofs
Publisher: Curwen Press in Signature
No. 9, 1938
Printer: Walsh, London

34　CLEGYR-BOIA II (Landscape in Wales)
Etching and aquatint, 1936
Size: $8\frac{1}{4}'' \times 5\frac{7}{8}''$; 20×14.9 cm
Black
Edition: no edition printed. One proof exists in
　　the collection of Mrs Sue Simon
Printer: Walsh, London

154　COMPLEX OF ROCKS
Lithograph, 1973
Size: $12'' \times 10''$; 30.7×25.5 cm
4 colours
Edition: 50 ex. numbered 1–50
Publisher: Fratelli Fabbri, Milan, for the Italian
　　Édition de Tête of *Graham Sutherland*
　　by Francesco Arcangeli
Printer: Valter and Eleonora Rossi, Rome

113　CONGLOMERATE
Lithograph, 1970
Size: $28'' \times 15\frac{3}{4}''$; 71.5×50.7 cm
6 colours
Edition: 75 and 15 artist's proofs
Publisher: Spirale, Milan
Printer: Spirale, Milan

28　COTTAGE IN DORSET, 'WOOD END'
Etching, 1929
Size: $5\frac{5}{8}'' \times 7''$; 14.3×18 cm
Black
Edition: 60
Publisher: the artist in 1930
Printer: the artist

2　COURSING (Greyhounds)
Drypoint, 1922
Size: $5\frac{3}{8}'' \times 9\frac{1}{2}''$; 13.6×24 cm
Black
Edition: 3 trial proofs only
Printer: the artist

183　THE COURT
Bon à tirer 10 December 1976
5 colours

18　CRAY FIELDS I (1st state)
Etching, 1925
Size: $4\frac{3}{4}'' \times 4\frac{7}{8}''$; 12×12.5 cm
Black

19　CRAY FIELDS VI
Etching, 1925
Size: $4\frac{3}{4}'' \times 4\frac{7}{8}''$; 12×12.5 cm
Black
Edition:　3 State I
　　　　 2 State II
　　　　 2 State III
　　　　 2 State IV
　　　　 2 State V
　　　 85 State VI (reproduced)
　　 including some artist's proofs
Publisher: Twenty-one Gallery, London
Printer: the artist

15　CUDHAM, KENT
Etching, 1924
Size: $3\frac{1}{4}'' \times 4''$; 8×10 cm
Black
Edition: 42 including some artist's proofs
Publisher: Twenty-one Gallery, London
Printer: the artist

94　CYNOCEPHALUS
Lithograph, 1968
Size: $26'' \times 19\frac{5}{8}''$; 66×50 cm
6 colours
Edition: 70 and 10 artist's proofs
Publisher: Marlborough Fine Art Ltd, London
Printer: Fernand Mourlot, Paris

143　THE DIVER
Etching and aquatint, 1973
Size: $15\frac{1}{8}'' \times 12\frac{1}{8}''$; 38.5×31 cm
Black
Edition: 95
Publisher: Valter and Eleonora Rossi, Rome
Printer: Valter and Eleonora Rossi, Rome

164　THE EGG
Lithograph, 1975
Size: $25\frac{5}{8}'' \times 19\frac{3}{4}''$; 65×50 cm
6 colours
Edition: 75 ex. numbered 1–75
　　15 ex. HC numbered I–XV
　　Series A–Z on Japan paper
Publisher: Teodorani, Milan
Printer: Teodorani, Milan

ELIOT, T.S., *see* ILLUSTRATION FOR
T.S. ELIOT

103　EMERGING INSECT
Lithograph, 1968
Size: $26'' \times 19\frac{1}{2}''$; 66×49.5 cm
6 colours
Edition: 70 and 10 artist's proofs
Publisher: Marlborough Fine Art Ltd, London
Printer: Fernand Mourlot, Paris

191　EXPULSION AND KILLING OF AN
ENEMY
Bon à tirer 10 December 1976
2 colours

FETCHING WATER
Etching, 1923
Size: $4'' \times 3''$; 10×7.4 cm
Black
Edition: 10
Publisher: Twenty-one Gallery, London
Printer: the artist

142　FIELD OF ROCKS, WITH A CANDLE
(CAMPO DI ROCCE)
Etching and aquatint, 1974
Size: $16\frac{1}{8}'' \times 12\frac{3}{4}''$; 41×32.5 cm
Black
Edition: 50
Publisher: XII Campiello Prize, Venice
Printer: Valter and Eleonora Rossi, Rome

192　FIGHT BETWEEN WORKERS AND
DRONES
Bon à tirer 2 March 1977
4 colours

184　FIGURE OF EIGHT DANCE:
ORIENTATION TO SOURCES OF NECTAR
AND POLLEN
Bon à tirer 15 April 1977
3 colours

162　FIREBIRD I
Lithograph, 1975
Size: $25\frac{5}{8}'' \times 19\frac{3}{4}''$; 65×50 cm
6 colours
Edition: 75 ex. numbered 1–75
　　15 ex. HC numbered I–XV
　　Series A–Z on Japan paper
Publisher: Teodorani, Milan
Printer: Teodorani, Milan

163　FIREBIRD II
Lithograph, 1975
Size: $25\frac{5}{8}'' \times 19\frac{3}{4}''$; 65×50 cm
6 colours
Edition: 75 ex. numbered 1–75
　　15 ex. HC numbered I–XV

Lithograph, 1973–74
Size: $26\frac{1}{2}'' \times 18\frac{7}{8}''$; 67.5×48 cm
5 colours
Edition: 75 ex. numbered 1–75
　　　　15 ex. HC numbered I–XV
　　　　Series A–Z on Japan paper
Publisher: Teodorani, Milan
Printer: Fernand Mourlot, Paris

148　For 3 LITHOGRAPHS
ROSES
Lithograph, 1973–74
Size: $26\frac{1}{8}'' \times 18\frac{1}{2}''$; 66.5×47 cm
6 colours
Edition: 75 ex. numbered 1–75
　　　　15 ex. HC numbered I–XV
　　　　Series A–Z on Japan paper
Publisher: Teodorani, Milan
Printer: Fernand Mourlot, Paris

147　For 3 LITHOGRAPHS
THE SWIMMER
Lithograph, 1973–74
Size: $26\frac{1}{2}'' \times 18\frac{3}{4}''$; 67.5×47.5 cm
5 colours
Edition: 75 ex. numbered 1–75
　　　　15 ex. HC numbered I–XV
　　　　Series A–Z on Japan paper
Publisher: Teodorani, Milan
Printer: Fernand Mourlot, Paris

LITTLEHAMPTON I (Boat Building)
Etching, 1922
Size: $8'' \times 8\frac{1}{4}''$; 20.3×21 cm
Black
Edition: 6
Publisher: Twenty-one Gallery, London
Printer: the artist

6　LITTLEHAMPTON II
Drypoint, 1923
Size: $2\frac{7}{8}'' \times 3''$; 7.2×7.4 cm
Black
Edition: 6
Publisher: Twenty-one Gallery, London
Printer: the artist

49　MAIZE
Lithograph, 1948
Size: $15'' \times 21\frac{1}{2}''$; 38×54.5 cm
4 colours
Edition: 60 plus a few artist's proofs
Publisher: Redfern Gallery, London
Printer: Ravel, Paris

140　MAN SMOKING
Etching and aquatint, 1973
Size: $10'' \times 8''$; 25.5×20.5 cm
Black
Edition: 50
Publisher: Valter and Eleonora Rossi, Rome
Printer: Valter and Eleonora Rossi, Rome

24　MAY GREEN
Etching, 1927
Size: $4\frac{1}{2}'' \times 6\frac{3}{8}''$; 11.3×16.1 cm
Black
Edition:　9 State I
　　　　17 State II

　　　　25 State III
　　　　18 State IV
　　　　23 States V/VI
　　　　including artist's proofs
Publisher: Twenty-one Gallery, London
Printer: the artist

26　THE MEADOW CHAPEL
Etching, 1928
Size: $4\frac{1}{2}'' \times 6''$; 11.4×15.4 cm
Black
Edition:　1 State I
　　　　3 State II
　　　　2 State III
　　　　1 State IV
　　　　5 State V
　　　　2 State VI
　　　　1 State VII
　　　　2 States VIII/IX/X/XI
　　　　83 State XII (published and reproduced)
Publisher: Twenty-one Gallery, London
Printer: the artist

179　METAMORPHOSIS: EGG, LARVAE,
PUPAE
Bon à tirer 15 April 1977
Size: $22\frac{3}{4}'' \times 18''$; 56.5×45.6 cm
6 colours

25　MICHAELMAS
Etching, 1928
Size: $3\frac{3}{8}'' \times 2\frac{7}{8}''$; 8.75×7.1 cm
Black
Edition:　2 State I
　　　　2 State II
　　　109 State III (reproduced)
Publisher: Twenty-one Gallery, London
Printer: Stanley Wilson
Print made for the Print Collectors' Club

165　LA MUSIQUE
Lithograph, 1976
Size: $11'' \times 10''$; 28×25.5 cm
Black
Edition: 50 ex. for the English Édition de Tête of
　　　　Graham Sutherland by Francesco
　　　　Arcangeli
Publisher: Fratelli Fabbri, Milan
Printer: Teodorani, Milan

14　NUMBER FORTY-NINE (No. 49)
Etching, 1924
Size: $6\frac{7}{8}'' \times 9\frac{3}{4}''$; 18×25.2 cm
Black
Edition: 15 State I
　　　　5 State II
　　　　60 State III
　　　　some artist's proofs included (I and III)
Publisher: Twenty-one Gallery, London
Printer: the artist

182　NUPTIAL FLIGHT. THE DISPATCH
OF A QUEEN BY POST
Bon à tirer 14 February 1977
6 colours

167　THE OAK TREE I
Lithograph, 1975
Size: $12'' \times 8''$; 30.5×25.5 cm
2 colours

Edition: artist's proofs only
Essay for the frontispiece of the Édition de Tête
of *Graham Sutherland*, published by Fratelli Fabbri
Printer: Teodorani, Milan

166　THE OAK TREE II
Lithograph, 1975
Size: $12'' \times 8''$; 30.5×25.5 cm
Black
Edition: artist's proofs only
Essay for the frontispiece of the Édition de Tête
of *Graham Sutherland*, published by Fratelli Fabbri
Printer: Teodorani, Milan

32　OAST HOUSE
Etching, 1932
Size: $6\frac{3}{4}'' \times 10\frac{3}{8}''$; 17.3×26.4 cm
Black
Edition: no edition printed, only trial proofs
Printer: the artist

111　OBJECT ON AN ESTUARY SHORE
Lithograph, 1970
Size: $10\frac{1}{4}'' \times 7\frac{7}{8}''$; 26×20 cm
3 colours
Edition: 100 Rives, 35 Japan, in addition 15
　　　　artist's proofs and 18 HC
Published in the 65 copies of the limited edition
of *Graham Sutherland*, *Das Graphische Werk* by Felix
H. Man
Publisher: Galerie Wolfgang Ketterer, Munich
Printer: Fernand Mourlot, Paris

79　ORGANIC FORM
Lithograph, 1967
Size: $4\frac{7}{8}'' \times 3\frac{5}{8}''$; 12.3×9.2 cm
Black
Edition: 25 and 25 artist's proofs
Publisher: Scheiwiller, Milan
Printer: Upiglio, Milan

102　OWL (rose ground)
Lithograph, 1968
Size: $26\frac{1}{8}'' \times 19\frac{7}{8}''$; 66.5×50 cm
5 colours
Edition: 70 and 10 artist's proofs
Publisher: Marlborough Fine Art Ltd, London
Printer: Fernand Mourlot, Paris

30　PASTORAL
Etching and engraving, 1930
Size: $5\frac{1}{8}'' \times 7\frac{5}{8}''$; 13×19.5 cm
Black
Edition: trial proofs only, new prints in 1973
Printer: the artist

21　PECKEN WOOD
Etching, 1925
Size: $5\frac{3}{8}'' \times 7\frac{3}{8}''$; 13.5×18.9 cm
Black
Edition:　1 State I
　　　　2 State II
　　　　85 States III, IV, V
　　　　including some artist's proofs
Publishers: Twenty-one Gallery, London
Printer: the artist

56　LA PETITE AFRIQUE
Lithograph, 1953

Size: $22\frac{5}{8}'' \times 17\frac{3}{8}''$; 57.5×44 cm
Black
Edition: 25 and 4 artist's proofs marked in the
 stone: J 23-6-53, printed on large Japan,
 signed
Publisher: Redfern Gallery, London
Printer: Curwen Press, London

12 THE PHILOSOPHERS
Etching, 1924
Size: $5\frac{3}{4}'' \times 7\frac{3}{4}''$; 14.7×19.7 cm
Black
Edition: 3
Publisher: Twenty-one Gallery, London
Printer: the artist
Test piece for the Prix de Rome

135 PICTON
Etching, 1973
Size: $18\frac{1}{2}'' \times 13\frac{3}{8}''$; 47×34 cm
Black
Edition: 75 ex. numbered 1–75
 15 ex. HC numbered I–XV
 Series A–Z on Japan paper
Publisher: Teodorani, Milan
Printer: Il Cigno, Rome
for *Due Acquaforti*

110 PINK MONKEY
Lithograph, 1968
Size: $26'' \times 19\frac{5}{8}''$; 66×50 cm
3 colours
Edition: 1 or 2 prints exist
Printer: Fernand Mourlot, Paris

155 POISED FORM
Lithograph, 1972–73
4 colours
Edition: trial proofs only

13 POLING POTTERIES
Etching, 1924
Size: $4\frac{1}{2}'' \times 5\frac{1}{2}''$; 11.5×14 cm
Black
Edition: 19 including artist's proofs
Publisher: Twenty-one Gallery, London
Printer: the artist

PORTRAIT OF DR KONRAD ADENAUER
Second plate
Drypoint, 1965
Size: $11\frac{7}{8}'' \times 10''$; 30.2×25.3 cm
Edition: only a few prints exist, also the plate
Not published

72 PORTRAIT OF DR KONRAD
ADENAUER
Drypoint, 1965
Size: $11\frac{7}{8}'' \times 10''$; 30.2×25.3 cm
Edition: only a few prints exist, also the plate

73 PORTRAIT OF DR KONRAD
ADENAUER
Lithograph, 1965
Size: $22\frac{7}{8}'' \times 15\frac{3}{8}''$; 58×39 cm
Black
Edition: 50 (?)
Publisher: Fischer Fine Art Ltd, London
Printer: J. Wolfensberger, Zurich

61 PORTRAIT OF SOMERSET MAUGHAM I
Lithograph, 1953
Size: $9\frac{1}{8}'' \times 6\frac{3}{8}''$; 23.3×16.3 cm
Black chalk
Edition: trial proofs only
Printer: Curwen Studio, London

60 PORTRAIT OF SOMERSET MAUGHAM II
Lithograph, 1953
Size: $9\frac{1}{8}'' \times 13\frac{1}{2}''$; 23.3×34.2 cm
Edition: State I, two proofs on the same sheet,
 No. 1 has been retouched by the artist
 in black chalk
Printer: Curwen Press, London

62 PORTRAIT OF SOMERSET MAUGHAM III
Lithograph, 1953
Size: $8\frac{7}{8}'' \times 5\frac{5}{8}''$; 22.5×14.7 cm
Edition: Final State 1021 for the limited edition
 of *Cakes and Ale* and 20 artist's proofs
 on Japan paper
Publisher: W. Heinemann Ltd, London
Printer: Curwen Press, London

67 PORTRAIT OF HELENA RUBINSTEIN I
Lithograph, 1960
Size: $11\frac{3}{4}'' \times 10\frac{7}{8}''$; 31×27.6 cm
Litho ink and chalk on transfer paper intended to
be laid down on stone
Edition: trial proofs only
Printer: Curwen Studio, London

68 PORTRAIT OF HELENA RUBINSTEIN II
Lithograph, 1960
Size: $8\frac{7}{8}'' \times 9\frac{7}{8}''$; 22.4×25 cm
Black
Edition: trial proofs only
Printer: Curwen Studio, London

PORTRAIT OF HELENA RUBINSTEIN III
Lithograph, 1960
Size: $7\frac{5}{8}'' \times 10''$; 19.5×25.4 cm
Litho ink and chalk on transfer paper intended to
be laid down on stone
Edition: trial proofs only
Printer: Curwen Studio, London

141 PORTRAIT OF ALOYS SENEFELDER
Lithograph, 1971
Size: $25\frac{1}{2}'' \times 19\frac{1}{4}''$; 65.7×49.2 cm
9 colours
Edition: 65 on Arches plus 18 artist's proofs, 35
 on Japan paper plus 12 artist's proofs (a
 proof is reproduced)
Publisher: Galerie Wolfgang Ketterer, Munich,
 published in *Europäische Graphik VIII,*
 edited by Felix H. Man
Printer: Curwen Studio, London

57 PREDATORY FORM
Lithograph, 1953
Size: $29\frac{3}{4}'' \times 21\frac{1}{4}''$; 75.5×54 cm
2 colours
Edition: 75 signed and numbered
Publisher: Redfern Gallery, London
Printer: Fernand Mourlot, Paris

188 PRIMITIVE HIVE I (SKEP)
Bon à tirer 14 February 1977
3 colours

189 PRIMITIVE HIVE II
Etching for the Édition de Tête
Bon à tirer 15 April 1977
3 colours

85 RAM'S HEAD (full face)
Lithograph, 1968
Size: $26'' \times 19\frac{5}{8}''$; 66.25×50 cm
2 colours
Edition: 70 and 10 artist's proofs
Publisher: Marlborough Fine Art Ltd, London
Printer: Fernand Mourlot, Paris

86 RAM'S HEAD (facing left)
Lithograph, 1968
Size: $15\frac{3}{8}'' \times 13\frac{1}{2}''$; 39×34.25 cm
2 colours
Edition: a few trial proofs only

87 RAM'S HEAD (facing left)
Lithograph, 1968
Size: $17'' \times 15\frac{3}{8}''$; 43×39 cm
2 colours
Edition: 70 and 10 artist's proofs
Publisher: Marlborough Fine Art Ltd, London
Printer: Fernand Mourlot, Paris

88 RAM'S HEAD (with rocks and skeletons)
Lithograph, 1968
Size: $25\frac{3}{4}'' \times 19\frac{3}{4}''$; 65.5×50 cm
3 colours
Edition: 70 and 10 artist's proofs
Publisher: Marlborough Fine Art Ltd, London
Printer: Fernand Mourlot, Paris

LA ROCCIA (THE ROCK)
Lithograph, 1972
Size: $6\frac{1}{4}'' \times 7''$; 16×18 cm
Black
Edition: no edition
 10 signed copies given to Teodorani and
 collaborators at the publication of *La
 Foresta, Il Fiume, La Roccia*
Printer: Teodorani, Milan

THE ROCK, *see* 3 LITHOGRAPHS

THE ROCK
Lithograph, 1972
Size: $29\frac{3}{4}'' \times 22''$ on Arches; 75.5×56 cm
 $29\frac{1}{2}'' \times 21''$ on Japan paper; 75×53.5 cm
4 colours
Edition: 225 ex. on Arches
 75 ex. on Japan paper
Publisher: Biennale internationale d'art de
 Menton
Printer: Fernand Mourlot, Paris

112 ROCK FORM
Lithograph, 1970
Size: $10\frac{1}{4}'' \times 7\frac{7}{8}''$; 26×20 cm
3 colours
Edition: 100 Rives, 35 Japan, in addition 15
 artist's proofs and 18 HC
Published in the 65 copies of the limited edition
of *Graham Sutherland, Das Graphische Werk* by Felix
H. Man
Publisher: Galerie Wolfgang Ketterer, Munich
Printer: Fernand Mourlot, Paris

ROSES, *see* 3 LITHOGRAPHS

74 ROSES
Lithograph, 1966
Size: 25¾″ × 19″; 65.5 × 48.5 cm
4 colours
Edition: 50 and 15 artist's proofs, signed
Publisher: Olivetti S. A., Italy
Printer: Emil Matthieu, Zurich

80 ROSES
Lithograph, 1967
Size: 20½″ × 22⅝″; 52 × 57.5 cm
Black
Edition: 25 printed for the artist on a variety of
 paper, of different colours, some prints
 are printed in blue instead of black,
 signed in pencil by the artist
Printer: Upiglio, Milan

185 ROUND DANCE: ORIENTATION TO
SOURCES OF NECTAR AND POLLEN
Etching for the Édition de Tête
Bon à tirer 15 April 1977
5 colours

22 ST MARY'S HATCH
Etching, 1926
Size: 4⅞″ × 7¼″; 12.4 × 18.7 cm
Black
Edition: 4 State I
 3 State II
 3 State III
 26 State IV
 59 State V
 including some artist's proofs
Publisher: Twenty-one Gallery, London
Printer: the artist

98 SHEET OF STUDIES (heads)
Lithograph, 1968
Size: 23⅞″ × 19¼″; 60.75 × 49 cm
2 colours
Edition: 70 and 10 artist's proofs
Publisher: Marlborough Fine Art Ltd, London
Printer: Fernand Mourlot, Paris

99 SHEET OF STUDIES (organic forms)
Lithograph, 1968
Size: 26″ × 19½″; 66 × 49.5 cm
2 colours
Edition: 70 and 10 artist's proofs
Publisher: Marlborough Fine Art Ltd, London
Printer: Fernand Mourlot, Paris

100 SHEET OF STUDIES (comparisons:
machines and organic forms)
Lithograph, 1968
Size: 26″ × 19¾″; 66 × 50.25 cm
2 colours
Edition: 70 and 10 artist's proofs
Publisher: Marlborough Fine Art Ltd, London
Printer: Fernand Mourlot, Paris

116 SHEET OF STUDIES
Lithograph, 1971
Size: 22¼″ × 30⅜″; 56.5 × 77 cm
3 colours
Edition: unknown 200 and 20 artist's proofs
 numbered

Given by the artist to the Prince Bernhardt
Foundation, Fondation Européenne de la
Culture, Praemium Erasmianum Foundation,
Amsterdam
Publisher: Cercle graphique européen
Printer: unknown

37 THE SICK DUCK
Lithograph, 1937
Size: 19¼″ × 30¾″; 49 × 77 cm
5 colours
Edition: 400
Publisher: *Contemporary Lithographs* (Robert
 Wellington School Prints)

156 SLEEPING BIRD I
Lithograph, 1975
Size: 23⅝″ × 20½″; 60 × 52 cm
5 colours
Edition: 50 ex. numbered 1–50
 15 ex. HC numbered I–XV
 Series A–Z on Japan paper
Publisher: given to La Jeune Chambre
 Economique de Menton in aid of
 Sahel
Printer: Teodorani, Milan

157 SLEEPING BIRD II
Lithograph, 1975
Size: 23⅝″ × 20½″; 60 × 52 cm
3 colours
Edition: not published
 15 artist's proofs only
Printer: Teodorani, Milan

10 THE SLUICE GATE
Etching, 1924
Size: 5½″ × 5¼″; 14 × 13.3 cm
Black
Edition: 2 State I
 1 State II
 10 State III
 56 State IV
 some artist's proofs of State III and IV
Publisher: Twenty-one Gallery, London
Printer: the artist

138 STANDING FORM
Etching and aquatint, 1973
Size: 6⅛″ × 4⅛″; 15.5 × 10.5 cm
Black
Edition: 25
Publisher: Marlborough Fine Art Ltd, London,
 for the American and French Édition
 de Tête of *Sutherland Sketchbook*
Printer: Valter and Eleonora Rossi, Rome
Printer of the facsimile of *Sutherland Sketchbook*:
 Daniel Jacomet, Paris

52 STANDING FORM AGAINST A
CURTAIN
Lithograph, 1950
Size: 22″ × 16⅜″; 56 × 41.5 cm
4 colours
Edition: trial proofs only (?)
Printer: Clarin, Paris

115 STANDING ROCK FORM
Lithograph, 1971

Size: 30¼″ × 20⅝″; 77 × 52.5 cm
2 colours
Edition: unknown 200
Given by the artist to the Prince Bernhardt
Foundation, Fondation Européenne de la Culture,
Praemium Erasmianum Foundation, Amsterdam
Publisher: Cercle graphique européen
Printer: unknown

STUDY FROM LIFE
Etching, 1922
Size: 5″ × 4″; 12.7 × 10.1 cm
Black
Edition: 5
Publisher: not published
Printer: the artist

STUDY IN DRYPOINT
Size: 2⅞″ × 4⅞″; 7.3 × 12.4 cm
Black
Drypoint, 1922
Edition: 5
Publisher: not published
Printer: the artist

3 STUDY OF HOUSES (New-Cross Backs)
Etching, 1922
Size: 6½″ × 3⅜″; 15.2 × 7.6 cm
Black
Edition: 5
Publisher: not published
Printer: the artist

106 SUBMERGED FORM
Lithograph, 1968
Size: 19⅝″ × 25⅜″; 50 × 64.5 cm
3 colours
Edition: 70 and 10 artist's proofs
Printer: Fernand Mourlot, Paris

107 SUBMERGED FORM II (shale on black
and white)
Lithograph, 1968
Size: 19⅝″ × 25⅜″; 50 × 64.5 cm
Black
Edition: no edition, one print exists
Printer: Fernand Mourlot, Paris

119 SUN RAY HEAD (poster for Menton)
Silk-screen, 1971
5 colours
Edition: unknown
Made for the Amis des Musées de Menton
(Designed but not printed by Graham Sutherland)

THE SWAN
Lithographic reproduction, 1972
Size: 29¾″ × 22″ on Arches; 75.5 × 56 cm
 29½″ × 21″ on Japan paper; 75 × 53.5 cm
4 colours
Edition: 225 ex. on Arches
 60 ex. on Japan paper
Publisher: Biennale internationale d'art de
 Menton
Printer: Fernand Mourlot, Paris

129 SWAN-LIKE FORM
Lithograph, 1971
Size: 19⅞″ × 19″; 50.5 × 48.5 cm